'True art is what does not seem to be art; and the most important thing is to conceal it, because if it is revealed this discredits a man completely and ruins his reputation.'

Castiglione, *The Book of the Courtier*

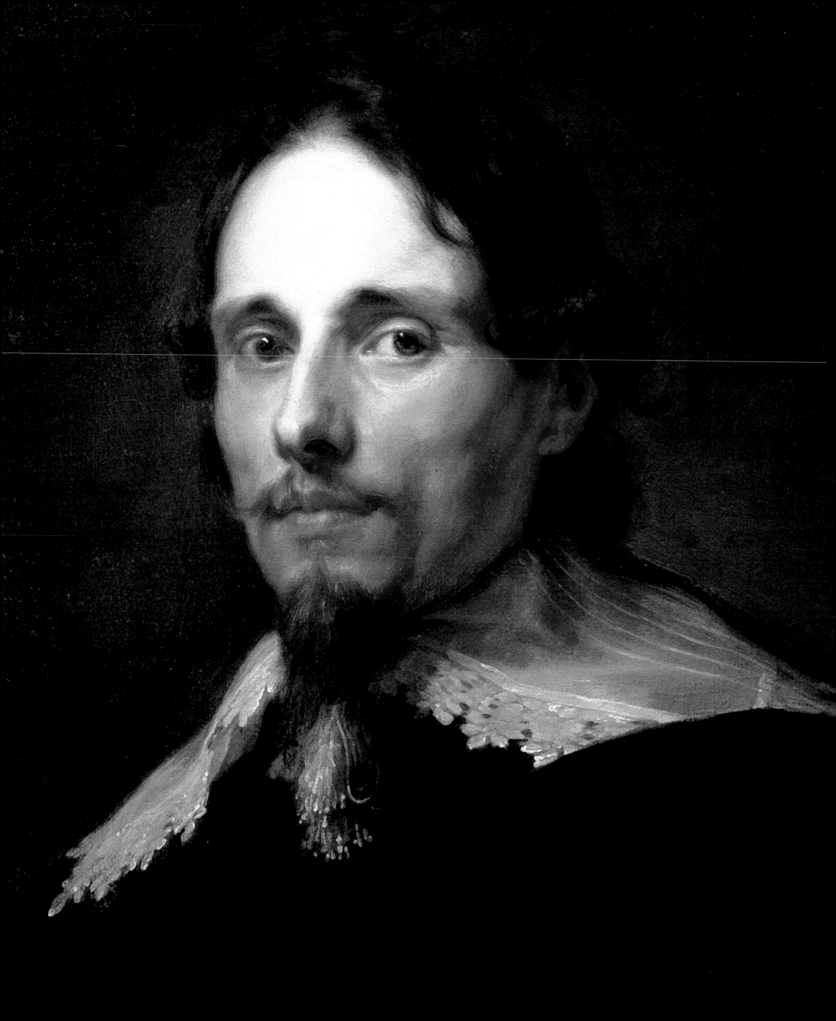

Van Dyck

AT THE WALLACE COLLECTION

Jo Hedley

List of Exhibits

The present catalogue was written to accompany the exhibition *Van Dyck at The Wallace Collection* which runs from 23 September – 15 December 1999. The catalogue focuses on the Van Dyck paintings in the Collection, and the exhibition includes the exhibits listed below.

THE ASHMOLEAN MUSEUM, OXFORD
Self-Portrait etching by Anthony van Dyck
Paul de Vos engraving by Adriaen Lommelin after Van Dyck
Philippe Le Roy etching by Anthony van Dyck
Philippe Le Roy etching and engraving by Anthony van Dyck and possibly Paulus Pontius

THE BRITISH LIBRARY
Monument to Philippe Le Roy and Marie de Raet engraving by Richard Collin from Jacques,
baron Le Roy, *Notitia Marchionatus Sacri Romani Imperii*, Amsterdam, 1678
View of the Château of Broechem engraving by Adam Pérelle after Van Weerden from Jacques,
baron Le Roy, *Castella et Praetoria Nobilium Brabantiae*, 1699

THE FITZWILLIAM MUSEUM, CAMBRIDGE
Philippe Le Roy engraving by Lucas Vorsterman and Paulus Pontius after Van Dyck
Jacques Le Roy engraving by Adriaen Lommelin after Van Dyck

THE LIBRARY OF HERTFORD HOUSE
Philippe Le Roy engraving by Paulus Pontius after Anselmus van Hulle

THE WALLACE COLLECTION
Isabella Waerbeke by Anthony van Dyck
Philippe Le Roy by Anthony van Dyck
Marie de Raet by Anthony van Dyck
The Shepherd Paris by Anthony van Dyck
Charles I after Van Dyck
Queen Henrietta Maria after Van Dyck
The Virgin and Child after Van Dyck
A Nobleman by Giovanni Bernardo Carbone
Raphael, Annibale Carracci, Van Dyck, Del Sarto, Titian and Rubens miniatures after Giuseppe Macpherson
A Souvenir of Van Dyck watercolour by Richard Parkes Bonington

All works of art are executed in oil on canvas unless stated otherwise.

Contents

Acknowledgements

The starting point for my research, as for any picture in the Wallace Collection, was the excellent series of catalogues by the former Director John Ingamells. In addition I have been particularly fortunate to write the present work in the wake of the Van Dyck exhibitions and conference held earlier this year in Antwerp. The wonderful opportunity these provided to study Van Dyck's paintings, drawings and prints has greatly influenced my own thinking. At the same time I have benefited enormously from the kind advice of many scholars, in particular Dr Horst Vey, who allowed me to see his unpublished catalogue entries on the pictures by Van Dyck in the Wallace Collection, and Herbert Lank and David Jaffé who read through the text. Similarly Stefan Crick and Henri Vydt of the *Jacques, baron le Roy Genootschap* were extremely kind in allowing me free access to their documentation on the Le Roy family.

In addition I would like to thank the following: Arnoult Balis, Susan Barnes, Donald Bauchner, Ben van Beneden, Monica Biondi, Melanie Blake, Piero Boccardo, Rachel Boom, François Borne, Arnauld Bréjon de Lavergnée, Christopher Brown, Jane Carr, Hugo Chapman, Bart Cornelis, Johan van Deesch, Luc Duarloo, Michael Eissenhauer, Clario di Fabio, Sue Fletcher, Donald Garstang, Axelle Givaudon, Anthony Griffiths, Mr Harlinghausen, Colin Harrison, Craig Hartley, Tim Hochstrasser, Jan Kosten, Christopher Lloyd, David Mannings, Victor Matveyev, Christopher Mendez, Oliver Millar, Jane Munro, Francine de Nave, Hans Nieuwdorp, Charles Noble, Gay Norton, Stephen Ongpin, Nicholas Penny, Aileen Ribeiro, Anne Rose, Martin Royalton-Kisch, Nicolas Sainte Fare Garnot, David Scrase, Charlotte Serhan, Ashok Roy, Anna Sandén, Marianne Scharloo, Nicholas Schwed, Sam Segal, Ray Sirjacobs, Luke Syson, Nigel Taylor, Simon Turner, Marc Vandenven, Hans Vlieghe, Jon Whiteley and various private collectors who wish to remain unnamed.

I thank the Directors, Trustees and Syndics of the British Museum, the Fitzwilliam Museum, Cambridge, and the Ashmolean Museum, Oxford, for kindly granting our loan requests. Their generosity has greatly enhanced the appeal of the exhibition, for which I am most grateful. Thanks are due also to Modeste Van den Bogaert and De Koninck Beer for their generous sponsorship of the opening.

Above all, I would like to thank Saven Morris, who proved an unflagging early critic of the text, and my colleagues at the Wallace Collection, who have been unfailingly supportive in this team effort: Stephen Duffy, Peter Hughes, Rosalind Savill, and Robert Wenley, for their advice on the text; Colin Jenner and Julia Parker for their efficiency and calm organisation of the catalogue production; Grania Lyster for her help in tracking down comparative photographs; Jo Charlton, Hannah Obee and Sharon Chastang for their help regarding photographs and publicity; Julia Murray and Marie Murray for associated events and marketing; Alastair Johnson for his work on the frames; the Conservation Department, Julien Sereys de Rothschild, and a succession of enthusiastic volunteers who helped with the mounting of the exhibition. Last, but not least, I owe a great debt of gratitude to my neglected friends for their understanding. JH

Preface

If you think of heroes in the Wallace Collection, surely Van Dyck's two great paintings of *Philippe Le Roy* and *The Shepherd Paris* spring to mind. Each has always been a visual treat and now, seen in this small exhibition devoted to Van Dyck's achievements, an absorbing intimacy is added to their public bravura. It is this personal element that Jo Hedley has focused on in her catalogue of eight pictures, discovering a wealth of biographical details to enliven our response to the sitters as people, while also enriching our understanding of them as enduring works of art. Her zest and zeal, dedication and thought-provoking scholarship, are here combined in five inspired essays which together provide an elegant sword, worthy of the one worn by Le Roy himself, in the Wallace Collection's arsenal of publications.

Once again we have assembled a group of works by an artist currently the subject of a major London exhibition. While this is not intended as an apology for the lending restrictions in Lady Wallace's bequest, it is a means of drawing attention to the extraordinary quality of this stunning Collection. Despite John Ingamells' remarkable Dutch and Flemish volume (1992) of his four-volume *Catalogue of Pictures in the Wallace Collection*, our Van Dycks have been rather neglected. Here we can play our part in the 1999 celebrations of Van Dyck, both in Antwerp and in London, and in this we have been generously assisted by loans of comparative material from the Ashmolean Museum, the British Library and the Fitzwilliam Museum. The Trustees of the Wallace Collection are very grateful to them all.

Van Dyck's heroes and heroines, collected by the 3rd and 4th Marquesses and admired by Sir Richard Wallace, have lived together in Hertford House for almost a hundred and fifty years. Until 1897 they were part of the family collection, then Lady Wallace bequeathed them to the nation, and since 1900 they have been shown as part of a national museum. Yet it has taken until now for all Van Dyck's sitters to appear together in one room where, joined by those of some of his followers, the masterly qualities that so inspired the Hertfords are clear for all to see. If one imagines that a work of art still in a private collection is alive and well, but once it enters a museum it goes to heaven, then today, we too, like Gainsborough 'are all going to heaven, and Van Dyck is of the company'.

This exhibition is the last of our small exhibitions in Gallery 21. From June 2000 we will have a new Exhibition Gallery in the basement Study Centre, which has been so creatively re-invented by the architect Rick Mather. This will enable us to have many more temporary exhibitions and, unlike in the main galleries of Hertford House, we will also be able to extend our exhibition programme to include occasional displays borrowed from elsewhere. It is hoped that the Wallace Collection staff will regularly produce exhibitions and monographs similar to *Van Dyck at the Wallace Collection*, and that these will breathe fresh life into our works of art for the inspiration and enjoyment of our visitors.

Rosalind Savill, *Director, The Wallace Collection*

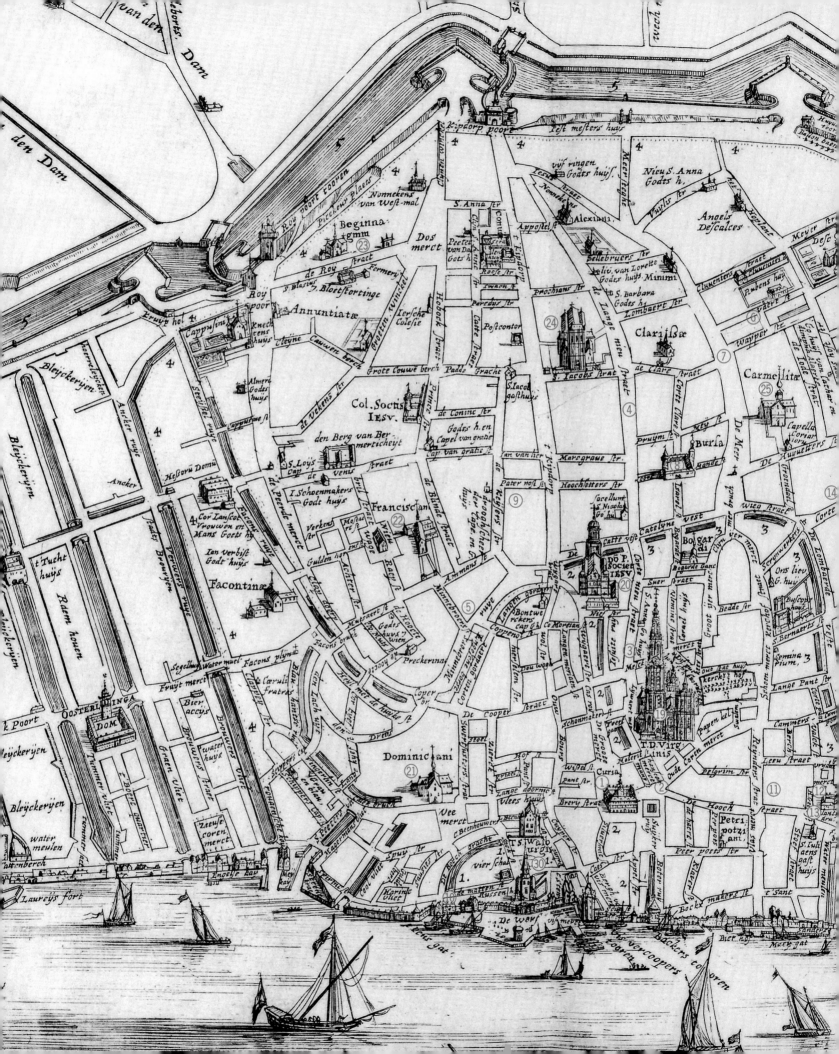

KEY TO MAP OF ANTWERP

Anonymous map engraving taken from Jacques, baron Le Roy, *Notitia Marchionatus Sacri Romani Imperii*, Amsterdam, 1678, p.1.

Views of Antwerp may be seen inside the cover, p.146 and in figures 2 and 4 in Chapter I.

NB: Street-name spellings have been adopted as on the map; modern spellings are slightly different in most cases.

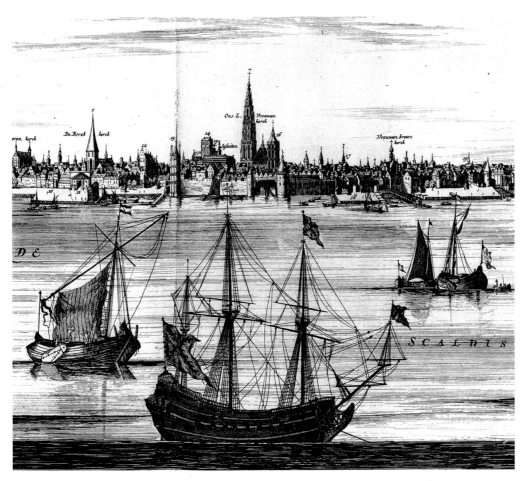

View of Antwerp, detail, anon. engraving, from LE ROY 1678, between pp.4–5, The British Library

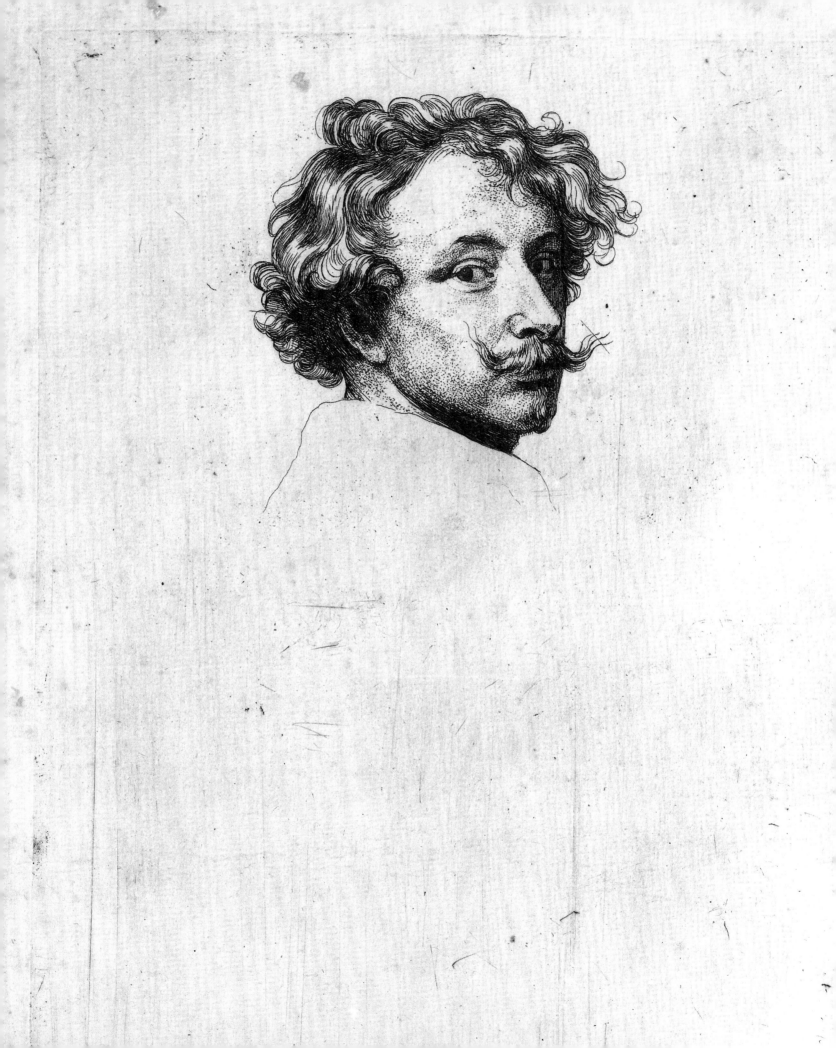

'Van Dyck, the phoenix of his day', Houbraken[1]
Van Dyck in Antwerp and his Portrait of Isabella Waerbecke[2]

This year Antwerp celebrates the 400th anniversary of its most famous native son, Anthony van Dyck (1599–1641), seen here in a *Self-Portrait* etching (fig.1).[3] Van Dyck was born at the end of an extraordinary century that saw his city fall from a position of greatness to one of virtual ruin. In this sense alone his career may well be likened to the ascent of an artistic phoenix rising from the ashes of a war-ravaged Antwerp. At the beginning of the century, in 1505, the German banking dynasty, the Fuggers of Augsburg, moved their trading houses to Antwerp from Bruges. When the Flemish-speaking Emperor Charles V later chose the city, situated on the river Scheldt, as the principal port of his domains, its rise was assured: Antwerp rapidly became the most important entrepôt of the sixteenth-century world, at the heart of the trading networks of Europe. From the outset luxury goods and the production of works of art played a major role in Antwerp's prosperity. Since the fifteenth-century Flemish artists had enjoyed a high reputation, and with the influx of wealth a new generation of artists and artisans were attracted to the city, including no less a figure than Albrecht Dürer in 1520. The proximity of a brilliant court at Brussels encouraged this trend, providing regal élan and important commissions.[4] By 1560 the city supported over 300 artists: that is, twice as many artists as bakers. Scholars and entrepreneurs from the whole continent flocked to this cosmopolitan centre. Sir Thomas More, who visited the city with Erasmus in 1515, even set the opening scenes of *Utopia* in an Antwerp inn. By the mid-century, according to the Florentine writer Lodovico Guicciardini, Antwerp was quite simply 'the most beautiful city in the world'.[5]

Antwerp's troubles began with the division of the Empire on the abdication of Charles V in Madrid in 1554. The Holy Roman Empire passed to his brother, Ferdinand I, while his son Philip II inherited the Spanish Empire and the Netherlands; a territory comprising what is today the Netherlands (including Holland), Belgium, Luxembourg and part of north-east France.[6] In these last days of the Council of Trent, Philip regarded himself as the champion of the Counter-Reformation. His religious views soon brought him into disastrous conflict with his traditionally free-thinking subjects in the Netherlands. In 1566 a wave of iconoclasm swept the Netherlands as zealous Protestants attacked Catholic churches and monasteries, including the Cathedral in Antwerp, which was then a predominantly Protestant city. Philip reacted swiftly and with great brutality. An army was despatched under the Duke of Alva in 1567; the rebellion was quelled, heavy taxation imposed and the Inquisition introduced. Unsurprisingly this oppressive regime, exacerbated by the effects of a widespread European financial crisis, resulted in bitter and catastrophic conflict between the Netherlands and the occupying Spanish forces. Antwerp found itself trapped geographically, and politically and religiously compromised, as it was passed back and forth between Spanish and native forces. Then in 1576 the Spanish troops,

Fig.1
Anthony Van Dyck (1599–1641), *Self-Portrait*, detail, etching, first state, Ashmolean Museum, Oxford. The print is based on a painting by Van Dyck (c.1630; private collection, Switzerland), which depicts the artist in the same attitude, in reverse, wearing a chain that is absent from the print.

quartered in the new citadel at Antwerp, rampaged through the city in a terrible orgy of death, rape and destruction, murdering thousands, in an episode known as the Spanish Fury. The Calvinists regained control of the city the following year, and in turn exacted revenge from the Catholic inhabitants and their institutions. William the Silent ruled the war-torn city for a brief period, but it finally fell irrevocably under Spanish control in 1585. The Northern and Southern Netherlands were effectively partitioned,[7] the river Scheldt blocked, and the Protestants given four years to leave. With its population more than halved, and many of its most enterprising citizens slain or forced to flee, Antwerp was described at the beginning of the seventeenth-century as 'a disconsolate widow, or rather some super-annuated Virgin, that hath lost her Lover, being almost quite bereft of that flourishing commerce wherewith before the falling off of the rest of the Provinces from Spain she abounded to the envy of all other Cities and Marts of Europe'.[8]

Antwerp was never to regain her commercial eminence in Europe, yet within only a few years she had once more risen to a position of great cultural and artistic importance.[9] The enterprising citizens worked hard to re-establish their city as the regional commercial centre of the Southern Netherlands, again specialising in the trade of luxury items. The pacific policies of the new Regents of the Netherlands, Archdukes Albert and

Fig. 2
View of Antwerp, anon. engraving, from LE ROY 1678, between pp.4–5, The British Library

Isabella,[10] created sufficient stability to enable and encourage this process. In 1609 they signed the Twelve Year Truce with the Northern Netherlands, an event that is alluded to repeatedly in the allegorical works of art of the period. One such picture, Jordaens' *Allegory of Fruitfulness* (*Homage to Pomona*; *c.*1618–20), may be seen in Gallery 6 of the Wallace Collection today.[11] At the same time, the Archdukes' insistent propagandist encouragement of Counter-Reformation Catholic art and architecture not only served to consolidate their own power, but also led to a remarkable artistic renaissance.[12] From hereon the two most prominent features of any view of Antwerp (fig.2) are the river Scheldt, which had brought such wealth in the past but was now blocked, and the famous skyline, remarkable for the religious architecture which grew daily more magnificent. This outward show certainly gave the appearance of prosperity, if not necessarily the substance[13]. Despite the interminable wars of the seventeenth century, which made the Spanish Netherlands one of the principal battle-grounds of Europe,[14] the diarist John Evelyn was able to comment in 1641, the year of Van Dyck's death, 'nor did I ever observe a more quiet, cleane, elegantly built, and civil place, than this magnificent and famous city of Antwerp'.

The artistic milieu in Antwerp and Van Dyck's early years[15]

The dominant spirit of Antwerp's artistic renaissance was undoubtedly Peter Paul Rubens (1577–1640).[16] Born in Siegen, Westphalia, in the midst of the troubles, Rubens later worked unceasingly, both as an artist and as a diplomat, to restore prosperity to his adopted city. The historical near-coincidence of Rubens' return to Antwerp in 1608 and the signing of the Twelve-Year Truce a year later was to prove symbolic. A man of great energy, culture and learning, Rubens moved with ease in the highest social circles. In Rubens the Archdukes found a brilliant artistic champion gifted also with skills of diplomacy, leadership and the entrepreneurial acumen which ensured the promotion of the Archdukes' political and artistic agenda at home and abroad. Antwerp today still bears testimony to this great artist's achievement: his powerful altarpieces dominate the Cathedral and other churches, his pictures fill the museums, and his grand Italianate house and studio may be visited in the Wapper Straet. The Wallace Collection contains nine works by Rubens, on display in Galleries 19 and 22. Rubens was fortunate also to attract the patronage and friendship of Antwerp's leading merchants, men such as the burgomaster Nicolaas Rockox (1560–1640), and the Dean of the Guild of Merchants, Cornelis van der Geest (1555–1638). Moreover his friendship and collaboration with the printer Balthasar Moretus (1574–1641)[17] ensured the wider dissemination of his work through the medium of prints, many of which adorned the great baroque Counter-Reformation texts produced by the Plantin-Moretus press. The words of the humanist scholar Jan Woverius were to prove prophetic: 'How fortunate is our city of Antwerp to have as her two leading citizens Rubens and Moretus! Foreigners will gaze at the houses of both, and tourists will admire them'.[18]

Rubens may have provided the focus for much of Antwerp's artistic revival, but he was only one member of a thriving artistic community. Although Antwerp in terms of its population was a large city for its time, its physical extent was quite small, as is appar-

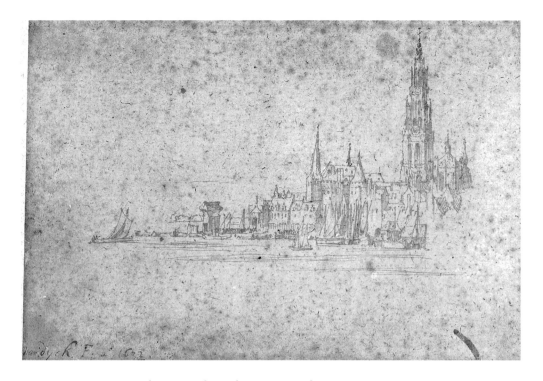

ent to anyone visiting the city today. The seventeenth century street map (see pages 8–11) shows the locations of the principal monuments, religious and secular, and the residences of Antwerp's most famous citizens and artists. One is immediately struck by the fact that everything is within walking distance. So it is not surprising that when we come to examine the relationships that governed the artistic community we should find a similar closeness. Young artists were apprenticed at an early age to a master. The master, if not actually a member of the same family, was probably a friend or acquaintance of their parents. Once the student had attained a sufficiently high standard, he would be allowed to practise as an independent master and admitted to the Guild of Saint Luke, which acted as a regulatory body for artists and related artisans. Artists often retained their links with their original master, and when in need of work at the beginning of their careers might return to their old master's studio as assistants. Communal Guild events, such as the annual St Luke's Day feast, further ensured that artists in the city got to know each other. This community of interest led to an unusual amount of collaborative work, which characterises the second Antwerp School. Thus we find artists like Rubens calling upon the services of specialist painters, like the animal painter Frans Snyders (1579–1657), to furnish individual elements in a larger composition. As we shall see, in addition many artists belonged to artistic 'dynasties', which often intermarried, making the ties yet stronger.

Van Dyck was born into this milieu, in a house called 'Den Berendans' ('The Bear Dance') on the Grote Markt (Main Market Square), in 1599 (fig.3). He was baptised only a few steps away in the Cathedral of Our Lady, which he sketched 33 years later from the river Scheldt (fig.4).[19] The interior of the Cathedral can be seen in a painting by Peeter Neeffs the Elder in Gallery 20 of the Wallace Collection.[20] Van Dyck's grandfather, also called Anthony, had been both an artist and a merchant dealing in silk and fancy goods, and his father Franchois, followed him into the luxury goods business. Van Dyck

above: Fig.3
View of the location of 'Den Berendans', rebuilt in the nineteenth century, with the Cathedral beyond

above left: Fig.4
Van Dyck, *View of Antwerp*, pen and brown ink on brown paper, signed and dated 1632, Koninklijk Bibliotheek / Bibliothèque Royale Albert Ier, Brussels

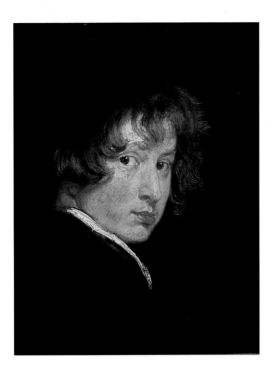

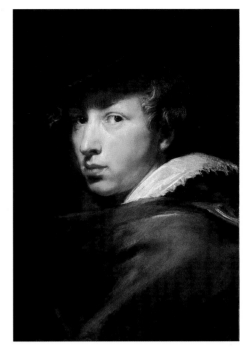

was thus born into comfortable bourgeois circumstances. Unfortunately, after the death of his mother in 1607 the family's affairs went increasingly awry. The documentary evidence for 1610–17 tells a tale of death threats, years of legal wrangling and eventual bankruptcy, which must have left their mark on the sensitive young artist. Van Dyck, meanwhile, was apprenticed at the age of ten to Hendrick van Balen (1575–1632), a popular painter of small cabinet pictures who often collaborated with his next door neighbour in the Lange Nieu Straet, the landscapist Jan Breughel the Elder (1568–1625). Breughel was a great friend of Rubens; indeed Rubens portrayed *Breughel and his Family* (c.1612–13) in a portrait which is now in the Courtauld Gallery in London. So it is not surprising that Rubens soon got to hear of the young Van Dyck's exceptional talent. Rubens must have thought that the young man had a great future, for in about 1614 he painted a dashing portrait of the slightly sulky adolescent (fig.5). The first of many *Self-Portraits* by Van Dyck himself dates from the same period (fig.6).[21] Aged about 14 or 15, he was already an accomplished artist. The precocious bravura of his rapid, loose, brushwork already seems aimed at differentiating his style from the smooth solid plasticity of Rubens' comparable portrait. Still a teenager, Van Dyck was sufficiently confident to set up his own studio with assistants in the Lange Minnerbroersstraet in 1616/18. In 1618 Van Dyck was admitted to the Guild of Saint Luke, and the same year the young artist painted the tapestry cartoons, after designs by Rubens, for a *History of Decius Mus* (Vaduz). By 1620 Van Dyck was Rubens' principal assistant working on the ceiling paintings for the Jesuit Church in Antwerp. The biographer Bellori vividly describes the mutually beneficial relationship between the two artists: 'Rubens, who, liking the good manners of the young man and his grace in drawing, considered himself very fortunate to have found so apt a pupil'. Indeed Rubens apparently 'came to earn a good hundred florins a day from his pupil's labours, while Anthony profited still more from his master, who was a veritable treasury of artistic skills'.[22]

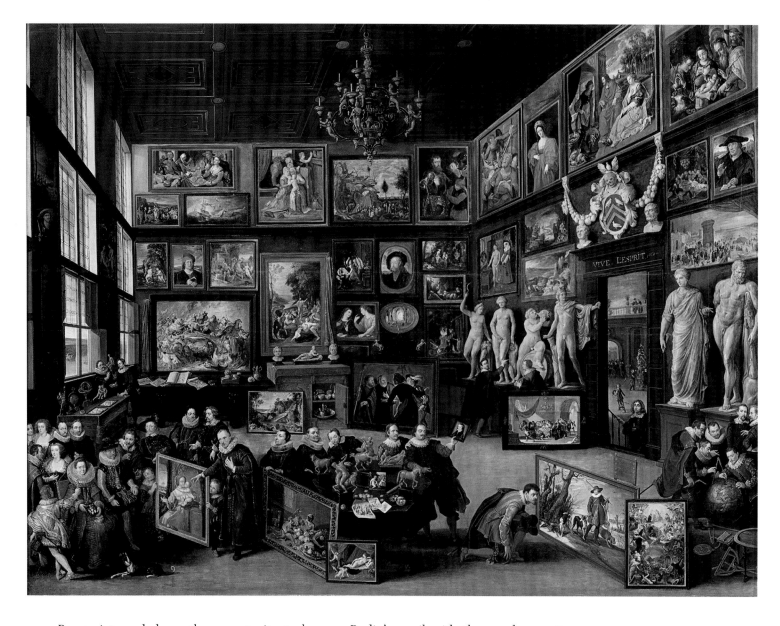

Brancusi turned down the opportunity to become Rodin's pupil with the words: 'little trees do not flourish in the shadow of great oaks'. In much the same way it must have been virtually impossible for Van Dyck to escape Rubens' shadow in Antwerp. No matter how cordial their personal relationship, an artist with Van Dyck's evident talent and ambition surely felt increasingly frustrated and confined by his elder compatriot's prodigious and continuing achievement. As he outgrew the phase of child prodigy it must have been difficult for Van Dyck to persuade contemporaries of his own individuality and originality, so closely associated was he with the most famous artist of the day. While Van Dyck's portrait of Rubens' wife *Isabella Brant* (1621; Washington)[23] may be seen as a symbol of the mutual admiration of the two men, we can perhaps also detect some marks of youthful rivalry. The portrait's slightly overblown, pompous monumentality and showy scintillating surface effect, so different from Rubens' own style, clearly stake a claim to artistic parity. But to liberate himself definitively from his elder colleague's pervasive influence Van Dyck found it necessary to leave Antwerp altogether. Thus in the autumn of

Fig. 7
Willem van Haecht (1593–1652), *Visit of the Archdukes to the Art Gallery of Cornelis van der Geest*, 1628, oil on panel, Rubenshuis, Antwerp

1620 the young artist embarked upon the first of what would be many journeys abroad, in a short life characterised by restless travel. His first brief visit was to England, and then in November of the following year Van Dyck left for Italy, where he was to spend a fruitful six years ripening his talent in the glow of Titian (*c.*1485–1576) and the other great masters of the Italian school.

It is worth quoting Bellori's description of our artist as he arrived in Rome: 'He was still a young man, his beard scarcely grown, but his youthfulness was accompanied by a grave modesty of mind and a nobility of aspect, for all his small stature. His manners were more those of an aristocrat than a common man, and he was conspicuous for the richness of his dress and the distinction of his appearance, having been accustomed to consort with noblemen while a pupil of Rubens; and being naturally elegant and eager to make a name for himself, he would wear fine fabrics, hats with feathers and bands, and chains of gold across his chest, and he maintained a retinue of servants. Thus, imitating the splendour of Zeuxis, he attracted the attention of all who saw him'.[24] Van Dyck's passion for dress and dressing-up was, as we shall see, to prove a great asset in portraying the fashion-obsessed aristocracy and would-be aristocracy of Europe, where dress was one of the main indices of status. His refined manners must also have endeared him to this clientele. It had the opposite effect, however, on his more down-to-earth Flemish brother-artists in Rome who took 'his reserved manner for contempt, and condemned him as ambitious, criticising his pride'.[25] Nevertheless, Van Dyck's career and renown soared, as he became, in particular, the favourite portraitist of Genoese high society.

It was as an experienced artist of international repute that Van Dyck, now aged 28, returned to Antwerp in 1627. The four paintings by Van Dyck in the Wallace Collection were painted during this *Second Antwerp Period.* Van Dyck's new status in the eyes of his contemporaries is clearly reflected in a painting by Willem van Haecht, *The Visit of Archdukes Albert and Isabella to the Art Gallery of Cornelis van der Geest* (fig.7). Although ostensibly illustrating an event that took place in 1615, it actually reflects the artistic status quo in Antwerp in 1628, the year the picture was painted.[26] Van Dyck is seen fashionably dressed *à la française,* in black with sword at hip and moustachios curled, standing behind and slightly to the left of Cornelis van der Geest, who gestures to a painting of the *Madonna and Child* by Quentin Massys. The Archdukes are seated bottom left, and above Archduke Albert's shoulder, to the right, Rubens inclines as if in conversation. The picture depicts the main social and artistic groups in the art world of the time. On the left we see members of the Brussels Court, in the centre a group of collectors, including the wealthy cloth merchant Peeter Stevens holding aloft a small portrait, and to the extreme right a group of painters, including Hendrick van Balen, who is depicted in profile on the edge of the canvas next to Frans Snyders. Van Dyck was clearly no longer 'the pupil of Rubens', but an artistic power in his own right, and, Rubens excepted, already a cut above all the other painters of his day.

Van Dyck's Portrait of Isabella Waerbeke

Oil on canvas, 119.7 × 94.2cm.

PROVENANCE

Possibly the portrait listed, together with that of her husband Paul de Vos, in the latter's will, 1675, and posthumous inventory, 1678; the sitter's son Peter Paul de Vos; by the eighteenth century, Henry Hope (1736–1811); his sale, Christie's, 1st day 27 June 1816 (79, *Portrait of the Wife of De Vos, the Companion*), bt. by the 3rd Marquess of Hertford,[27] 100gn.; subsequently sold; G.W. Taylor (1771–1841) by 1821; his sale, Christie's, 1st day, 13 June 1823 (54, *Wife of [Simon] de Vos*, 340 gn., bt. William Wells (c.1768–1847) of Redleaf; his sale, Christie's, 13 May 1848 (102, *Portrait of the Wife of de Vos*, ex colls. Hope and Taylor; exh. BI 1822 [sic]), bt. Robertson, 750 gn., for the 4th Marquess of Hertford; seen in Hertford House in 1851 by Waagen;[28] Hertford House inventory 1870; bequeathed by Lady Wallace, as part of The Wallace Collection, to the British nation in 1897.

VERSIONS

Brussels, private collection 1987.[29]
Innsbruck, Museum Ferdinandeum; head only.[30]
Paris, Charpentier, 10 December 1951; half-length, ex. Coll. Gréffuhle.

EXHIBITIONS

British Institution 1821 (93, *Wife of Simon de Vos*[31]) lent Taylor.
British Institution 1836 (19, *Wife of De Vos*) lent Wells.
Manchester, *Art Treasures*, 1857 (saloon H, no.8, *Female Portrait*) lent 4th Marquess of Hertford.
Bethnal Green 1872–5 (116, *Wife of Cornelius de Vos*, painter) lent Sir Richard Wallace.

LITERATURE

SMITH 1829–42, no.356, and Supplement, no.56; GLÜCK 1931, pp.325, 555; LARSEN 1980, no.640, and 1988, no.634; INGAMELLS 1992, pp.99–101.

Van Dyck's *Portrait of Isabella Waerbeke* in the Wallace Collection (fig.8) is a quiet reminder of the artist's artistic links, traditional influences, and innovatory style at the beginning of his *Second Antwerp* Period. Obscured by other flashier, attention-grabbing products of Sir Anthony's brush, she has been consistently overlooked by writers on the period, rarely mentioned other than in passing, and virtually never illustrated.[32] In some ways her fate at the Wallace Collection has been little more fortunate. Although she normally hangs in the Great Gallery (22), her discreet charm means she is often over-looked on a wall where Rembrandt's *Portrait of Titus* (c.1655) and Hals's *The Laughing Cavalier* (1624) vie for our attention. If nothing else, the current exhibition should redress that balance for a short while and focus our attention on a work that is deceptive in its seeming artlessness.

To understand a painting it helps to understand its subject, but as so often for women

Fig.8
Van Dyck, *Portrait of Isabella Waerbeke*, c.1628, Wallace Collection

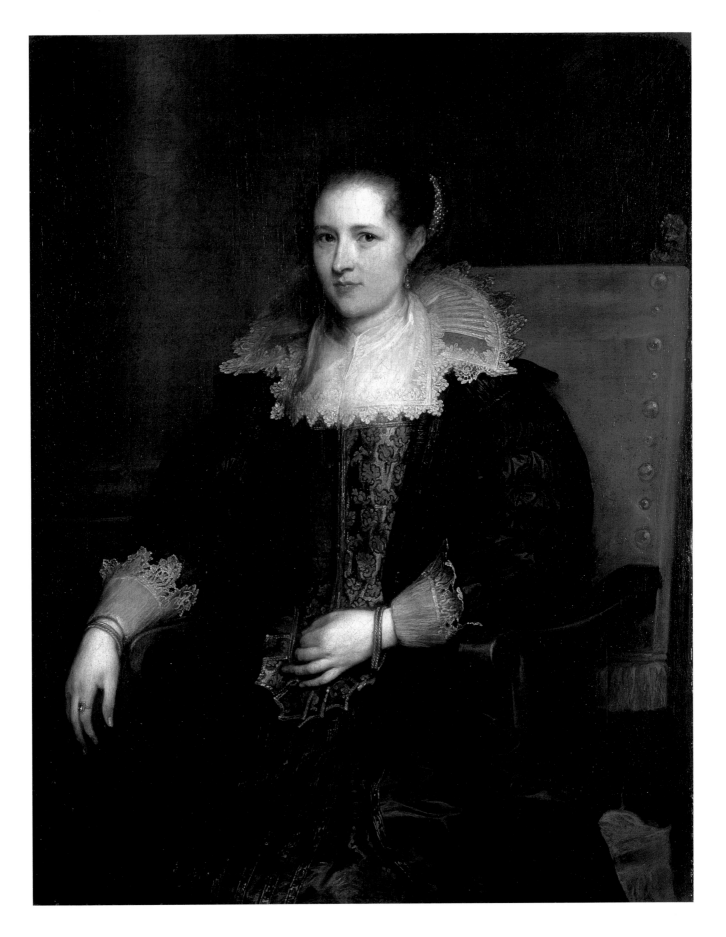

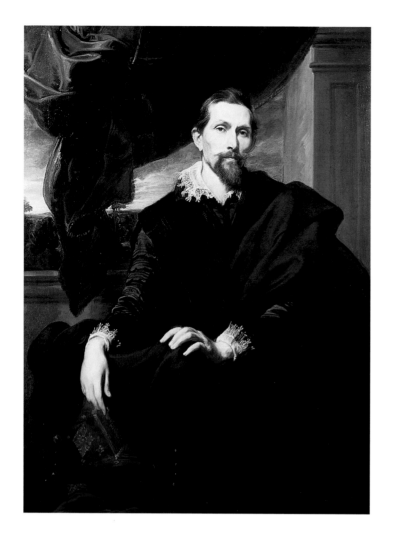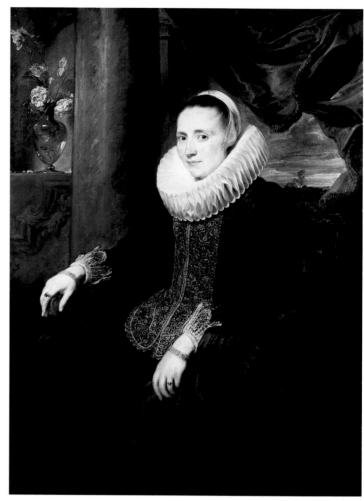

of this period, we have little information about Isabella's life. Her birth-date is not known, but we do know that her father, Jan, was a wealthy notary.[33] On 15 November 1624 she married the painter Paul de Vos (1591–2 or 1595–1678),[34] by whom she had ten children, and died on 27 August 1660. Taking into account her appearance in the portrait, and the relatively young age at which women were married in the seventeenth century, she must have been in her 20s when Van Dyck's portrait was painted.

Paul de Vos's life is better documented. Brother of the portraitist Cornelis de Vos (c.1584–1651), whose *Portrait of a Lady* (c.1622; fig.15) hangs in Gallery 22 of the Wallace Collection,[35] and of Margaretha de Vos, wife of Frans Snyders (1579–1657), De Vos was a prolific painter of still lifes, animal and hunting scenes. At the beginning of his career he may have worked for his brother-in-law, who bequeathed 'his large rubstone and the large mortar' to De Vos in 1657. Certainly De Vos became one of Snyders' most gifted followers. The *Pantry Scene with a Page* in Gallery 22 may be cited as an example of Snyders' work.[36] De Vos's friendship with Van Dyck was probably longstanding, since Van Dyck portrayed his sister and brother-in-law superbly in 1621 (figs.9–10),[37] and the sitter of an early portrait by Van Dyck, of which there are versions in the Louvre and Vienna, has been traditionally identified as Paul de Vos (fig.11).[38] The two young men had a lot in common. Both were of the up and coming generation of young artists in

above left: Fig.9
Van Dyck, *Portrait of Frans Snyders*, c.1621, The Frick Collection, New York

above right: Fig.10
Van Dyck, *Portrait of Margaretha de Vos*, c.1621, The Frick Collection, New York

Fig. 12
Van Dyck and Paul de Vos (1591/2 or
1595–1678), *Rest on the Flight into Egypt*,
1628, The State Hermitage Museum,
St Petersburg

Fig. 11
Van Dyck, *Portrait of a Man, said to be Paul
de Vos*, Kunsthistorisches Museum, Vienna

Antwerp, and both had worked for highly successful members of the first generation. When Van Dyck returned to Antwerp in 1627, it was natural that he and De Vos should soon be found imitating their elders and collaborating on a picture, *The Rest on the Flight into Egypt* (1628; fig. 12), for the Jesuit Confraternity of Bachelors.[39] In the same year Paul de Vos and Isabella Waerbecke had their first son whom they named Peter Paul, and to whom his namesake Rubens acted as godfather. Perhaps it was this happy event that inspired Van Dyck's portraits of the couple.

As can be seen in the *Provenance*, the Wallace Collection *Portrait of Isabella Waerbeke* was originally twinned with a pendant portrait of her husband *Paul de Vos*. According to the inventory taken after De Vos's death in 1678 portraits of the artist and his wife hung downstairs in their front room along with other pictures from De Vos's collection.[40] In his will of 1675 Paul de Vos bequeathed the two portraits to the same son, Peter Paul, who had perhaps inspired their commission. The two paintings were still together in 1816, when they briefly entered the collection of the 3rd Marquess of Hertford. Hertford subsequently sold the paintings, and they resurfaced in the sale of George Watson Taylor in 1823, where they parted company forever: Isabella's portrait entered the collection of William Wells; the *Portrait of Paul de Vos* was bought by Baron Stockmar and entered the collection of Leopold II King of Belgium by 1831. Unfortunately the *Portrait of Paul de Vos* perished in a fire at the Laeken Palace in Brussels in 1890–1. Its appearance, however, may be surmised from a number of painted copies (fig. 13),[41] and from prints of De Vos made by Van Dyck and his collaborators (fig. 14).[42] It was about this period that Van Dyck conceived his scheme of producing a series of engravings, after his own works, depicting the most notable men of his day. The first series of eighty prints, known as *The*

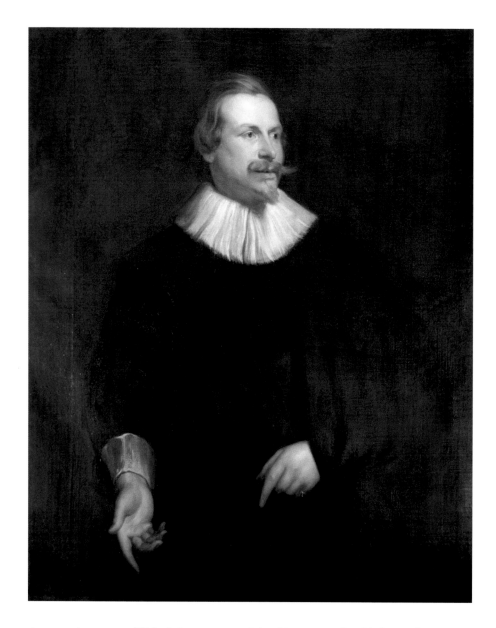

Iconography, was published (*c.*1635–1641) by Martin van den Enden and was organised into
three sections: Princes and Generals, Politicians and Scholars, Artists and Collectors. It is
a mark of Van Dyck's esteem for his friend that De Vos's image was probably one of the
first to be designed, and merited Van Dyck's personal attention. Indeed Paul de Vos's
portrait was one of only 21 prints made by Van Dyck in his lifetime, and Van Dyck etched
De Vos's image in a manner reminiscent of his etching of himself (fig. 1).

Comparing Isabella's portrait with her husband's exuberant gesticulating pose, we are
struck with how much more static Isabella's image appears to be. Like her sister-in-law,
Margaretha de Vos (fig. 10), Isabella is depicted as sedentary, inactive and submissive,
while both husbands stand. As we shall see again in the next chapter, such visual contrasts
between the male and female subjects of Van Dyck's matched portraits of Flemish bour-
geois couples are common, and reflect the modesty and reserve expected of an ideal wife.
That is not to say that nothing is going on in Isabella's portrait. Chameleon-like, one of
Van Dyck's greatest gifts as a portrait painter was his ability to identify the aspirations of

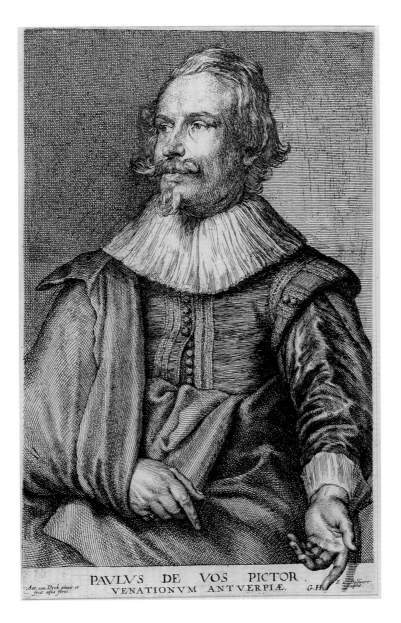

PAVLVS DE VOS PICTOR,
VENATIONVM ANTVERPIÆ.

sitters of differing class and nationality, respond to their ideals, and then add a little extra refinement of his own which lifts even the most unassuming sitter into the realm of great art. It is often in the smallest throwaway detail, artfully applied, that the effect or atmosphere of a portrait may rest. Isabella sits straight-backed in her chair, yet seems approachable and relaxed. The secret of this apparent paradox resides in the position of her hands; one lightly resting on her bodice, the other draped nonchalantly over the arm of her chair. Light from her white collar illuminates her face which is turned three-quarters toward us in the attitude which, as anyone who has ever posed for a photograph will know, is the most flattering to the subject. Van Dyck first used a similar modest but refined pose to the same effect in his portrait of *Margaretha de Vos* (fig.10), and its appeal was immediate. Within a year Margaretha's brother Cornelis de Vos was churning out female portraits like the portrait seen in the Wallace Collection (fig.15);[43] capitalising, in his absence, on Van Dyck's perfect formula of bourgeois female charm.

Isabella's social status, as a member of the well-heeled Antwerp middle classes is

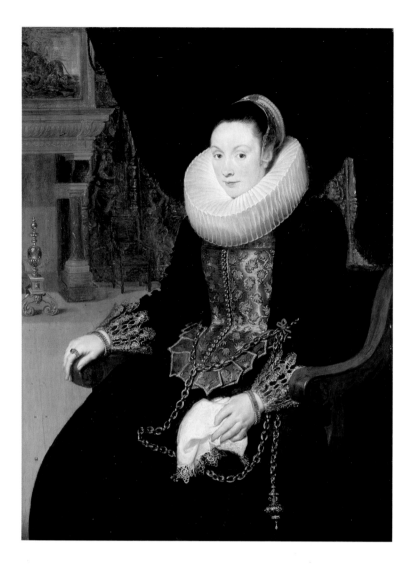

Fig. 15
Cornelis de Vos (*c*.1584–1651), *Portrait of a Lady*, *c*.1622, oil on panel, The Wallace Collection

illustrated by her carefully depicted costume. As already noted, Van Dyck was highly sensitive to matters of dress and its associated social connotations. A comparison of Isabella's portrait with Van Dyck's picture of *The Merchant Sebastien Leerse and his Wife* (fig. 16) confirms her similar social standing. Isabella wears a black silk gown and over-dress with heavy ruched sleeves, and a gilded leather bodice with pointed tabs, similar to that worn by the unidentified lady in De Vos's *Portrait of a Lady* of some six years earlier. Fashion in the Netherlands in these social circles was innately conservative, so it is not so strange to find a young woman adopting a mode of dress which was well established even in the previous decade, as can be seen also in Rubens' *Portrait of the Artist Jan Breughel and his Family* in the Courtauld Institute.[44] Isabella does eschew, however, the heavy millstone ruff seen in the De Vos and Rubens portraits for a softer standing collar, edged with Brussels lace, a lawn fichu and matching lace-edged lawn cuffs similar to those worn by Sebastien Leerse's wife. Her hair is adorned with what appears to be a small cap, embroidered in silver thread, placed over her chignon, and her jewellery is conservative, tasteful and expensive. Van Dyck has been careful to draw attention to the single white highlight of a drop pearl at her ear, and of a square-cut diamond on her finger. Now the reason behind the placing of her hand on her bodice is revealed; it is to show off one of a pair

Fig.16
Van Dyck, *The Merchant Sebastien Leerse and his Wife*, c.1629, Gemäldegalerie Alte Meister, Kassel

of heavy gold bracelets that glints with little dabs of yellow paint.

But if Isabella's pose and clothes are so similar to those of Cornelis de Vos's Lady, why is it that the two portraits are so very different? The answer lies partly in Van Dyck's greater mastery of paint, but also in a new sophistication in his art evident after his return from Italy. As we have seen, from his very earliest years, even in his first *Self-Portrait* (fig.6), Van Dyck had been interested in the surface effects he was able to achieve in paint. Although he admired Rubens' creative genius, was able to imitate his technique and borrowed freely from his compositions, he was less enamoured of his former master's sculptural modelling and hard finish. All the while another artistic god – Titian – exerted his fascination over him, and Van Dyck was finally able to study his hero's work in the great English collections he visited in 1620. But it was in Italy that Van Dyck truly absorbed the spirit of Titian's art and refashioned it as a tool for his own use.[45] *The Portrait of Isabella Waerbeke,* unmistakably Flemish in its costume and directness, nevertheless bears eloquent witness to Titian's influence in its handling, warmth and intensity. Van Dyck eschews the traditional Flemish panel support, and like Titian, paints on canvas, which allows him to create a more textured surface. We find a similar hand resting on a chair in Titian's *Portrait of Paul III* (1545–46; Galerie Nazionale Capodimonte, Naples),[46] and

 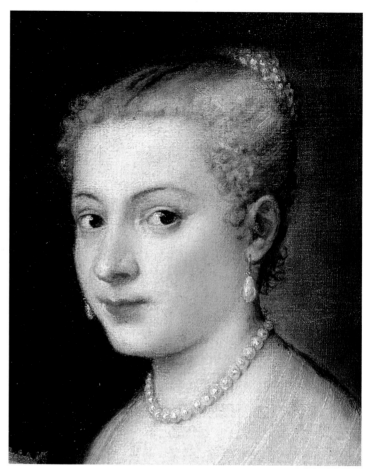

Isabella's deceptively simple, seated, three-quarter length pose recalls the regal Duchesses of Urbino, *Eleonora Gonzaga della Rovere* (1536–38; Uffizi, Florence)[47] and *Giulia Varano* (1545–47; Pitti Gallery, Florence).[48] A comparison of Isabella's head (fig.17) with that of Titian's *Lavinia as a Bride* (fig.18) is yet more telling. In both portraits we find the same delicate application of dryer, pigment-laden paint, to suggest the escaping tendrils of hair, which soften the face. They share a similar approach to the delicate blending of flesh tones to model the face, which is thrown into relief by the melting shadows. Van Dyck's *Portrait of Isabella Waerbeke* thus achieves the same quiet intensity as Titian's portrait, which in turn convinces the viewer of a personal connection with the sitter; surely one of the criteria of a good portrait.[49] Van Dyck observed Titian's subtle use of glazes, his use of shadow to model form, and his bravura expressionistic handling of paint. One can see the increased use of brown outlining and shadow quite clearly in Van Dyck's treatment of Isabella's left hand (fig.19), where the elegant tapering fingers emerge in their three-dimensionality from a brown outline of shadow. Of course this tendency to outline everything in brown also enabled the artist to work more rapidly and cut a few corners, a habit which would become a little too useful when he was over-burdened with commissions later in his career. Yet one only has to compare the lively treatment of Isabella's gilded leather bodice (again fig.19), with its flicks of yellow paint to highlight reflections and its use of thin grey-black washes to indicate reflections and form, against the flat schematic effect of the bodice worn by De Vos's *Lady* (fig.15) to see how far Van Dyck's

above left: Fig.17
Van Dyck, *Portrait of Isabella Waerbeke*, detail, c.1628, The Wallace Collection

above right: Fig.18
Titian (c.1485–1576), *Lavinia as a Bride*, detail, c.1555, Gemäldegalerie Alte Meister, Dresden

Fig. 19
Van Dyck, *Portrait of Isabella Waerbecke*,
detail, *c.*1628, The Wallace Collection

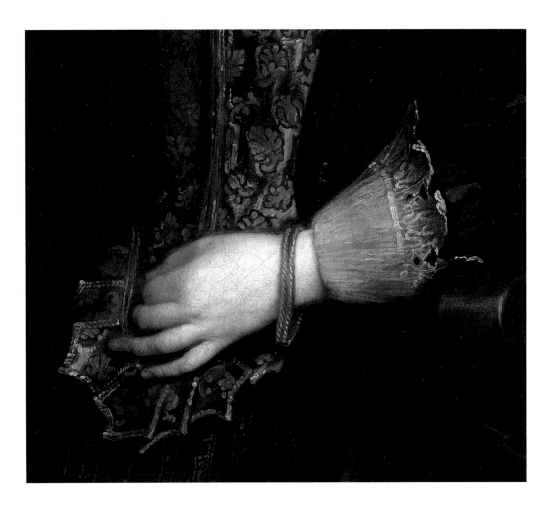

art soared above most of his contemporaries. At the same time, however, it should be noted that Van Dyck was not an artist interested in painterly effect for its own sake. His handling of paint, however dazzling, is always subject to an idea, or in the case of a portrait, to the appearance and aura of his sitter. He does not wish to draw attention to how a painting is made, but to encourage us to look through it all the more closely at his subject.

Van Dyck's *Portrait of Isabella Waerbeke* may not be grand, but it is quietly seductive, and remarkably convincing as a psychological portrait. Where Rubens tended in his portraits to convey the physical substance and public status of a sitter, Van Dyck here reveals a subtler approach. Acknowledging Isabella's status, he then proceeds to refine it by reference to grand artistic precedents, and by keen observation of telling detail. Perhaps most importantly, even in this relatively modest image, Van Dyck manages to impart a feeling of intimacy which in turn gives one the illusion of 'connection' with the sitter and convinces us all the more keenly of the accuracy of the portrayal. We know very little about her, but Isabella remains the epitome of the discreet charm of the Antwerp bourgeoisie; how Van Dyck fared with a more demanding sitter will be seen in the next chapter.

1 HOUBRAKEN 1753, p.185.

2 To help the reader follow the complicated history of the period a *Chronology* is provided in Chapter VI, with particular emphasis on the history of the Spanish Netherlands, plus parallel events in the lives of Van Dyck and Philippe Le Roy (the subject of the next chapter). For a contemporary's view of these recent events in Antwerp's history, see LE ROY 1730, pp.31–4, who singles out 'Pierre Paul Rubens & Anthonie Van Dyck excellans Peintres, dont le nom est celebre par toute l'Europe' ('Peter Paul Rubens & Anthony Van Dyck excellent painters, whose name is famous throughout Europe') as amongst the most illustrious of Antwerp's former citizens.

3 See MACQUOY-HENDRICX 1991, I, no. 4, pp.105 & II, pl.1–2; and ANTWERP 1999c, no.5, pp.92–100.

4 For the importance of the court at Brussels in providing artistic patronage, see BRUSSELS 1991.

5 L. Guicciardini, *Description de tout le Pais-Bas, aultrement dict la Germanie inférieure*, 1567; quoted in BRUSSELS 1995, p.48.

6 See C. Billen, 'Les Flandres. Histoire et géographie d'un pays qui n'existe pas', *idem*, pp.48–53.

7 The Union of Utrecht, formed by the Northern provinces of the Netherlands in 1579, was not, however, officially recognised by the Spanish until 1648, with the signing of the Peace of Westphalia; see *Chronology*, and *Chapter II* for Philippe Le Roy's role in the Peace.

8 As described by James Howell, who visited the city in 1619; see WALTER STONE 1968, p.251.

9 For a good general history of the art of the period see VLIEGHE 1998.

10 Appointed Regents of the Netherlands 1596; they signed the Twelve-Year Truce with the United Provinces in 1609. After Archduke Albert's death in 1621, Archduchess Isabella ruled alone till her death in 1633: see *Chronology* for major events in their reign.

11 INGAMELLS 1992, pp.183–5.

12 See LEUVEN 1998, and DUARLOO 1998; especially essays by P. Arblaster, 'The Archdukes and the Northern Counter-Reformation', pp.87–92; C. Brown, 'Rubens and the Archdukes', pp.121–8; R. Baetens, 'La relance d'une dynamique culturelle sous le règne des archiducs', pp.145–50; E. Put, 'Les archiducs et la réforme catholique: champs d'action et limites politiques', pp.255–66, & L. Duarloo 'Archducal Piety and Hapsburg Power', pp.267–84.

13 The city's most famous inhabitant, Rubens, often paints a rather different picture. For example writing to Pierre Dupuy on 10 August 1627: 'Here we remain inactive, in a state midway between peace and war, but feeling all the hardships and violence resulting from war, without reaping any of the benefits of peace. Our city is going step by step to ruin, and lives only upon its savings: there remains not the slightest bit of trade to support it. The Spanish imagine that they are weakening the enemy by restricting commercial license, but they are wrong; for all the loss falls upon the King's own subjects'; MAGURN 1955, p.279.

14 These included the Thirty Years War and the continual struggles against the Dutch and the French; see *Chronology*.

15 An exhibition was held in Antwerp on this very subject in 1991; see ANTWERP 1991 for further details.

16 Born in Siegen, in Westphalia, in 1577; for works in the Wallace Collection by Rubens, see INGAMELLS 1992, pp.308–36; for an introduction to Rubens' life and career, see WHITE 1987 and JAFFÉ 1989.

17 Rubens and Moretus were friends from childhood, and studied together at the School of Latin at the Antwerp Chapter House under the direction of the rector, Rumoldus Verdonck. For a general introduction to the Plantin-Moretus printing house see DE NAVE 1995.

18 REULENS 1887–1909, II, p.254.

19 ANTWERP 1999b, no.11, pp.84–5.

20 INGAMELLS 1992, pp.226–7.

21 For further information on this portrait, see ANTWERP 1999a, no.1, pp.94–5.

22 BELLORI 1672, p.17.

23 *Ibid*, no. 27, pp.154–5; and WASHINGTON 1990–1, no.23, pp.141–3.

24 BELLORI, *op.cit.*, p.18.

25 *Ibid*.

26 The picture obviously benefited from knowledge of Van Dyck's portraits of some of the sitters, such as those of Peeter Stevens (1627, Mauritshuis, The Hague; see fig.23) and Frans Snyders (c.1621, Frick Collection, New York; see fig.9). For a detailed discussion of the picture, see HELD 1957.

27 See p.23.

28 WAAGEN 1854, II, p.158; IV, p.86.

29 Letter on file at the Wallace Collection.

30 A workshop replica according to GLÜCK 1931, p.555.

31 This identity, written in what appears to be an early nineteenth-century hand, is found on the verso of the lining canvas: 'Portrait of the Wife of Simon de Vos the painter/ by Vandyke'.

32 She is not mentioned, for instance, in any of the recent major exhibitions of Van Dyck's paintings, WASHINGTON 1990–1, GENOA 1997 and ANTWERP 1999a, nor in Christopher Brown's monograph on the artist, BROWN 1982, and only in passing, in connection with her husband, in the recent Van Dyck print exhibition, ANTWERP 1999c, p.151.

33 VAN DER STIGHELEN 1990, p.251, quotes a document drawn up by the notary J. Van Waerbeck in 1692, presumably a member of the same family.

34 For Paul de Vos's career see BALIS 1996.

35 INGAMELLS 1992, pp.402–3.

36 INGAMELLS 1992, pp.349–50.

37 BROWN 1982, pp.48–9, figs.38–9.

38 This may be, however, because of mistaken comparison with Van Dyck's print for the *Iconography*; see GLÜCK 1931, pp.532–3, and fig.14.

39 De Vos joined the Confraternity in 1619, and Van Dyck in 1628.

40 On 5 November 1638 Paul de Vos purchased a house at no.15, Corte Gasthuys Straet, called 'Oud Brabant' ('Old Brabant'). He himself lived next door at no.17, which he rented. Only in 1661, shortly after the death of his wife, did he move into his own house at no.15. It was in the latter that he died; see F.J. van den Branden, *Geschiedenis der Antwerpsche Schilderschool*, Antwerp, 1883, p.682. Information kindly supplied by Dr Horst Vey and Dr Arnout Balis.

41 Figure 13 shows a copy by Gustav Müller in Schloss Ehrenburg, Coburg, and others have been recorded; one formerly in the collection of Sir Edmund Verney, and another in the collection of the Earls of Verulam, Gorhambury, Herts.: information kindly provided by Dr Horst Vey.

42 These include an etching by Van Dyck showing just the head and ruff; an etching by Van Dyck and Johannes Meyssens (1613–1670) depicting the artist half-length, with an inscription, and gesturing with his left hand; and an etching and engraving by Van Dyck, Meyssens and Schelte à Bolswert (1586–1659) of the same figure with the addition of a shadow under De Vos's left index finger and a longer inscription. The etched and engraved image was then later copied, in reverse, by Adriaen Lommelin; see MACQUOY-HENDRICX 1991, I, nos.16 & 181, pp.112–4, 206 & II, pl.12 and 112 and ANTWERP 1999c, no.18, pp.151–4.

43 See, for example, VAN DER STIEGHELEN 1990, nos.13 and 14, pp.43–6.

44 For an introduction to fashion in Holland, which was basically the same as in the Southern Netherlands at this period, see VAN THIENNEN 1951.

45 Van Dyck's *Italian Sketchbook*, now kept in the British Museum, is crammed with images copied after Titian; see ADRIANI 1940.

46 See WETHEY 1969–75, II, no.73, pl.118.

47 *Ibid*, no.87, pl.70.

48 *Ibid*, no.90, pl.148.

49 Van Dyck copied Titian's *Portrait of Lavinia as a Bride* in his Italian sketchbook, fol.104v, c.1623, British Museum; see ADRIANI 1940.

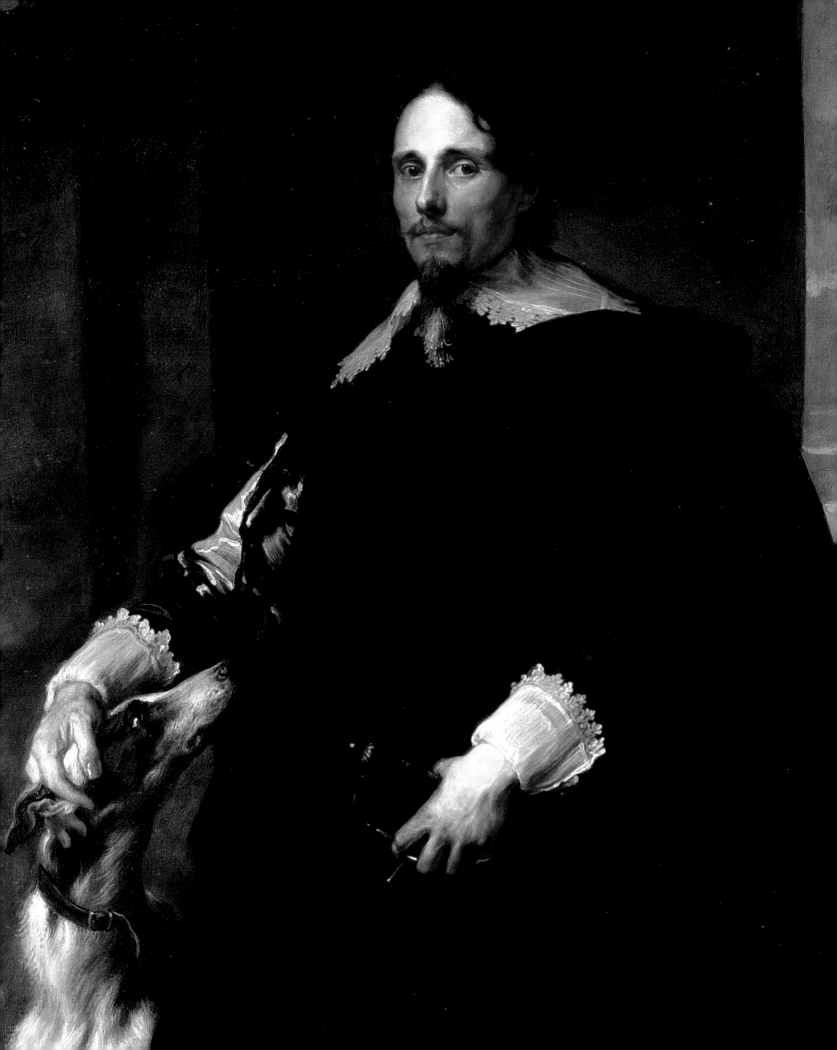

II

'No longer knights, but cavaliers', Fromentin[1]
Creating the Courtier: Van Dyck and Philippe Le Roy

A Young Man on the Make: the Life of Philippe Le Roy before 1630

In Antwerp in 1630, Van Dyck created one of his finest aristocratic images for a young man then known as the 'Lord of Ravels' (figs.20 & 36). Looking at the *Portrait of Philippe Le Roy* that hangs in the Wallace Collection today, it is easy to believe that we are standing before a scion of a great family; the Flemish equivalent, perhaps, of the noble families of ancient lineage that Van Dyck was to portray so successfully at the English Court soon afterwards. Le Roy's bearing, dress, accoutrements and setting alike contribute to this combined sense of breeding and grandeur; but, above all, it is the compelling face, with its high cheek-bones, broad brow and penetrating eye, that convinces us of the veracity of Van Dyck's portrait. At the same time handsome, sensitive and intelligent, it seems to present a physiognomic blueprint of 'nobility' in the truest sense, and prompts us to ask: just who was this striking man? The answer, as we shall see, reveals a reality more complicated than can be guessed at first glance: a story which is as revealing of Van Dyck's skill as it is of Philippe Le Roy's true origins.

Fig.20
Van Dyck, *Portrait of Philippe Le Roy*, detail, 1630, The Wallace Collection

Fig.21
Claes Jansz. Visscher (1587–1652), *Plan of Antwerp with a Profile View of the City*, tinted engraving, 1624, Rockox House, Antwerp

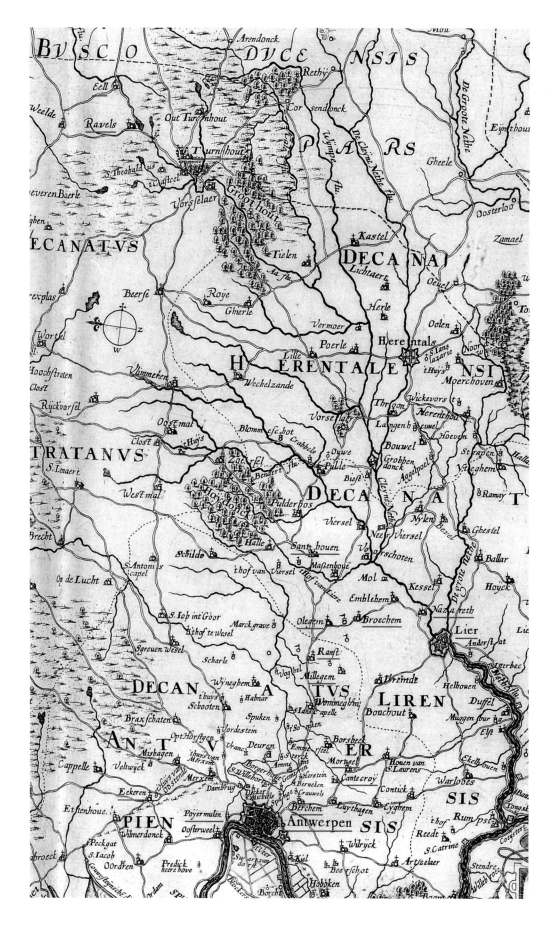

Fig.22
Detail of *DIOECESIS EPISCOPATVS ANTVERPI-ENSIS*, anon. engraving taken from LE ROY 1678, between pp.52–3, The British Library

Philippe Le Roy was born in 1596, not, as we might have supposed, the elder son of a noble line, but the illegitimate grandson of a successful gunpowder manufacturer and merchant of Antwerp, Jacques I Le Roy.[2] In 1563 Philippe's grandfather bought a substantial property at Steenborgerweert (figs.21–2),[3] to the north-east of Antwerp, where he used the saltpetre, found in the polders, to make gunpowder. Over the next thirty years Jacques I Le Roy successfully expanded his business, obviously profiting greatly from the fighting that beset the rest of Antwerp; an irony that can hardly have escaped the notice of his hard-pressed contemporaries.[4] Certainly by the time of Van Dyck and Philippe's youth in Antwerp, the name Le Roy had become inextricably associated with the manufacture of gunpowder. The location of the Le Roy gunpowder mills is clearly shown in an engraved map of 1617 by Pieter van der Keere, re-issued by Visscher in 1624, indicating that they were very literally a landmark at the time (fig.21)[5]. Whom exactly Jacques was supplying with gunpowder in the sixteenth century is not known, but in view of the family's Catholic religion, their subsequent rise under the Hapsburgs, and the inscription on his tomb, it is probable that Jacques I Le Roy was treating mainly with the Spanish.[6]

The irregularity of Philippe's birth was perhaps related in some way to the social dislocation occasioned by the troubles in the region. Philippe's mother, Elisabeth Hoff, at the then mature age of thirty-three was rather old to be a mistress and having her first child. She too was of bourgeois origin: her grandfather, Max Hoff, had been a former Guild Master of Freiburg in Germany, but her father had been ruined by the wars.[7] Philippe's father, Jacques II Le Roy, the eldest son of Jacques I, was twenty-eight at the time of Philippe's birth, and perhaps not yet economically secure enough to think of marrying. Philippe's parents' relationship was probably longstanding; certainly the couple seem to have remained on friendly terms even after his father's marriage in 1607.

In 1603 Jacques I Le Roy died in Antwerp, in his house on the 'Minnerbroersstraet': the same street where Van Dyck was later to have his first independent studio. Jacques I expressed a wish to be buried in the Franciscan church of the Recollets, where his eldest son later erected a monument in his honour, to which Philippe, in an act of retrospective legitimisation, then added his own coat of arms.[8] Jacques II inherited the gunpowder factories, where he repulsed an attack from Maurice of Nassau, Prince of Orange, in 1605. The previous year he had risen in the military supply structure when appointed Commissioner General of Saltpetre and Gunpowder to the Artillery of the Spanish army in the Netherlands. Jacques II Le Roy thus became an important servant of both the Archdukes and the Spanish Crown. To consolidate this increase in wealth and status Jacques II, now aged 38, contracted an advantageous marriage with the young daughter of a well-to-do Antwerp family. His new wife, Jeanne Maes, was the daughter of Guillaume Maes, almoner of Antwerp, Lord of Millegem, and part owner of the château of Zevenbergen at Ranst, and sister of Jean Maes, Lord of Cantecrode, Mortsel, Edegem, etc. By this marriage Jacques II gained access to the local minor nobility. His social ambition is made abundantly clear by his research into his family history, which prompted a letter from his uncle the same year. The latter's account of the original family motto, in decidedly unfashionable Flemish: 'Godt kendt de beste Le Roy', and his vague description of the family coat of arms seem to bear comparison with what is known of an earlier Le Roy family of Brabant.[9] Such mundane antecedents, however, obviously failed to satisfy

the ambition of the new Commissioner, who, in a fit of amnesia, soon afterwards adopted the arms of a more illustrious Le Roy family of French origin.[10]

Elisabeth Hoff and her son were thus sacrificed to the social ambition of Jacques II Le Roy. They were not, however, forgotten: on the eve of his wedding, Jacques II Le Roy provided for his former mistress and their son with an annuity of 75 florins secured on the property of Steenborgerweert and its gunpowder factories.[11] In subsequent years, not only did Jacques continue to support Elizabeth, but also apparently integrated their son so well with his new wife and family that Philippe's irregular birth seems to have been virtually forgotten (and where not forgotten, intentionally obscured).

By 1610, Jacques II Le Roy and his new family had moved to Brussels, due to Jacques's elevation to the post of auditor of the *Chambre des Comptes*, or Treasury.[12] This met daily in the Palace of Coudenberg, the centre of the government of the Spanish Netherlands, and principal residence of the Archdukes. Later, when the rue Isabelle was built to connect the archducal court with the collegiate church of Saint Gudule, Jacques II Le Roy became one of its first residents.[13] At about the same time, according to Richard Collin's engraving of Philippe Le Roy's funerary monument (c.1670; fig.69),[14] Philippe, now aged sixteen, was sent to 'serve the Emperor Mathias in Prague'. Unfortunately, bearing in mind Philippe's tendency to re-invent his personal history, it has so far been impossible to check the veracity of this claim. A period, possibly as a page to Mathias, who inherited the Imperial throne from his brother, Rudolf II, in 1612, would have been an excellent training for an ambitious young man. Here he could have learnt the necessary skills to be a perfect Hapsburg courtier, as well as gaining the opportunity to study one of the greatest art collections of Europe.[15] Yet it was hardly the ideal time to visit Prague. The previous year Rudolf II had been forced to abdicate as King of Bohemia in favour of his brother when the troops of Archduke Leopold overran the city. On the old Emperor's death, Mathias could not wait to transfer the court to Vienna, and began to move as much of his brother's collection as he dared without attracting the hostility of his Bohemian nobles. Still, Philippe might have caught a glimpse of Prague's former glory, and it is certainly the glamour of this association that he later aimed to evoke in his funerary inscription.

Back in Flanders the Le Roy family went from strength to strength. In Brussels Jacques II Le Roy was made a Councillor of the *Chambres des Comptes* in 1618, and the same year in Antwerp, Philippe, at the age of twenty-two, became Comissioner General of Saltpetre and Gunpowder to the Spanish King. Philippe thus inherited a post previously held by his father. It appears that he benefited from the fact that his father produced no surviving legitimate male heir until the relatively advanced age of fifty-one in 1620, and treated Philippe as such in the meantime.[16] That the young man was so obviously gifted must have considerably eased this process. In 1621 the Twelve-Year Truce came to an end. By this date, father and son had no more financial need of the gunpowder factories at Steenborgerweert and, probably not welcoming the extra worry that war would bring and wishing to rid themselves of their mercantile associations, the factories were sold. Elisabeth Hoff later testified before the *Aldermen* of Antwerp that she had been the beneficiary of this sale, thereby receiving the capital of the annuity originally settled by Jacques Le Roy upon their natural son Philippe. We should not be too surprised to learn

that the document recording this last official acknowledgement of Philippe's illegitimacy was soon afterwards defaced.[17]

During the whole of this period Philippe is recorded acting as an agent in what must have been a series of lucrative property deals, many of which involved the family of his father's wife Jeanne Maes.[18] As a result of this sort of astute financial management Philippe, aged only thirty, was able to acquire the land and feudal rights to the villages of Ravels and Eel near Turnhout. It may only have been a modest property, rather inconveniently situated for Antwerp, but it gave Philippe his first title: the right to call himself 'Lord of Ravels'.[19] Genealogy was an important concern of the middle and upper classes in the seventeenth century, so it is hardly surprising that he should have inherited his father's lust for status, but in Philippe's case, his irregular start in life seems to have inspired a fervour for this which sometimes bordered on the obsessive. So, after the death of his mother in Antwerp the following year we find him copying his father's earlier behaviour and writing to the Magistrate of Freiburg to investigate her family history. Happily for Philippe, the official, partly from a wish to please his distinguished correspondent and partly from ineptitude, conflated the true bourgeois history of the Hoff family with a local aristocratic family of the same name, and sent him a sketch of a coat of arms, which Philippe would later quarter with his father's.[20] Even more extraordinary was the inscription he caused to be written on his mother's monument in the Church of the Carmelite Convent, which implied that his mother was the widow of Jacques Le Roy 'of Tourneppe', when the true Jacques Le Roy was very much alive and well in Brussels.[21] While Philippe may be excused for being protective of his mother's memory, in this case his filial piety seems excessive.

In 1630 Jacques II Le Roy became President of the *Chambres des Comptes* and Lord of Herbaix on acquiring the estate of that name. As we have seen, father and son were close, and it is not impossible that this new elevation of the Le Roy family prompted Philippe to look for a bride. His choice fell upon the teenage daughter of François de Raet, almoner of the city of Antwerp, Lord of Couwenstyn, proprietor of the fiefdom of Ten-Noele and the château of 'Postmeestershof';[22] and of Marguerite Maes, sister of Jacques II Le Roy's wife, Jeanne. In choosing to marry a niece of his father's wife, Philippe was aping his Hapsburg masters' time-honoured practice of strengthening the family through intermarriage: 'Let the strong wage war. You, lucky Austria, marry'.[23] By his own marriage Philippe not only consolidated his position in the ranks of the respectable land owning classes, but also at last became a truly legitimate member of the Le Roy family: his own father's nephew-in-law. Understandably Philippe was keen to mark his engagement, which he did in the most stylish way possible by commissioning a portrait from Anthony van Dyck, the very latest artistic sensation of the Brussels court.

Van Dyck and Philippe Le Roy

Signed on step, bottom left: 'A VAN DYCK.F.'; inscribed and dated top left: 'AETATIS SUAE/ 34 A° 1630';
coat of arms, a later addition: Le Roy quartered with Hoff and the motto: '[SERV]IRE DEO [REGNARE EST].[24]

Oil on canvas, 213.3 × 114.5cm.

PROVENANCE

Both portraits of Philippe Le Roy and his wife, Marie de Raet (see below), were from 1680,[25] in the collection of *Le chevalier* Michel Peeters; given to his grandson, the future banker, Jan Egidius Peeters d'Aertselaer (1725–86),[26] 17 August 1729; his daughter, Marie Louise, and her husband, baron Henri Joseph Stier d'Aertslaer (1743–1821), Antwerp. The latter sent the collection to America from 1794–1816 for safekeeping during the French occupation;[27] his sale, Antwerp, 27 August 1817 (2, *un chevalier de la famille de Leroy*; 3, *portrait de son épouse*), bt. in 5,000 and 7,070fl., respectively, by his nephew, Charles J. Stier; Stier and Faber, sale Antwerp, 20 October 1825 (71, 18,000fl., 72, 18,900fl.) to the dealer, Nieuwenhuys,[28] who sold them to the Prince of Orange, later William II of Holland (1792–1849);[29] his sale, The Hague, 5th day, 16 August 1850 (71, *Philippe Le Roy, seigneur de Ravels*; 72, *Made. Le Roy*), bt. 4th Marquess of Hertford 63,600fl.;[30] seen in Hertford House in 1851 by Waagen;[31] reframed in Hertford House in 1857;[32] relined and restored in 1863;[33] Hertford House Inventory 1870; bequeathed by Lady Wallace, as part of The Wallace Collection, to the British nation in 1897.

PRINTS[34]

Van Dyck, etching, reversed, head only c.1630 (first state, fig.49); states III–IX later completed by an unknown engraver (possibly Pontius), who made the sitter bust-length, adorned with a gold chain (received 1647), and placed in an oval; states VII–IX, with the title 'Philippus Baro de Le Roÿ et S.R.I./ dominus de Ravels Brouchem Oelegem et in fano St Lamberti' plus the sitter's coat of arms, c.1671 (seventh state, fig.71).
L. Vorsterman, re-worked by P. Pontius, engraving, half-length, the figure in the same sense as in the painting, with dog's head, but set before a pillar with classical statues carrying Le Roy's Greek motto, 'ΚΑΛΩΣ ΘΑΝΩΝ / ΠΑΛΙΜ ΦΥΕΙ'[35] (states V–XVI), and the title 'PHILIPPVS LE ROY/ DOMINVS DE RAVELS, ETC. ARTIS PICTO-RIAE./ AMATOR ET CVLTOR/ A° 1631' (sixteenth state, fig.51).
Anon., engraving, copied from the above engraving, enlarged, with the Greek inscription incorrectly transcribed, and the title omitted.
J. F. Leonhart (attrib.), engraving, similar to the above.
Anon., mezzotint, again similar to the above.[36]

COPIES

Woburn, half-length, with coat of arms as in the present picture. Pittsburgh, Mrs Jones 1940; half-length.[37]
Antwerp, Stedelijk Prentenkabinet no.736, drawn copy, half-length in black chalk, probably after a lost drawing associated with the transference of the composition to the engraving by Vorsterman and Pontius (fig.51).[38]
London, with Colnaghi's June–July 1972, drawn copy of head attributed to Pontius, black, red and brown chalk with brown wash on buff paper, squared for transfer; again possibly associated with the Vorsterman-Pontius engraving described above.[39]
Another (?), Brett sale, Christie's, 5 April 1864, lot 547.
Joseph Danhauser, drawn copy, 1842, Albertina, Vienna.

EXHIBITIONS

Riversdale, Maryland, 1816.
Manchester, *Art Treasures*, 1857 (saloon H, no. 6).
The Royal Academy, 1872 (no.134).
The Royal Academy, 1888 (149).[40]

LITERATURE

SMITH 1831, Nos. 369 & 370; WAAGEN 1854, II, pp.157–8; MANCHESTER 1857, p.74; BÜRGER 1860, p.220; BLANC 1857, pp.103–5, 113; GUIFFREY 1882, p.270, nos.659–60; THE ATHENAEUM 1888, pp.90–1; DE RAADT 1891, pp.106–7; CUST 1900, p.256, nos.64–5; SCHAEFFER 1909, pp.232–3; GLÜCK 1931, pp.328–9; GÖPEL 1940, *passim*; LARSEN 1980, nos.662–3; LARSEN 1988, nos.546–7; INGAMELLS 1992, pp.102–4 and 107–110.

Van Dyck's *Portrait of Philippe Le Roy* has long been acknowledged as one of the artist's greatest works, so it is only fitting that in his 400th anniversary year we should take time to consider why it is so special (fig. 36). The artist and his sitter had a great deal in common. Born within a few years of each other, they were both ambitious products of the generation born at the beginning of Antwerp's period of recovery. They shared the general sense of confidence common to this new generation, while at the same time their personal insecurity seems to have driven them all the more to prove themselves. Both were highly intelligent, able, and keen to distance themselves from their bourgeois pasts. Already sensitive, their aspirations to the nobility made them more so, alive to every nuance of dress, behaviour and heraldic honour; for the greatest snobs are often people of heightened sensibility. Both men also exhibited an element of courtly vanity. Van Dyck's fascination with his own image has already been noted, and a similar obsession, directed more toward practical political and social ends, lies behind Le Roy's relentless self-promotion. In one sense Le Roy's betrothal portrait provided an excuse for both men simultaneously to announce their ability and ambition to the world.

One of Van Dyck's first commissions on his return to Antwerp in 1627 was for another betrothal portrait: that of the wealthy cloth merchant and art collector, Peeter Stevens (fig. 23).[41] With its twisting pose and lively expression, the *Portrait of Peeter Stevens* has been hailed as the first example in Van Dyck's art after his return from Italy of the sense of carefully calculated nonchalance, known as *sprezzatura*, that was such an impor-

below left: Fig. 23
Van Dyck, *Portrait of Peeter Stevens*, 1627, Mauritshuis, The Hague

below right: Fig. 24
Van Dyck, *Portrait of Nicolas Lanier*, 1628, Kunsthistorisches Museum, Vienna

tant element in Venetian High Renaissance painting. Although it is certainly true that Van Dyck infuses the portrait with his characteristic elegance and a new vivacity of pose, its restrained three-quarter-length format, matt background and relatively conservative costume[42] make it comparable to similar bourgeois images produced by the artist. The composition is not so very different, for example, from the *Portrait of Paul de Vos* discussed in the previous chapter (figs.13–4). In contrast, Le Roy, by commissioning a more expensive full-length portrait, was making his wish to be portrayed in an altogether grander manner clear from the outset. But how was Van Dyck to move from this recognisably middle class portrait, howsoever skilfully painted, to the aristocratic? More importantly, how was he to create a convincing image to match Le Roy's ambition, without subverting those aspirations by making him appear *arriviste*?

The answer again lies in Van Dyck's use of *sprezzatura*, only this time in a more profound application of the ideal: it will become an apparent quality of the sitter, as well as of the artist's technique. Here we find an artistic precedent in Van Dyck's portrait of Charles I's agent and Master of Music, *Nicolas Lanier* (fig.24).[43] Lanier passed through Antwerp in 1628, on his return to England from Mantua, where he had just completed the successful purchase of the Gonzaga collection for his royal master. Comparing Lanier's image with that of Peeter Stevens, one is immediately struck by the true courtier's air of nonchalant grace, which is mirrored by the apparent ease with which the artist has captured the likeness upon the canvas, even leaving a small area beneath the right arm seemingly unfinished. The success of *sprezzatura* lies of course in its apparent artlessness and implication of innate superiority. So, although we learn from Walpole that 'Sir Peter Lely told Mrs Beale, that Laniere assured him he had sat seven entire days to him, morning and evening, and that notwithstanding Vandyck would not once let him look at the picture till he was content with it himself',[44] no trace of this effort is allowed to mar the display of virtuosity on the canvas.

Similarly in the *Portrait of Philippe Le Roy* we find no reference to the hard work which had resulted in the young man's early fortune and which allowed him, aged thirty-four, to commission such a stunning image. His bearing is quintessentially aristocratic, and even makes reference to imperial precedent: namely Titian's *Portrait of Charles V* (fig.25).[45] But Le Roy's portrait is subtler, more refined, less an image of absolute power than one of the perfect servant in power.[46] Until the middle of the seventeenth century Castiglione's *Courtier*, first published in Venice in 1528, and frequently translated and reprinted thereafter, provided the chief guide as to how such a royal servant should behave. Castiglione's manual was widely read by individuals who wished to gain entrance to European court circles, and was even kept in the libraries of the various courts and courtiers of the period.[47] So it is hardly surprising to find that Le Roy's portrait encapsulates all the major requirements for the perfect courtier as described by Castiglione, made yet more convincing by Van Dyck's brilliant and courtly style. For Castiglione, after nobility of birth, *sprezzatura* was the foundation on which all other virtues rested: the ability 'to practise in all things a certain nonchalance which conceals all artistry and makes whatever one says or does seem uncontrived and effortless'.[48] Castiglione goes on to state that 'grace springs especially from this', and indeed nonchalance and grace are two of the defining qualities of Van Dyck's image of Philippe Le Roy. Like Lanier before him, Le Roy turns three-

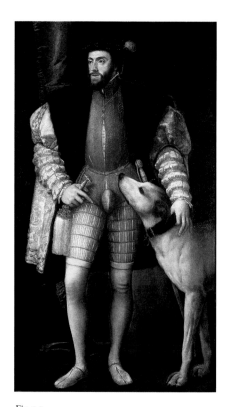

Fig.25
Titian, *Charles V and Hound*, 1533, Museo del Prado, Madrid

40

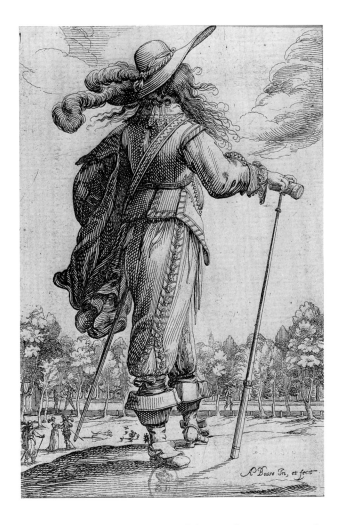

quarters to face us, in a graceful attitude suggestive of upward movement, his step arrested by the greyhound at his side. At the same time the pose can be seen as heroic, akin to the victorious mountaineer at the summit, and it provides a satisfying pyramidal composition focussing attention upon the head at the apex. The sense of monumentality thereby gained is subtly reinforced by the strong verticals of the wall behind. This sense of height is further emphasised by the low viewpoint. The portrait is meant to be hung relatively high on the wall so that one is forced to look up at the erect figure, which is slimmed down and made to appear yet more elegant by its oblique pose.

Philippe's clothes add to this impression of fashionable ease. Castiglione stressed the importance of elegant but restrained dress in a courtier, preferring black to any other colour. Indeed his advice regarding dress could almost have been given with the effect of portraiture in mind: 'he should decide for himself what appearance he wants to have and what sort of man he wants to seem, and then dress accordingly, so that his clothes help him to be taken for such, even by those who do not hear him speak or see him perform anything at all'.[49] In the courts of seventeenth-century Europe dress was keenly studied as an index of wealth, refinement, and social prestige.[50] Philippe, accordingly, is shown dressed in the latest courtly fashion. It was French taste that set the fashions for the most stylish courts of Europe in the seventeenth-century. Dressing in black for formal social occasions became the mode for the French aristocracy, who combined this with the use

of sumptuous materials, such as silks and velvets, and softer innovations, like the turned-down collar which replaced the stiffer ruff.[51] The resulting style, a model of luxurious understatement, was soon adopted as the international dress of the European elite, which is made immediately apparent if we compare contemporary French fashion-plates (fig.26) with images of the leading trend-setters of the day, such as Charles I (fig.27). Like Charles, Le Roy wears a jacket with slashed sleeves, broad turned-back lace cuffs and a soft turned-down collar, also edged in lace. He has the same knee-length breeches, with ribbon and silk tasselled garters below the knee, and, flung stylishly over one shoulder, he carries a similar cloak. Even his shoes are elegant, with their small pointed heels and luxurious double bows. But what makes Philippe's costume a more telling indicator of his innate nobility is the ease with which he seems to carry off his smart ensemble. One of Van Dyck's great achievements in the development of courtly style in portraiture was his ability to suggest the physical presence inside even quite an elaborate costume. His sitters really wear and move with their clothes; indeed Van Dyck's concern for fluidity and elegance in dress inspired him later to invent imaginary fashions even more in keeping with his vision of this ideal.[52] The depiction of costume also afforded Van Dyck the opportunity to dazzle the onlooker with his consummate ability to render material texture in paint. With the painting hung lower than would normally be possible in the Great Gallery of the Wallace Collection, the present exhibition allows us to examine these effects closely. The scintillating scumbled brushstrokes on the slashed sleeve tell us immediately that Philippe's suit is made of costly silk, whereas the treatment of the translucent linen cuffs, rendered in differing shades and textures of white and grey, reveals how they are turned back first over themselves and then over the black silk jacket, indicated by an almost imperceptible deepening of shadow at the cuff (fig.28). Through a similar palette and skilled use of shadow, Van Dyck implies the fine texture of the softly falling linen collar, with single strokes of raised paint indicating a striped surface, and delicate feathery lines drawing in the silken tie and tassels at Philippe's throat (fig.33). Even the soft leather of Philippe's shoes is made to shine dully in contrast to the crisper texture of their matching ribbons. Sadly these exquisite passages also alert us, by contrast, to those less well preserved elements in the picture: namely the dark shapeless black mass of Philippe's torso and cloak. Once these too would have glowed with silvery highlights, giving volume and form, such as are seen on the black cloak of Nicholas Lanier (fig.24).

Neither Lanier nor Le Roy were soldiers, yet both are depicted with swords (figs.24 & 28). Examples of contemporary swept hilt rapiers, such as that seen in Le Roy's portrait, may be viewed in Gallery 9 of the Wallace Collection today.[53] For Castiglione 'the first and true profession of the courtier must be that of arms'.[54] In addition, in the seventeenth century fencing became a desired accomplishment for aristocrats, widely taught in institutions such as the renowned Academy of Sieur Pluvinel, who tutored three French kings in the arts of war.[55] As we have seen, Philippe's career to date had brought him into closer contact with military life than he may have cared later to admit: arms dealing was a long way from the glorious 'profession of arms' expected of the ideal courtier. In arming Philippe with a sword, Van Dyck, at first glance, seems merely to be following a convention, by demonstrating that the sitter was sufficiently noble to have the right to bear arms. Again, however, he subtly nuances this reference by the deliberate

Fig.27
George Glover (active 1634–52), *Charles I and Charles, Prince of Wales*, engraving, *c*.1635/6, The Royal Collection

42

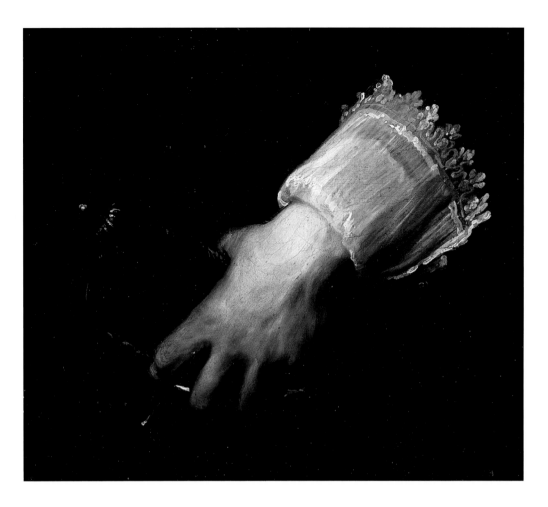

attitude in which he places Philippe's hand. Firstly it is in the visual centre of the compo-
sition; our eyes cannot help but be drawn to it, emphasised as it is, pallid against the black
of Philippe's costume and hovering above the glinting hilt of the sword, picked out in
flashes of white paint. Secondly, unlike Lanier, who rests an inert, rather foppish, hand
on his weapon, Philippe is shown grasping this sword-hilt. Reflected in the gesture is the
decisive man of action which, for all his courtly pretensions, we know Philippe to have
been. Van Dyck thus conveys the true practical ability which lay beneath the guise of
aristocratic nonchalance assumed by his patron.

The fine hunting-dog at Philippe's side serves to reinforce the artist's depiction of
his sitter's nobility. A fine hound, like a fine horse, was an essential accoutrement of nobil-
ity, vital for success in the hunt. Since medieval times hunting had been an exclusively
and typically noble pastime. It was considered not only the proper form of relaxation for
the nobility, but was also a way the nobility could maintain the distinction between them-
selves and the well-to-do burgher class. Hunting rights thus represented a confirmation of
the courtier's social superiority.[56] When he bought Ravels and Eel, Philippe acquired not
only the title 'Lord' but also the right to hunt the territory. It is hardly surprising that
he wanted this new distinction recorded in his portrait. Van Dyck had included dogs in
portraits before. A leaping hunting hound is first seen in Van Dyck's *Sir George Villiers and
Lady Katherine Manners as Adonis and Venus* (c.1620–1; London Art Market),[57] although it
is doubtful that the entire painting is by the artist's hand. Dogs thereafter make frequent

appearances in Van Dyck's portraits of the children of the Genoese aristocracy. It is in his *Portrait of a Little Girl as Diana*, c.1624 (fig.29),[58] for example, that we first encounter the motif of a full-length figure, standing with hand placed upon the head of a devoted hound. *The Portrait of Philippe Le Roy* represents the first definite use with an adult of a motif that proved a highly successful and immediately recognisable pictorial indicator of nobility. Van Dyck was to use the idea again and again, most notably in his *Portrait of James Stuart, Duke of Richmond and Lennox* (fig.30).[59] James Stuart was cousin to Charles I, and his portrait was painted in 1633 to commemorate his elevation to the Order of the Garter. The strong characterisation of Lennox's greyhound, which is based on a drawing in the British Museum,[60] has even prompted anecdotes that it once saved its master's life. Certainly the inclusion of a dog in both Lennox's and Le Roy's portraits contributes to the seeming informality of the two pictures. But, as we are learning with Van Dyck, such devices may have more than one purpose. In both pictures the sitter's hound looks faithfully up at its master, who in turn gazes steadfastly at the viewer. It is not hard to make a connection between the animal's devotion, and the devotion of the sitter to his royal master; in Philippe's case to the Hapsburg Regent of the Spanish Netherlands and to the King of Spain.

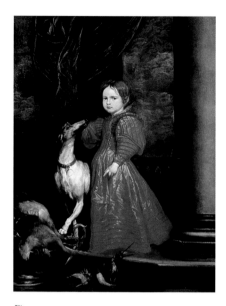

Fig.29
Van Dyck and Jan Roos, *Portrait of a Child as Diana*, c.1624, Private Collection

Yet the hound in Philippe's portrait is more than a mere cipher. It is commonly said that dogs and their masters grow to look like each other, and with his thoroughbred athletic frame, Philippe's dog reinforces his master's equally powerful physical presence. The closeness of man and animal is already apparent in the way that Philippe's hound mirrors his master's pose with his back legs, and then curves the rest of his body round Philippe's leg in expectation, we might think, of a pat on the head. But Van Dyck rewards the faithful dog with a gesture far more touching than any seen in his other portraits (fig.31), and thereby brilliantly conveys a real sense of affection between man and dog, which in turn increases our own sympathy for Philippe. We can forgive much of Le Roy's snobbery and ambition as we look at his hand fondling his adoring dog's ear.[61] Van Dyck's seemingly simple compositional invention gives us the key to an extra dimension of humanity and feeling which the artist's sensitive handling of paint refines. When we stop to examine the surface of the painting we can admire the silky texture of the dog's coat, with the suggestion of the angular frame beneath, achieved through deft modelling and shading in tones of black, brown and white, with silvery grey shadows. Van Dyck blends the paint, and then every so often allows fine brushstrokes to be read as separate hairs, running in the direction of the dog's coat, and softening the overall line of the form. He slims down Philippe's foreshortened hand with reddish brown shadows and outlining, and then works up the three-dimensional form of the fingers through the blending of flesh pigments: rose tints to indicate the knuckles, blue shadows to indicate veins beneath the flesh, and lighter thicker paint on the highest points. Finally he adds the highlights, such as the small dab of impastoed white to denote the hard shine of the thumbnail.

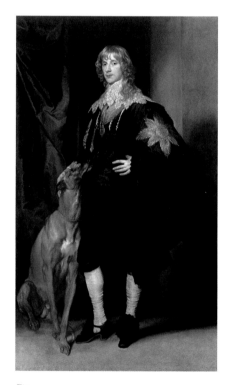

Fig.30
Van Dyck, *James Stuart, Duke of Richmond and Lennox*, 1633, The Metropolitan Museum of Art, New York

The humanity and sense of responsibility shown in Philippe's relationship with his dog temper the ruthless impression created by the hand on his sword. The sitter's new landed status is conveyed in Van Dyck's special attention to the park-like setting of the portrait. In contrast to the interior found in his *Portrait of Peeter Stevens* (fig.23), Van Dyck chooses to place Le Roy out of doors, as he had done with the worldly *Nicolas Lanier*

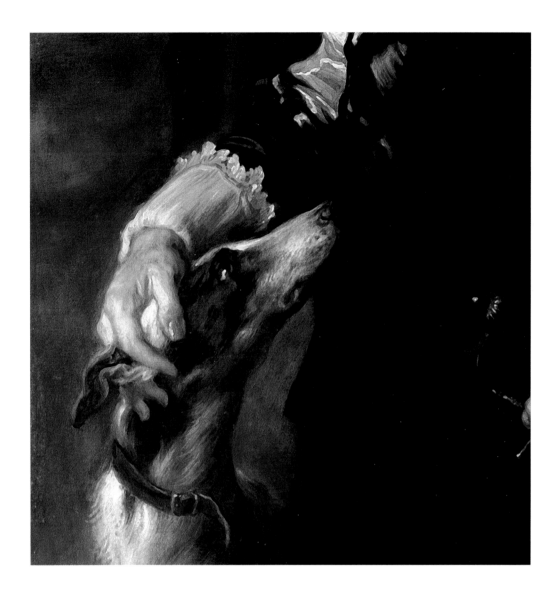

(fig. 24). The cosmopolitan feel thereby gained evokes High Renaissance Venetian portraiture, and Van Dyck's own work produced over the previous decade in Italy. Van Dyck had already experimented to great effect with the pictorial possibilities of the palatial terrace setting in his great Genoese portraits, as we can see in the regal image of the *Marchesa Elena Grimaldi, Wife of Marchese Niccolò Cattaneo,* 1623 (fig. 32). Although Van Dyck is not as attentive to background detail in Le Roy's portrait as he is in the portrait of the Marchesa, he nevertheless adopts many of the same compositional ideas. Thus the vertical line of the figure in both is emphasised by the hard edge of a building silhouetted against a cloudy Titianesque sky. With its sharply underlit clouds and dragged streak of silver white impastoed paint to denote the rising sun, the sky in Le Roy's portrait is particularly dramatic, and invites comparison with works such as Titian's *Resurrection*.[62] Perhaps Van Dyck intended it as a flattering reference to his sitter's potentially great future? In any case, it produces a wonderful visual foil for the stark wall and dark costume. Another eye-catching colour contrast which the portraits of Le Roy and the Marchesa Grimaldi share is the use of red against black: seen in the parasol, collar and cuffs of the Marchesa, and in the plant to Philippe's right. It has been suggested that the plants on the Marchesa's

terrace might have some deeper iconographic significance,[63] and by association one might think the same applied here. But the plant captured in a few bravura strokes of the artist's brush is in fact a hollyhock,[64] which is not known to carry any connotation beyond the idea of *vanitas* which any plant that flowers and dies would convey. So we can be sure that its presence in Philippe's portrait is primarily for visual reasons: to add a splash of vibrant colour that sets off all the more brilliantly the stylish blacks and whites of the main composition. The sense of movement in both portraits also increases their overall impression of courtly grace; the Marchesa seems to glide elegantly forwards, while Philippe, in a more manly pose, ascends a stone step with the same seeming ease that he ascended the social ladder. It is no wonder that later Flemish and Dutch aspirants to the aristocratic life insisted on being portrayed outdoors on similar terraces overlooking their new estates, as a glance at *A Family Group in a Landscape* by Gonzales Cocques in Gallery 18 of the Wallace Collection confirms.[65]

Required 'to appear both manly and graceful', Castiglione's perfect courtier had also to exhibit 'beauty of countenance'.[66] Beauty is of course subjective and ideals of beauty change like fashion. It is quite difficult, for example, to reconcile the plump Rubensian blonde with the razor-thin supermodels of the present day. Standards of masculine beauty have always been less subject to change, yet it is still surprising to discover, more than three hundred and fifty years later, a face as handsome to our eyes today as when it was painted (fig.33). We might speculate that the particular attractiveness of the model inspired the artist to create such a compelling image. A need for caution is suggested, however, by an amusing anecdote recounted in the *Memoirs* of Princess Sophia, niece of Charles I: 'Van Dyck's portraits gave me such a marvellous impression of all English ladies that when I met the Queen, whom I had seen as so beautiful in a painting, I was surprised to find her a short woman on a high chair, with long scrawny arms, ugly shoulders and teeth that stuck out of her mouth like battlements'.[67] Philippe, then, may not have been quite as glamorous as he seems. The important thing is that through Van Dyck's artistry he appears convincingly so, and is remembered that way. So how does Van Dyck do this? In the present exhibition we have the opportunity to stand virtually face to face with our subject and examine how these painterly effects were achieved. Again the artist's superb ability to model paint so that one forgets it is paint comes into play. Van Dyck lavishes as much care and attention upon Philippe's head as he was to do five years later upon the more famous *Portrait of Charles I in Three Positions*, of which the central pose is shown here for comparison (fig.34).[68] The impression created by each head is, however, very different. Charles's hooded eyes, with their watery lower lids indicated by a mere sliver of white paint, lend his countenance a rather lugubrious air. Philippe's eyes, on the other hand, are made to shine penetratingly with more prominent highlights of white paint on the iris, and less white on the lower lid. Note also how Van Dyck makes the speck of white more obvious on the further eye, which in shining out so prominently helps to marry the darker receding left side of the face with the right. The light on Philippe's face overall is also more dramatic. He is spot-lit from above, which allows the artist to emphasise through strong contrasts of light and shadow the aristocratic angularity of the aquiline nose, prominent cheekbones and brow. The light highlighting the broad forehead draws attention to the sitter's intelligence while his sensitivity is implied in the pensive charac-

Fig.32
Van Dyck, *Portrait of the Marchesa Elena Grimaldi, Wife of Marchese Niccolò Cattaneo*, 1623, The National Gallery of Art, Washington (Widener Collection)

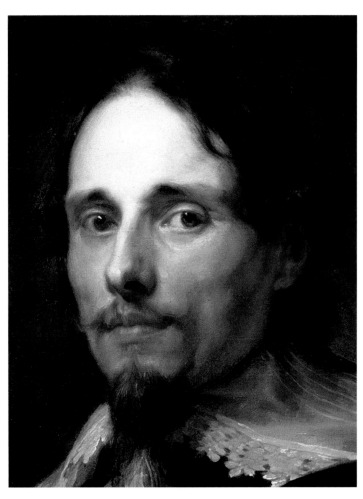

above right: Fig.33
Van Dyck, *Portrait of Philippe Le Roy*, detail,
1630, The Wallace Collection

above left: Fig.34
Van Dyck, *Portrait of Charles I in Three
Positions*, detail, 1635, The Royal Collection

terisation of the eyebrows, drawn upwards in a smudge of darker paint beside the bridge
of the nose. The outline of the face was first drawn using a red-brown outline and the
flesh modelled from light to dark. Shadows were built up in glazes over the darker areas,
helping to define the shape of the chin, the area around the mouth and the lower cheeks.
Although these areas are now somewhat thin, they still successfully convey an impression
of the shadow of the sitter's incipient beard. Warmer redder tints were applied on the
cheeks and mouth, with the lighter flesh tones of the forehead, line of the nose and top
of the cheeks, painted in more opaquely. Finally the right note of careless elegance is
conveyed in the contrast of the fashionable goatee and immaculately upturned moustache
with the softly curling slightly tousled hair, a lock of which strays across the pallid brow.

Van Dyck had created an image of the Lord of Ravels 'clearly worthy of the compan-
ionship and favour of the great'.[69] He must have been proud of it: it is one of the few
works to which the artist added his signature.

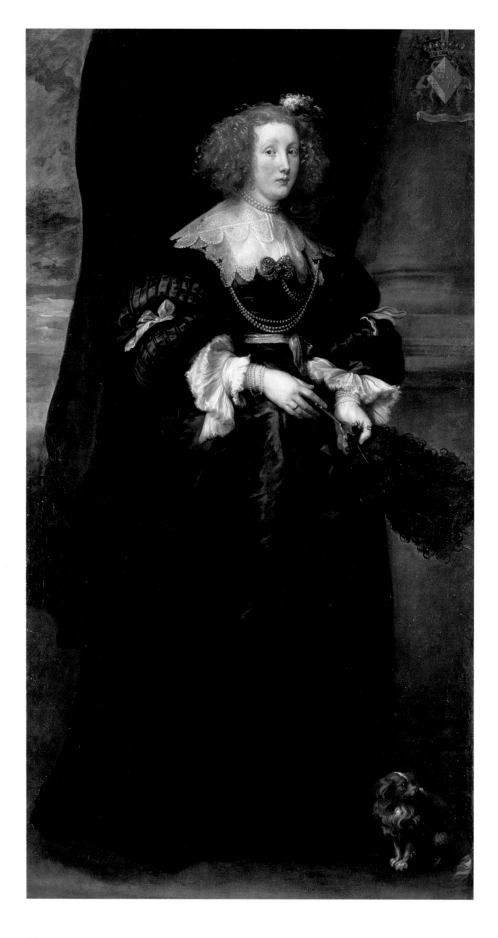

Fig. 35
Van Dyck, *Portrait of Marie de Raet*,
1631, The Wallace Collection

Fig. 36
Van Dyck, *Portrait of Philippe Le Roy*, 1630,
The Wallace Collection

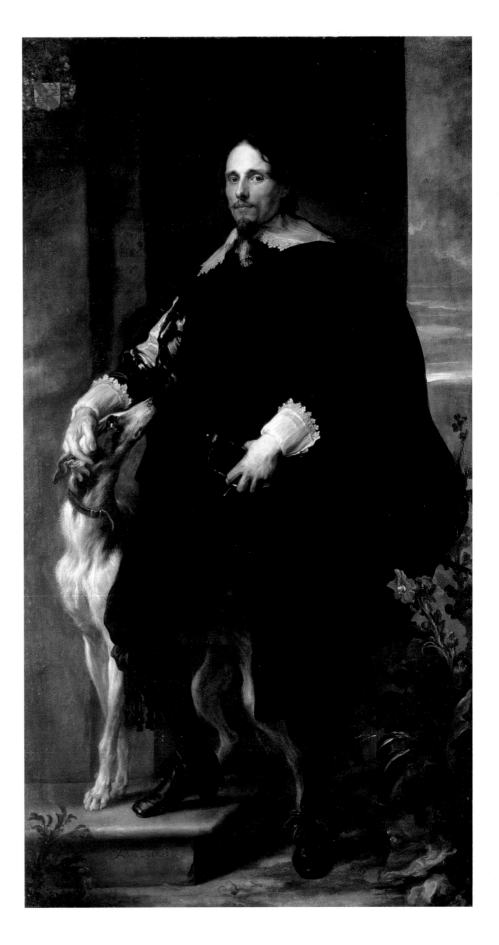

The Blushing Bride: Van Dyck's Portrait of Marie de Raet

Inscribed 'AET.SVAE 16.A°.1631'; with coat of arms, a later addition, beneath an imperial coronet: De Raet quartered with Le Roy, and the motto: 'ICY DOVL[EVR] LA HAVLT BONHEVR'[70]

Oil on canvas, 213.3 × 114.5cm.

PROVENANCE
See *Philippe Le Roy* above.

PRINTS
Anon. engraving, half-length.[71]
Anon. engraving, bust-length, seventeenth century.[72]
E. Gaujean 1882, three-quarter length.[73]

COPIES
Ex-collection A. L. Nicholson (ex-collection Lord Charles Townshend), Christie's, 23 March 1956 (lot 37), half-length 'in a dark dress with slashed sleeves, white lace collar, holding a black feather fan, a spaniel at her side'.

EXHIBITIONS
Riversdale, Maryland, 1816.
Manchester, *Art Treasures*, 1857 (saloon H, no.7).
Bethnal Green, 1872–5 (no.59).
Royal Academy, 1872 (no.128).
Royal Academy, 1888 (no.147).[74]

LITERATURE
See *Philippe Le Roy* above.

Philippe Le Roy and Marie de Raet were married at the Church of Saint George in Antwerp on 29th May 1631. The bride and groom would have known each other for some time. Marie, three years previously, had acted as godmother at the baptism in Brussels of her cousin Theodore Le Roy, son of her aunt and uncle, Jeanne Maes and Jacques II Le Roy. Marie and her parents were resident in the parish of Saint George in Antwerp, and Philippe, also resident in Antwerp, probably watched his little cousin blossom into the shy but pretty young woman we see in the portrait. Marie was baptised in Saint Jacob's Church, Antwerp, in 1614, and so was only sixteen at the time of their marriage. Such age gaps were common in seventeenth-century marriages. Middle-class men, in particular, often waited until they felt financially secure enough to support a family. Philippe's own father had not been in a position to marry until the age of thirty-eight, and Peeter Stevens' portrait shows him to have been a mature man of thirty-seven at the time of his betrothal to the twenty-one year old Anna Wake (fig.23). In view of the infant mortality rate of the time and his own dynastic ambitions, it would have been

Fig.37
Rubens, *Self-Portrait with Hélène Fourment and their Son Peter Paul*, c.1639, Metropolitan Museum, New York

Fig.38
Abraham Bosse, *A Fashionable Lady*, engraving taken from *Le Iardin de la Noblesse Françoise dans lequel ce peut Ceuillir leur manierre de Vettements*, Paris, 1629, Bibliothèque Nationale, Cabinet des Estampes, Paris

important for the thirty-five year old Philippe to choose a wife young enough to bear as many children as possible. Indeed a glance at the *Chronology* in Chapter VI shows that Marie was continually pregnant or recovering from pregnancy from soon after her wedding until 1653, during which period she bore fourteen children, at least four of whom died young. The most famous happy marriage of the period between an older man and a younger woman had taken place in Antwerp just the year before, between the fifty-three year old Rubens and his bride of sixteen, Hélène Fourment (fig.37). In a letter to his great friend, Peiresc, Rubens candidly revealed the motivation for his choice of bride: 'I made up my mind to marry again, since I was not yet inclined to live the abstinent life of the celibate, thinking if we must give the first place to continence, "We may enjoy licit pleasures with thankfulness". I have taken a young wife of honest but middle-class family, although everyone tried to persuade me to make a court marriage. But I feared "pride, that inherent vice of the nobility, particularly in that sex", and that is why I chose one who would not blush to see me take my brushes in hand. And to tell the truth, it would have been hard for me to exchange the priceless treasure of liberty for the embraces of an old woman'.[75] Philippe, too, for all his social ambition, chose a bride of similar solid respectable background, of equal youth and beauty, whom he had painted in the trappings of nobility but with the reserved demeanour of the middle classes.

So, having marked his engagement with his own portrait, Philippe chose to celebrate his marriage by commissioning an equally sumptuous companion portrait of his bride (fig.35). It is interesting to note that *The Portrait of Anna Wake* (fig.42),[76] Peeter Stevens' bride, was also painted a year after her bridegroom's portrait, and in the same year as their wedding. The most famous portrait in the Wallace Collection, Frans Hals' *The Laughing Cavalier*, 1624, confirms that there was a tradition of independent male betrothal portraiture in the Netherlands at this date.[77] The portraits of Philippe Le Roy and Peeter Stevens could thus have been conceived independently and then later complemented with images of their new brides, painted in such a way as to give the retrospective appearance of matched pairs. This partially explains why the man in each pair stands on the right, whereas according to established practice in Netherlandish portraiture and the laws of heraldry he should in fact be placed on the left. Also if we compare the two portraits of Marie de Raet and Philippe Le Roy as they hang next to each other for the first time in the Wallace Collection (also illustrated as such figs.35–6), a surprising discrepancy in the scale of the figures becomes apparent. Although each canvas is virtually the same size, the figure of Marie is markedly taller and further forward in the picture plane than is that of her husband. Marie, sailing forward in her black dress, appears to dwarf her husband, not an effect that either Van Dyck or Philippe would have welcomed, bearing in mind the painstaking care with which Philippe's image was created. The only conclusion we can draw from this anomaly is that Philippe's portrait had long since been delivered when Van Dyck came to start the picture of his wife. Although Van Dyck obviously had the measurements for the first portrait he forgot the exact scale he had been working to; we can only guess at his reaction when he realised his mistake.

Marie's portrait, like that of her husband, is meant to impress, if for rather different reasons. She is the perfect embodiment of her new husband's taste and wealth, made all the more charming by her air of innocence and touching vulnerability. Van Dyck

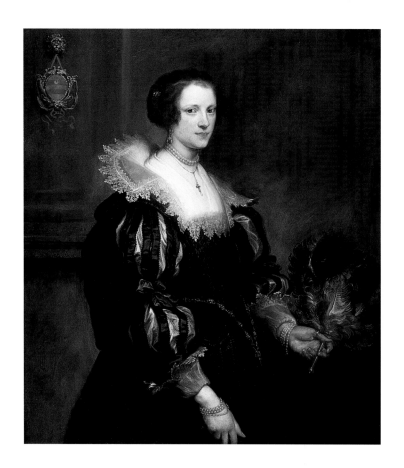

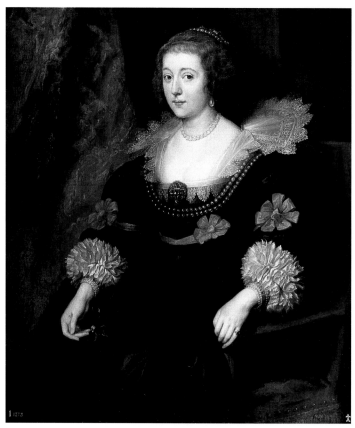

dresses her in the latest international fashion, as can be seen by comparison with fashion plates of the period (fig.38), or with Van Dyck's own paintings of other fashionable ladies like *Jeanne de Blois* (fig.39)[78] and the Princess of Orange, *Amalia van Solms* (fig.40).[79] If anything, Marie's dress is even showier, just as her portrait is more ambitious and finely painted. Like both ladies Marie is dressed in black. Black, as we have seen, was *the* colour of the fashionable elite. Although young women can be seen wearing coloured silks in genre scenes by Janssens such as *The Ball* (musée des Beaux-Arts, Lille), or in the later Dutch seventeenth-century interiors of the Wallace Collection, dressing in black for formal occasions became a social habit from *c.*1625 onwards.[80] Marie is seen, therefore, in her best dress as befits the formality of the portrait and the importance of the occasion it commemorates. She wears a black silk over-dress tied at her elbows and waist with silver-grey ribbons, over a black bodice with figure-of-eight sleeves and a black silk skirt. Van Dyck, as we have seen, was keen to make his figures appear as svelte and graceful as possible; here, by using a low viewpoint, Van Dyck succeeds in lengthening the skirt in proportion to the body, thus making Marie appear taller and more elegant.[81] Sadly this bottom half of the portrait has suffered the ravages of time, and what would have shone with silvery scumbled highlights, suggesting the sheen and moving folds of fabric, now looks dull and flat. Van Dyck's extraordinary facility of rendering material texture in paint can be seen, however, in the passage at the centre of the painting (fig.41) where the fluid highlights still suggest the rustle of shiny silk beneath the sitter's hands. Delicate strokes of silvery paint conjure a transparent striped ribbon around Marie's waist, while the fine pleated linen cuffs that swirl around her wrists present a virtuoso display of how a surface,

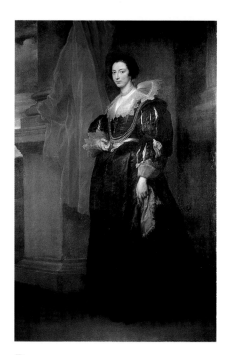

Fig.39
Van Dyck, *Portrait of Jeanne de Blois*, *c.*1631, Devonshire Collection, Chatsworth

opposite right: Fig.40
Van Dyck, *Portrait of Amalia van Solms*,
c.1632, Museo del Prado, Madrid

opposite left: Fig.42
Van Dyck, *Portrait of Anna Wake*, 1628,
Mauritshuis, The Hague

below: Fig.41
Van Dyck, *Portrait of Marie de Raet*, detail,
1631, The Wallace Collection

apparently of one colour, is in fact fractured into many different tones by light, reflected light and shadow. Van Dyck's brush follows the line of the pleats then breaks off to flick highlights of paint along the curling frayed edges. The same cuffs are found on a Lady painted by Van Dyck in the Brera picture gallery at Milan,[82] but there they stay decorously and stiffly in their place. Van Dyck was obviously determined in his picture of Marie de Raet to equal his achievement of the previous year, and present her husband with an image of beauty in paint.

Marie carries an expensive silver and ostrich-feather fan in her hand, like that seen in the *Portrait of Anna Wake* (fig.42). Anna clearly displays her fan in a manner reminiscent of Titian's *Lavinia as a Matron* (Gemäldegalerie, Dresden), which has led some commentators to speculate that the fan might have been a wedding gift from her husband. Marie's gesture, however, is more cleverly conceived. It betrays the nervousness of a girl, who despite her finery, is still only sixteen and unsure of what to do with her hands. One can imagine Van Dyck as fashion stylist suggesting she hold on to the fan to calm her

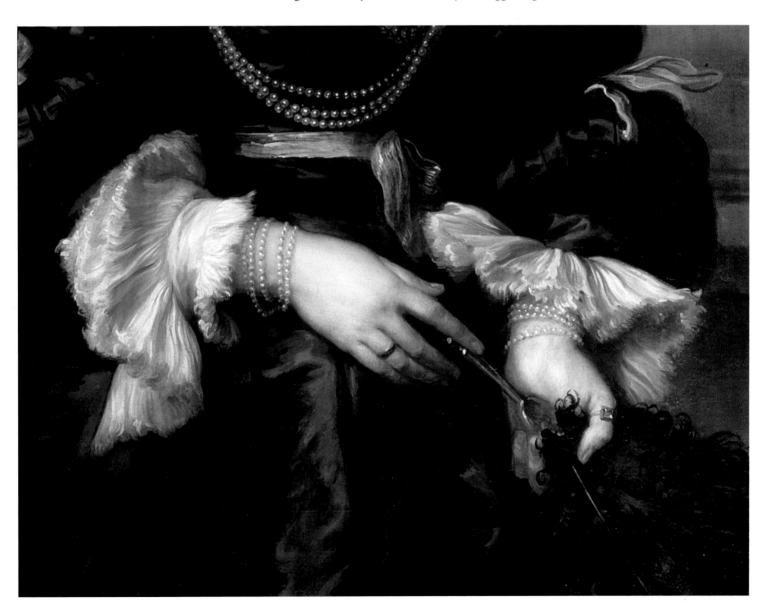

53

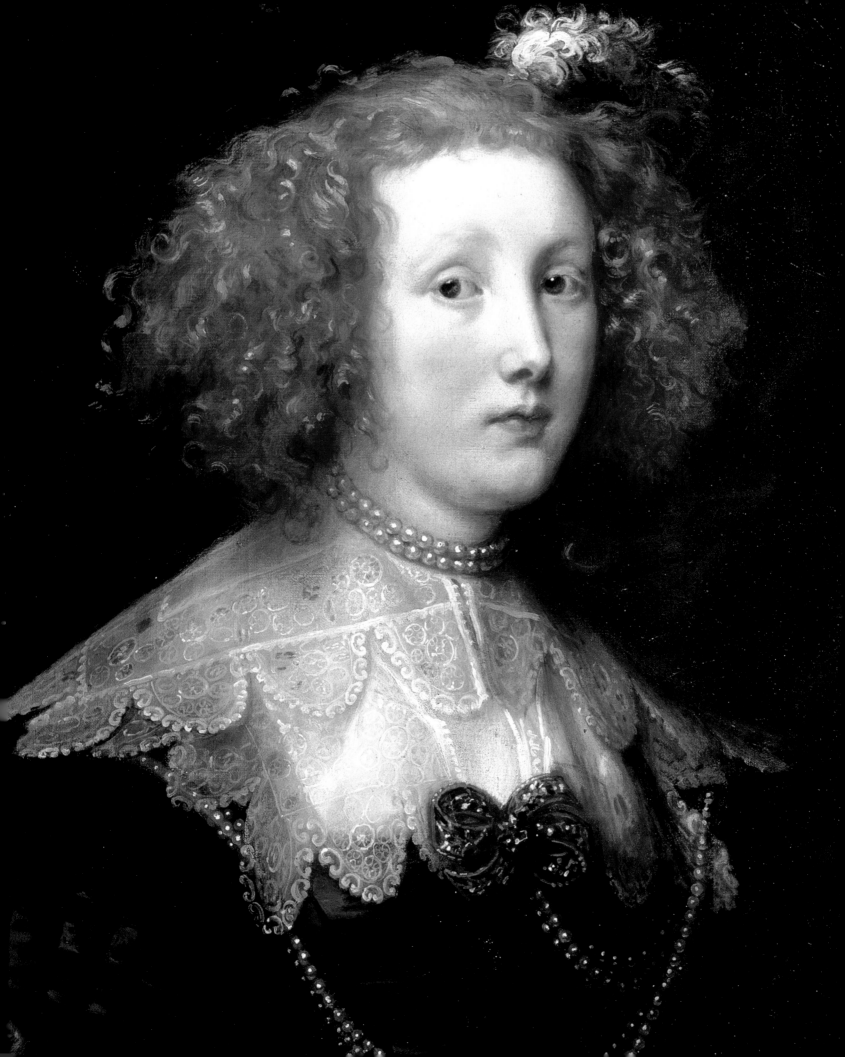

nerves. Of course at the same time it allows the artist to play with yet more contrasting textures: the hard metallic shaft of the fan contrasting with the curving fronds of feather rendered in black curls of paint against the pale flesh of Marie's hands. The hands themselves are painted with exceptional care. Very little slick brown outlining is visible here as Van Dyck brings the flesh tones right up to the edges of the hand, and blends the paint as smoothly as possible to create the impression of soft plump flesh. The position of the hands, too, allows the artist to draw attention to Marie's wedding and engagement rings, the latter a large square-cut diamond, worn on the thumb as in the *Portrait of Anna Wake*.[83] Philippe's wealth is ostentatiously displayed in the rich jewellery he has given his young bride on their marriage (fig.43). A large gold brooch set with diamonds stands out on her corsage, painted in thick impasto with sparkling flashes of yellow and white highlight. Yet more expensive are the ropes of pearls looped across her corsage and around her wrists, with an impressive double necklace of larger pearls at her throat. Pearls were an extremely important status symbol in the seventeenth century: the jewellery lists of Amalia van Solms, criticised by contemporaries for her lavish way of dressing, always start with the pearls. As we can see, with the exception of the hair ornament, Marie's jewellery seems every bit as impressive as that of the Princess of Orange.[84]

A magnificent double collar of expensive Brussels lace covers Marie's fashionably low décolleté. Another *Portrait of Amalia van Solms*, painted only two years later by Rembrandt, shows her wearing a similar collar (fig.44). The way in which each artist paints the same item of clothing reveals his very different artistic aims and techniques. Rembrandt, concerned with capturing physical reality in paint, uses thick creamy paint, laid on in little dabs, to evoke the pattern, texture and weight of each knot of lace. Van Dyck takes an altogether more idealistic approach, interested more in evoking the tantalising effects of transparent folds that hide or reveal the flesh of a young girl's bosom. With thin washes of paint he evokes the transparency of the material, the blue grey shadows of the folds, and opaque white highlights where they are caught by the light. The pattern is then lightly sketched onto the form in white in a series of curling squiggles and lines. Amalia's collar may be astonishingly well-painted, but it looks like an old woman's shawl, concealing rather than enticing, as in Marie's portrait. The hair, too, of both women, although dressed in the same fashionable style, with short fringe and frizzy curls framing the face, creates a very different impression. While Amalia may look truthfully dowdy, it is evident from Marie's exuberant ginger ringlets, escaping in little squiggles of paint and glistening with yellow highlights, that Van Dyck is determined to glamourise his subject. Indeed we know from a manuscript in the Bodleian Library, Oxford, that Van Dyck advised artists to finish a picture by imitating 'prettily the greatest refinement of the hair with winding brushstrokes'.[85] No heavy hair ornament is allowed to drag down the golden curls, instead a jaunty little feather reinforces their sense of airy weightlessness.

But despite all the glamour of her dress and person, what makes Van Dyck's *Portrait of Marie de Raet* so memorable is the telling contrast between the ostentatious costume and Marie herself. Today we see a little girl, uncomfortable in her big dress, her face staring wide-eyed and solemn, like a shy child in front of a camera. Her evident youth is emphasised by the wonderful translucent quality Van Dyck obtains through his accomplished modelling of the face. Her peaches and cream complexion is aided by a lighter ground used in the top half of the canvas, which gives her face a smooth glow like fine porcelain. In contrast to the angular shadows of her husband's face Marie's countenance is bathed in a more even light, and her oblique pose does nothing to hide her plump cheeks and rounded chin. The feathery blond eyelashes and anxiously raised eyebrows invite our sympathy as her dress invites our admiration. What a different impression Rubens creates of his teenage bride at about the same period (fig.45).[86] Hélène Fourment looks knowingly at the viewer, confident and proud of her smart clothes and new status. Rubens is evidently much influenced by his younger colleague's new style of portrait, but he misses something of the latter's finesse. Indeed our image of Marie is as much a reflection of the artist's own sensibility as of her personality.

Van Dyck completes his picture with a witty flourish: as he paired Philippe with an aristocratic hunting dog, so he pairs Marie with a little spaniel (fig.46), whose anxious pose and fluffy ears remind one of his mistress. Marie and her little dog are reminiscent not so much of Titian's adults as of his portraits of children, like the curly-headed *Clarice Strozzi* with her pet spaniel.[87] An emblem of fidelity, Marie's dog looks nervously over its shoulder beyond the canvas towards Philippe's great hound, and in so doing emphasises his mistress's dependence and duty towards her Lord.

Fig.45
Rubens, *Hélène Fourment awaiting her Carriage, accompanied by Nicolaas Rubens, c.*1631, The Louvre, Paris

The Model Paterfamilias

Philippe Le Roy was obviously so pleased with Van Dyck's portraits that he commissioned a third portrait from the artist.[88] *The Portrait of Jacques Le Roy* (fig.47),[89] painted the same year as his daughter-in-law's, shows the new President of the *Chambres des Comptes* and Lord of Herbaix seated, half-length, in a chair. It is the perfect image of the *paterfamilias*, and was probably commissioned not by the sitter but by his son, wishing once again to convey the impression that he was Jacques' legitimate son.[90] There is a reassuring sense of tradition to the portrait. Not as flashy as his son's full-length picture, it shows the sixty-one year old President in the more conservative garb appropriate to one of his advancing years: a ruff and long fur-lined *tabaard*. It became common in the first half of the seventeenth century for elderly men to have themselves portrayed in the *tabaard*, which was already perceived as quite an old-fashioned garment.[91] The merchant Nicolaas Ruts was

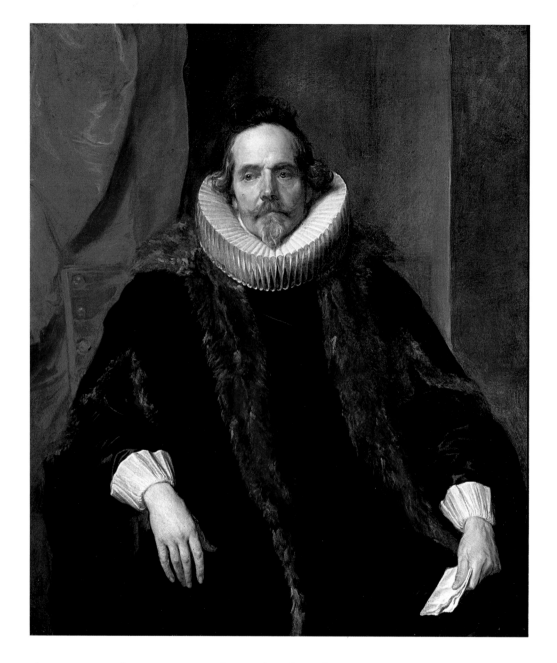

shown wearing the same costume by Rembrandt in the same year (Frick Collection, New York), and Van Dyck depicted the painter Martin Ryckaert in similar guise at about the same time (Prado, Madrid). Rembrandt and his school later characterised philosophers, alchemists and sages as elderly men wearing *tabaards*. The garment also carried with it legal and governmental associations. If we look at the illustrations recording the funeral procession of Archduke Albert, published in 1623, we find that all the members of the *Chambres des Comptes* wear long robes and ruffs and were often referred to as *Conseillers de longue robe,* Councillors of the long robe: a term similar to the French *noblesse de robe* indicating a recently ennobled bureaucrat.[92] Jacques' garb, therefore, while sharing certain mercantile connotations, is primarily intended to indicate his governmental status, exalted years and wisdom. The contrast between Jacques in his *tabaard* and Philippe and Marie in their French finery is comparable to Dirck Dircksz. Santvoort's *Portrait of Dirck Bas Jacobsz.*

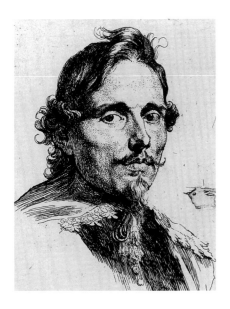

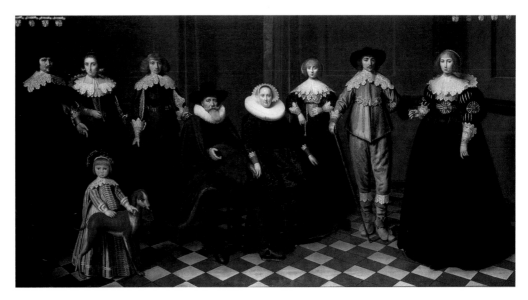

above right: Fig.48
Dircksz. Santvoort (1610–80), *Dirck Bas Jacobsz and his Family*, c.1635, Amsterdams Historisch Museum

above: Fig.49
Van Dyck, *Philippe Le Roy*, detail, etching, c.1630, first state, The British Museum

Fig.50
After Van Dyck, *Philippe Le Roy*, black chalk on white paper, Stedelijk Prentenkabinet, Plantin-Moretus Museum, Antwerp

and his family (fig.48) which depicts a Northern Netherlands family of about the same date (c.1635). An elderly respectable bourgeois couple, the founders of the family's wealth, sit surrounded by their seemingly more aristocratic and elegant progeny. Like the Jacobsz. family, the Le Roys were on the social ascent. By commissioning Van Dyck to paint their portraits at such a crucial moment Philippe was not just telling the world how much he had already achieved but where he wanted to be in the future, and using art from the outset to help him achieve that aim.

The Subsequent Fate of Van Dyck's Subject and Image: a Study in Art and Power

Van Dyck's *Portrait of Philippe Le Roy* soon became an important part of Philippe's campaign for social recognition. His self-promotion finds a defender in Castiglione: 'I should wish our courtier to bolster up his inherent worth with skill and cunning, ensuring that whenever he has to go where he is a stranger and unknown he is preceded by a good reputation and that it becomes known that elsewhere, among other lords, ladies and knights, he is highly regarded. For the fame which appears to rest on the opinions of many fosters a certain unshakeable belief in a man's worth which is then easily maintained and strengthened in minds already thus disposed and prepared'.[93] One of the most effective ways to get one's face known at the time was through the medium of print, so it is not surprising that Le Roy (probably the same year: 1630) persuaded Van Dyck to etch his portrait (fig.49).[94] The print is one of only eighteen produced by the artist, yet it was not included in the *Iconography* during Van Dyck's lifetime, despite being converted to bust length soon afterwards by an engraver (possibly Pontius). Philippe's greatest achievements on the political and diplomatic arena took place after the artist's death, so he was perhaps not yet prominent enough either as a politician or a collector to figure in the first series. In addition Le Roy seems to have owned the plate of Van Dyck's etching himself, thus personally controlling all subsequent reproductions of his image. The etching itself is a fine example of Van Dyck's skill in the medium. As in the painting, the face is dramatically lit, with

dark shadows emphasising Le Roy's prominent cheekbones and finely chiselled nose. The dark brows, high forehead, and intense eyes make the face as commandingly intelligent as in the portrait. This effect is dissipated in a drawing after the painting (fig. 50)[95] and a related print completed the following year by Vorsterman and Pontius (fig. 51). Vorsterman made such a hash of capturing Le Roy's likeness in the earliest states of the print that Pontius had to remove the head entirely from the plate and engrave it from scratch. The result is a bloodless copy of Van Dyck's original, but it still reveals Le Roy's growing pretensions. He is now seen in front of a pillar with classical statues bearing the Greek inscription 'to die nobly is to be reborn', and is described not only as Lord of Ravels but as a 'lover and patron of the art of painting' – he had after all just commissioned three great portraits by Van Dyck.

But promoting one's own image was not the only way to use art to create reputation. Following the example of the Archdukes, Philippe realised the propaganda value of combining public patronage and piety. In 1633, the year of Archduchess Isabella's death, while his father was welcoming the new provisional Governors of the Netherlands in Brussels, Philippe acted as an almoner at the *Maagdenhuis* (Girl's Orphanage) in Antwerp (fig. 52).[96] Despite the flourishing art scene, there was an increasing problem among the lower classes, hit by Antwerp's general economic decline and the resumption of overt hostilities with the northern provinces following the end of the Twelve Year Truce. In 1627 Rubens wrote to Pierre Dupuy from Antwerp complaining that: '…we have the inconvenience of war without the advantage of peace. This city, at least, languishes like a consumptive body, declining little by little. Every day sees a decrease in the number of inhabitants, for these unhappy people have no means of supporting themselves either by industrial skill or by trade…our own misery far exceeds the little damage we can inflict upon our enemies'.[97] In an age without social security, alms-giving, or charitable donation, was vital in alleviating the harsh conditions of the poor. So Philippe, as a rich member of the community was showing his Christian sense of responsibility by assuming a role which his father in law, too, had performed at the beginning of the century in the same Parish of Saint George. Interestingly Philippe's name appears in the Almoners' list below those of Sebastien Leerse (seen in fig. 16 in Chapter 1) and Peeter Stevens (fig. 23)

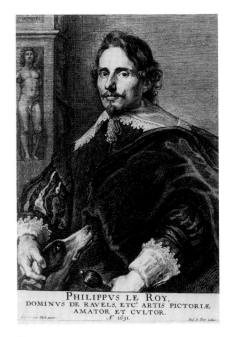

Fig. 51
Lucas Vorsterman (*c.*1595–1675) and Paulus Pontius (1603–58) after Van Dyck, *Philippe Le Roy*, engraving, sixteenth state, The British Museum

below left: Fig. 52
Detail of the *List of Almoners 1458–1754*, Maagdenhuis Museum, Antwerp

below right: Fig. 53
Detail of the main gallery of the new courtyard, 1634–5, the Maagdenhuis, Antwerp

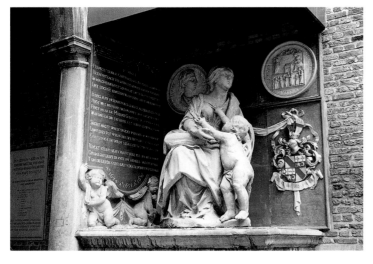

above left: Fig. 54
Monument to Charity, donated by Philippe Le Roy and Marie de Raet, The Maagdenhuis, Antwerp

above right: Fig. 56
Reconstruction by E. Batkin, 1895, of the original stained glass window (1635) by Van Diepenbeeck, The Almoners' Chapel, Cathedral of Our Lady, Antwerp

Fig. 55
Abraham van Diepenbeeck (1596–1675), *Portrait of Philippe Le Roy*, 1635, fragment of stained glass, Cathedral of Our Lady, Antwerp

who had both acted as almoners in previous years. The following year he helped fund the expansion of the *Maagdenhuis*, as was duly recorded in an inscription for all to see in the new courtyard (fig. 53). Philippe's donations continued in 1635, and 1636, when he also acted as Regent of the institution. Later he presented them with an elaborate monument, which was set up in a corner of the new courtyard (fig. 54).[98] It can still be seen there today and includes a sculpture of *Charity* by Huybrecht van den Eynde (1594–1661; the original is kept in the adjacent museum).[99] On the wall behind, above the coats of arms of Philippe Le Roy and Marie de Raet, are two roundels which copy the recto and verso of an antique coin: one shows a profile head of Faustina, wife of the Roman Emperor Marcus Aurelius, and the other depicts the girls' orphanage founded by her. To the side is an acrostic *SONNET,* or song, beneath a line of music. The first letter of each line spells out the name 'PHILIPPVS LE ROY', and the words teach the little girls to pray to Mary, Mother of God, and to be thankful to Faustina and the modern almoners who helped build their orphanage. One wonders whether the children were obliged to remember their patron daily with a song.[100]

For Philippe's next charitable enterprise Van Dyck's image again came in handy. In 1635 he acted as municipal almoner for the whole of Antwerp, and he and his fellow almoners decided to commemorate their collective act of charity by commissioning an impressive stained glass window for the almoner's chapel inside Antwerp Cathedral.[101] The window, designed by Abraham Diepenbeck (1596–1675), showed Saints Roch, Stephen, Lawrence and Elisabeth giving alms to the poor below a vision of God the Father and the Son. Beneath this the current almoners of Antwerp were shown kneeling in prayer. The window was damaged and removed in the eighteenth century. Among the fragments that survive we again meet the familiar face of Philippe Le Roy; the head obviously copied from Van Dyck's painting, or from Vorsterman and Pontius's print after the painting (fig. 55). Today in Antwerp Cathedral the memory of Philippe Le Roy lives on in a nineteenth-century copy of the almoners' portraits by E. Batkin (fig. 56).

By 1638, Le Roy's fortunes had improved further as he was appointed to the extremely lucrative post of Councillor and Receiver General of Licences, or Tax Collector, to the King. He marked his increasing wealth with another ostentatiously pious present, this time to the Collegiate Church of Saint Gudule (later the Cathedral) of

Brussels. His loyalty to his Hapsburg masters was now also emphasised, for his gift, which was to be placed in the chapel of the Holy Sacrament, was a crown decorated with portraits of the first twelve Emperors of Austria. There was no chance the church would forget its generous benefactor, either, for the burgomaster of Brussels promised to ensure that the crown would be exhibited on major feast days, and an annual mass said for the happiness of Le Roy and his wife, and for the repose of their souls after their deaths. At about the same time the couple contributed towards a silver tabernacle for the altar of the same chapel.[102] The following year, on the recommendation of the new Governor of the Netherlands, the Cardinal-Infante Ferdinand, Philippe's father was made a knight in recognition of his thirty-five years of faithful service. By 1640 Philippe, too, was calling himself *Jonkheer* or Knight, and had acquired his first château at Mortsel, south-west of Antwerp.[103]

In 1642 Philippe received one of the hardest, but most important jobs in the Spanish Netherlands, that of *Commissaire général des vivres des armées du roi* or General Superintendent of Supplies to the Spanish Royal army in Flanders. Logistics were of prime importance to armies of this period; more men were lost to starvation, disease and to the desertions resulting from these and lack of pay than to enemy action.[104] An army cannot march on an empty stomach and, as the Thirty Years War was grimly demonstrating in Germany, an army that was not adequately supplied was apt to go on the rampage, even in friendly territory. To keep an army supplied required considerable organisational expertise and financial outlay. The government in Brussels was an unreliable paymaster, so Philippe was probably expected to fund a large part of his responsibilities himself.[105] 'Money is the sinews of war', said Cicero, and the defence of the Spanish Netherlands, increasingly under attack from France and the northern provinces, could not be sustained without Spanish bullion to pay the troops. Yet the government in Spain was slow to provide, and when it did so there was always the problem of how to transport the silver to Flanders. Many a cargo was waylaid before reaching its destination, and Philippe, it seems, often had to make good the shortfall. No wonder he was granted the lucrative post of *Surintendant des contributions greffiers,* or Superintendent of Taxes, the same year. Philippe's first mission to The Hague, just two years later, was to investigate the possibility of reaching an accord with the Dutch about the shipping of Spanish silver.[106] By 1646 Philippe had become so indispensable to the government in Brussels that he appears to have become resident there until his retirement in 1661. Despite the fact that their country was in increasingly desperate financial straits, the Le Roy family fortunes continued to go from strength to strength. In an attempt to raise money the government started alienating leasehold land. Philippe, now Clerk to the Council of Finances, was thus able to acquire complete rights to the estates of Broechem and Oeleghem in the region of Santhoven,[107] while his father bought the complete rights to his estate at Herbaix, and the following year guaranteed 6000 florins of a new governmental loan.

The achievement for which Philippe is chiefly remembered by history, however, is his diplomatic mission to The Hague in 1647.[108] The Congress of Münster had been convened in 1644 to discuss terms for the ending of the Thirty Years War, but this had in no way checked French territorial ambitions in the Spanish Netherlands. Their expansionist policy unnerved their allies the Dutch, who became more open to negotiation with

Flanders. Dutch neutrality was vital for the new Governor of the Spanish Netherlands, Archduke Leopold, to repel the French without fear of reprisals from the north. Philippe was the man entrusted with the difficult task of persuading the Dutch to break with the French and enter into an alliance with the Spanish Netherlands and the Spanish King. Towards the end of 1646 he was granted a special passport and given letters of recommendation from the Marquis de Castel-Rodrigo to the States General (Governmental Assembly) of the United Provinces, and to the Prince of Orange and his wife Amalia van Solms.[109] It was not enough for a diplomat in the seventeenth century to be able, cultured and trusted by his king, he had also to be of sufficient social standing to negotiate on an equal footing with the opposition. Philippe behaved like an aristocrat, had himself portrayed as one, but was not yet officially noble. This distinction was understood by his Hapsburg masters whose gift to the new envoy, just before he left, was the longed-for letters patent, which confirmed his right to the rank of knight.[110] From that moment onwards he was officially allowed to bear the Le Roy arms adopted by his father,[111] as seen on the engraving of his father's portrait (fig.66), quartered with the Hoff arms of his mother.[112] He left for The Hague in May with letters from Archduke Leopold charging him to effect 'the cessation of arms by land and by sea, negotiated according to his judgement'. In an age before the fax and the conference call, the responsibility for the future peace of his country lay in Philippe's hands. Diplomacy was a ruthless business, 'the continuation of war by other means', to invert the words of Clausewitz, and Philippe's skill at the game was immediately recognised by his adversary, the French ambassador Servien, who tried to get him expelled from The Hague. Nevertheless, by intelligence, and by the judicious use of diplomatic 'gifts', Philippe prevailed.

Philippe Le Roy returned triumphant to the Spanish Netherlands where the Archduke, who was able to reconquer Armentières, Comines, Lens and Landrecies, rewarded him with a pension. The personal thanks of the Emperor himself arrived in the form of a gold chain with the Emperor's portrait. Only a few months later Le Roy was promoted to the position of *Conseiller et Commis des Domaines et Finances*, or Counsellor and Advisor on Land and Finances, and described as a resident of the fashionable rue Isabelle. The Peace of Westphalia was signed between Spain and the United Provinces on 30th January 1648. This temporary diplomatic victory, however, did not prevent the destruction of Archduke Leopold's entire army by the French under Enghien the following August. At last the Thirty Years War was brought to an end by the signing of the Treaty of Westphalia in Münster on 24 October, an event commemorated by Ter Borch in a painting given to the National Gallery by Sir Richard Wallace (fig.57).[113] A contemporary view of Münster by Isaac van Ostade (1621–49) can be seen in gallery 19.[114] By the terms of the Peace and Treaty of Westphalia Spain finally recognised the independence of the northern United Provinces of the Netherlands. The real terms of the treaty were a disaster for the Southern Netherlands; the river Scheldt remained effectively closed for trade, and Amsterdam consolidated its position as undisputed trading capital of the Low Countries. At the time, however, the war-weary Spanish Netherlands rejoiced in the peace, as can be seen in a contemporary engraving depicting *The Publication of the Treaty of Münster in Antwerp in 1648* (fig.58). Philippe's title and coat of arms were recognised by the Spanish King, Philip IV, the following year, when the extent of his loyalty was

Fig. 57
Gerard ter Borch (1617–81), *The Swearing of the Oath of Ratification of the Treaty of Münster*, 1648, The National Gallery, London

made clear in the letters patent: 'He has served us for thirty-one years in many honourable positions, as Commissioner General of the war munitions, especially of saltpetre and gunpowder, as Commissioner General of Supplies for our armies, as Superintendent of Taxes, as Clerk of our Domaines and Finances, and at present he serves as Counsellor and Advisor to the same, and during this time of employment he has rendered us many very agreeable services, especially at the time of the siege of Lens and Bassée and at the battle of Honcourt; he always organised the supplies well, not without peril to his own life, so that nothing failed, despite the great numbers of the army in locations far from our frontiers and in enemy territory, and in addition he often helped our armies on the most urgent occasions with very great sums of money which he advanced at one time or another with no recompense from our Lieutenant Governors and Captains General of the Low Countries and Burgundy, who also sent him in our name to many Princes and Lords where he acquitted himself to our entire satisfaction, and most notably in his mission to the Estates General of the United Provinces with letters of credit, instructions and powers of the aforementioned Governors General on the subject of the peace subsequently concluded with the aforementioned United Provinces'.[115] Already in 1640 the Cardinal-Infante had written enthusiastically about Philippe's capabilities; by the end of the war the Governor General of Mello was claiming that Philippe Le Roy had saved his country from total ruin.[116]

To commemorate the Treaty of Münster the portraits of the plenipotentiaries were painted by Anselmus van Hulle and engraved by Pontius for a series called the *Pacificatores* or Peacemakers. Le Roy was not present at the signing of the Treaty in Münster, and so not included in the first official commemorative series.[117] Image conscious as ever,

Fig. 58
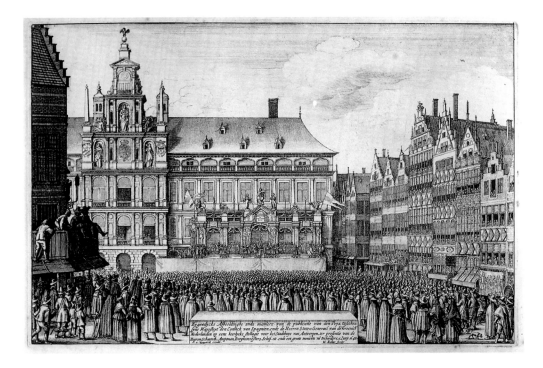

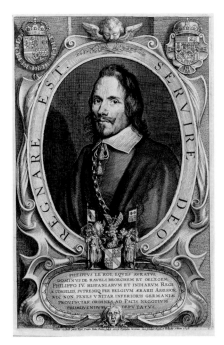

Fig. 59
Pontius after Anselmus van Hulle, *Portrait of
Philippe Le Roy*, engraving, second state,
1651, The British Museum

however, he nevertheless had his portrait painted and engraved in exactly the same manner, and in the course of time people forgot the distinction and Le Roy's image came gradually to be included in later editions and derivative series.[118] Although dated 1648, the first state of the engraving was probably made in 1649 following his confirmation of nobility from Philip IV, for it shows the newly augmented Le Roy arms granted at that date.[119] In 1651 Philip IV allowed Le Roy to embellish his coat of arms further, and these modifications appear in the second state of the engraving illustrated here (fig. 59). Philippe is shown wearing the gold chain, given by the Emperor, in an elaborate cartouche, similar to those seen in the *Pacificatores* series. It bears a Latin motto, 'To serve God is to rule', which derives from a Spanish emblem book of 1589.[120] Castiglione maintained that the aim of the perfect courtier was, by means of his accomplishments, to win the mind and favour of the prince he serves.[121] Philippe's loyalty to both the Spanish and Austrian Hapsburgs is now emphasised in the two coats of arms at the top of the engraving: on the left the arms of the King of Spain,[122] and on the right the arms of Archduke Leopold, brother to the Emperor and Governor of the Spanish Netherlands until 1656.[123] Philippe is described as knight, Lord of Ravels and Oeleghem, Assessor and Councillor of Philip IV in Belgium, and a deputy of the peace negotiations. His splendid coat of arms is here supported for the first time by two Swiss guards carrying *bannerets*, or square banners, denoting the fact that he had been elevated to the rank of *chevalier banneret*: a knight who, according to medieval tradition, had sufficient vassals to fight under his own banner – a trifling distinction to us, perhaps, but one which merited the re-issuing of his engraving for this honour-sensitive man. Although Philippe looks older, his hair thinner and his moustache heavier, his face has the same slim aristocratic demeanour seen in Van Dyck's painting. Pontius had of course engraved Van Dyck's image seventeen years earlier, so it is not surprising if we can detect some kinship between the works. Nor could Philippe resist interferring with Van Dyck's paintings themselves to make sure that they too

far left: Fig.60
Van Dyck, *Portrait of Philippe Le Roy*, detail,
1630, The Wallace Collection

left: Fig.61
Van Dyck, *Portrait of Marie de Raet*, detail,
1631, The Wallace Collection

reflected his present glory as well as his past youthful glamour. We find in the top left corner of his portrait a much abraded, and much altered coat of arms above his Latin motto 'SERVIRE DEO REGNARE EST' (fig.60). It appears that Philippe had his coat of arms repainted to reflect each new nuance of his social advancement. His wife Marie's coat of arms were also added to the top right of her portrait, showing De Raet (three golden skates on a red ground) halved with the arms of her husband beneath an imperial coronet, with the motto in French 'HERE BELOW SADNESS. HAPPINESS ABOVE [IN HEAVEN]' (fig.61). The fact that they were not painted by Van Dyck himself is immediately evident if we look at instances where Van Dyck did include coats of arms in paintings (figs.23 & 42). The evident quality of Peeter Stevens and Anna Wake's coats of arms, and the way they are conceived as important decorative elements within the pictures themselves, emphasises the fact that Philippe had no such official coat of arms to show off in 1630 when his portrait was painted.

The arms of Philippe and of his wife appear prominently displayed to top left and right on a view of the magnificent château Philippe now began to build in Broechem to reflect his new status (fig.62). He acquired the old manor of *Root hoffken* or *Red Court* in 1649. Secular architecture in Flanders at the period was conservative, and Philippe, mindful as ever of historical precedent, was no exception to this trend.[124] He used the foundations of this essentially medieval building as the basis for a new château, constructed in traditional brick, which can still be seen, somewhat modified, today (fig.63). His wealth and rank had brought Philippe what every Belgian still desires today: a beautiful house in the country. According to his son's account of his life and the information included in his epitaph, the successful diplomat, following his success at The Hague, retired, covered in honours, to Broechem where he spent the rest of his days embellishing his château and enjoying aristocratic country pursuits.[125] Philippe's supposed retirement reflected a growing propensity on the part of the moneyed classes to abandon the towns, ridding themselves

Fig.62
Adam Pérelle (1640–95) after a drawing by
J. van Weerden, *View of the château of
Broechem*, engraving from LE ROY 1699, III,
pp.87–8, The British Library

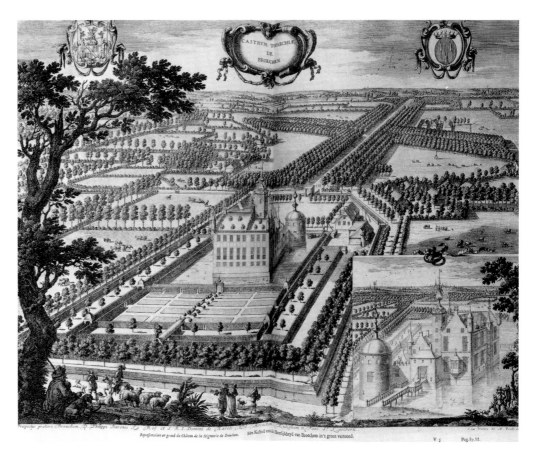

Fig.63
View of the Château of Broechem today

of their mercantile associations in the process, and to install themselves on grand country estates; a fashion resulting in images such as the *Group Portrait* by Gonzales Coques already noted. The reality in Philippe's case was probably less clear-cut than his biographers would have us believe, for on his return from The Hague he was given new responsibilities at court and acquired a large new house behind the Church of Saint Gudule. In 1653 he acquired a country property more conveniently situated for Brussels: the castle and village of Chapelle Saint Lambert (fig.65). The estate of Broechem, however, remained his overriding passion, on which he lavished a great deal of care and expense, not just on the château, but on the gardens and surrounding terrain as can be seen in the engraving. Again exhibiting that combination of patronage and piety that is such a defining feature of the period, he supported the local church, obtained the right to celebrate mass in the chapel of the château, and financed the building of a small baroque shrine in the village of Broechem itself, which can still be visited today (fig.64).

Publicly Philippe Le Roy's life at this period must have seemed more than fortunate, yet privately he and his wife suffered a series of tragedies. In the year of Philippe's triumph

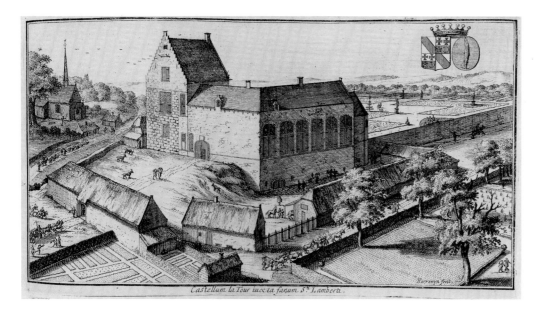

Castellum la Tour iuxeta fanum S.t Lamberti.

above: Fig.64
The Le Roy Chapel, Broechem

above left: Fig.65
Harrewyn, *View of the Castle of La Tour in the village of Chapelle St. Lambert*, from LE ROY 1699, II, p.40, The British Library

in The Hague their baby daughter Barbe died, barely a year old. She was followed to the grave the next year by three more of their children, all interred within the space of twelve months in Saint Gudule. In 1653, Marie, now aged thirty-eight, bore her fourteenth and final child, a little girl, christened Françoise Pauline Le Roy de Saint Lambert. Perhaps in gratitude for her safe delivery the couple donated a painting by Gaspar de Crayer, *Saint Lutgardis kneeling before Christ on the Cross*, to the Abbey of Nazareth near Lier the same year.[126] The following year Jacques II Le Roy died at the age of eighty-four. A commemorative engraving was made by Adriaen Lommelin after Van Dyck's 1631 portrait (fig.66) and dedicated by the publisher Hendricx to Philippe rather than to his half brother Ignace, his father's principal heir.[127] The dedication may be taken as further evidence of Philippe's commissioning of the original picture. Also perhaps his love of family portraits was by now common knowledge amongst his contemporaries. It must have been this that encouraged the medallist Adriaan Waterloos (1598–1681) to design two speculative medals of Le Roy, which exist in silver, gilt bronze, bronze and copper in the royal medal cabinets in Brussels, Leiden and in the Mayer van den Bergh Museum, Antwerp.[128] They carry a portrait of Le Roy in profile on the recto (fig.67) and slightly different designs on the verso incorporating his ubiquitous coat of arms, and his related mottoes: 'TO SERVE GOD IS TO RULE' in Latin, and 'BUT THE KING SERVES GOD' in old French.[129] Waterloos produced many such designs at this period for members of the Brussels court. The medal shown here may have been struck to commemorate the subject's sixtieth birthday. It must have found favour, for Philippe was named as a witness at the baptism of Waterloos's daughter, Elizabeth-Catherina, six years later.

In 1661 Philippe retired from his official post in Brussels which passed to his eldest son Jacques III Le Roy. His retirement may have been prompted by his wife's illness, for the couple drew up their will, and the following year Marie died at the age of forty-seven, and was interred in the parish church of Broechem. His bereavements of the past decade focused Philippe's mind on his own mortality; this is clear from a surprisingly different image of *Philippe Le Roy* produced by Victor Boucquet (1619–77; fig.68).[130] Boucquet was a minor Flemish painter who spent his entire career in the small town of Furnes, producing

Fig.66
Adriaen Lommelin (d.1673) after Van Dyck,
Portrait of Jacques Le Roy, engraving, fourth
state, 1654, The British Museum

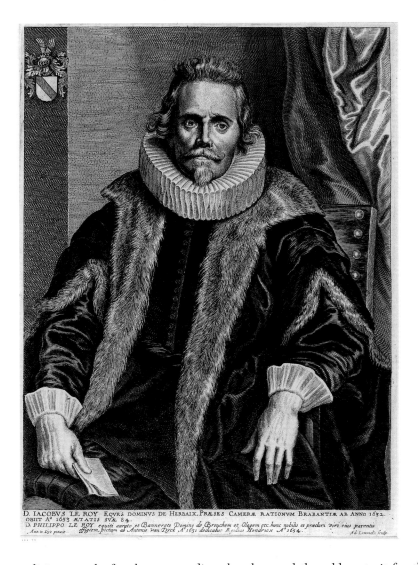

D. IACOBVS LE ROY EQVES DOMINVS DE HERBAIX, PRÆSES CAMERÆ RATIONVM BRABANTIÆ AB ANNO 1632.
OBIIT Aº 1653 ÆTATIS SVÆ 84.
D. PHILIPPO LE ROY equiti aurato et Bannereto Domino de Broychem et Olegem etc. hanc nobilis et preclari viri eius parentis
Ant.v. Dyc pinxit effigiem, pictam ab Antonio van Dyck Aº 1631 dedicabat Ægidius Hendricx Aº 1654. Ad Lommelin sculp.

Fig.67
Adriaan Waterloos (1598–1681), *Portrait
Medal of Philippe Le Roy* (recto), 1656,
Koninklijk Bibliotheek/Bibliothèque Royale
Albert Ier, Brussels

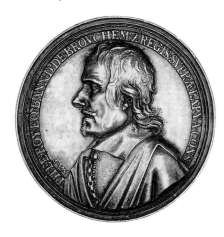

religious works for the surrounding churches, and the odd portrait for the local gentry.[131]
At first glance it is difficult to understand why Philippe should commission such a provin-
cial artist. There was certainly no one of Van Dyck's stature painting portraits in Antwerp,
but perhaps the real reason for Philippe's choice lies in the sombre nature of the image
itself. Boucquet's style in his other known portraits, although often ambitious in scale, is
notably restrained and severe. Far from the debonair vision of Van Dyck, Boucquet's
portrait is an unpretentious image of bereavement, quietly moving in its unflattering
directness.[132] Philippe sits heavily, bloated of figure, in a dowdy suit of brown woollen
cloth. Across his chest a black sash indicates his state of mourning, while behind him a
broken column, symbolising fortitude in bereavement, recalls the death of his father, the
pillar of the family. In his hands wilting flowers provide a more poignant testimony to his
deceased wife and children, cut down in their prime. No longer seen with an athletic
hunting dog, Philippe carries a stick and is accompanied by a cowed spaniel, a reference
perhaps to the dog seen in Van Dyck's portrait of Marie, or perhaps a real pet missing
its dead mistress. He sits on a broken section of classical entablature implying the unpre-
dictability of fate and the vanity of the mighty. Yet Philippe still cannot resist another
ostentatious display of his smart coat of arms; although one might argue that its effect is

Fig.68
Victor Boucquet (1619–77), *Portrait of Philippe Le Roy*, c.1662, Musée des Beaux-Arts, Lille

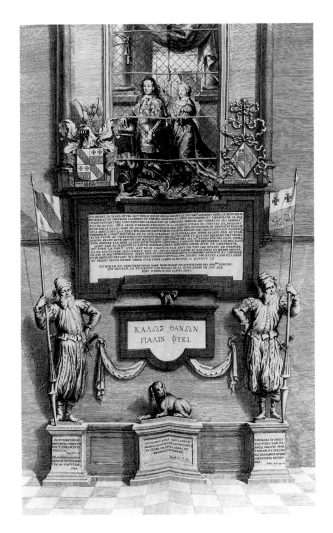

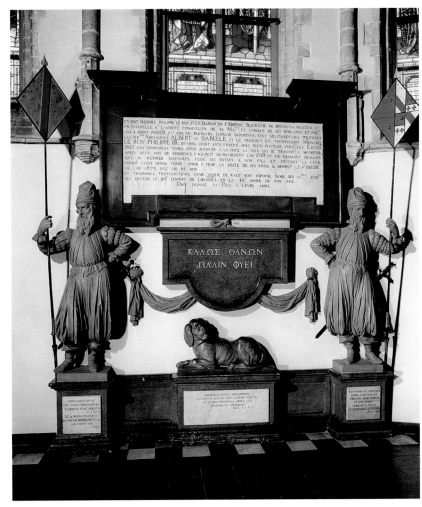

above left: Fig.69
Richard Collin, *Monument to Philippe Le Roy and Marie de Raet*, engraving, c.1670, from LE ROY 1678, pp.180–1, The British Library

above right: Fig.70
The Le Roy Monument as it appears today, Parish Church, Broechem

mitigated by the self-abasing motto from Psalm 62: 'BUT THE KING SERVES GOD'. However keenly Le Roy felt the loss of his wife, he was soon writing to her relatives to clarify her genealogy.

Although he had retired from public life Le Roy's thirst for aristocratic preferment continued unabated. It is not clear whether his next move was prompted or merely aided by his son Jacques, but suddenly, over twenty years after his promotion from arms dealer to diplomat and aristocrat, Philippe Le Roy, and all his descendants male and female were created Barons of the Holy Roman Empire by the Emperor Leopold I in 1671.[133] Philippe, quick as ever to fix his new distinctions in the public mind, set about building a splendid monument to the memory of himself and his wife in the parish church at Broechem. An engraving by Richard Collin, used to illustrate one of Jacques III Le Roy's works published the year before his father's death, shows how this was intended to look (fig.69).[134] A stained glass window depicts the couple kneeling in prayer, before a view of their château. Philippe is shown dressed in a heraldic tabard and armour like a medieval lord. Marie's image, however, clearly derives from her portrait by Van Dyck. She is depicted with the same fair curls, wearing a similar dress; but more conclusively her little dog again appears staring nervously over its shoulder as in the foreground of Van Dyck's *Portrait of Marie de Raet*. To either side of this window are the elaborate coats of arms and old French mottoes

we have met before, but Philippe's baronial coronet is still absent, which suggests the monument may well have been begun even before Philippe received his barony. The inscription, however, makes his new title clear. Its undated status, and its inclusion in Jacques III Le Roy's book of 1678, confirm that Philippe conceived the monument before his death.[135] Beneath the epitaph another decorative plaque carries the third Le Roy motto 'TO DIE NOBLY IS TO BE REBORN', flanked by sculptures of the two Swiss Guards, bearing the arms of Le Roy on the left and Hoff on the right, while in the centre a hound lies guarding the sepulchre. The guards and dog are each raised upon a podium bearing an inscription from a learned classical author justifying Le Roy's decision to erect his own monument during his lifetime.[136] The monument today (fig.70) has lost its stained glass window and coats of arms,[137] but in general follows Collin's engraved design. To record the crowning achievement of his career, however, Philippe could do no better than return to that commanding image of his youth produced by Van Dyck. The etched and engraved plate was brought out, dusted off and again worked upon by an engraver. The chain Philippe received from the Emperor in 1647 had already been added to the bust length portrait, now it was the turn of the new Le Roy title and coat of arms to be recorded for posterity (fig.71).[138] It is not surprising to read that numerous examples of the final state were printed and survive to the present day.

This final feather in the heraldic cap proved almost ruinously expensive, for three years later over half of the property of Jacques III Le Roy's rich young second wife had been alienated or mortgaged to the hilt, and the estate at Broechem seized by the bailiff on behalf of her furious father. The Le Roys circumvented the situation by using the estate as surety against loans totalling 23,000 florins, and the estate was finally sold and the proceeds split between the Le Roy children on the death of their father. Philippe Le Roy died on 4 December 1679, aged eighty-four years. Proud and devout to the end, he was interred next to Marie, in the shadow of their monument, in front of the main altar of the parish church at Broechem (fig.72).

As the portraits of Philippe Le Roy and Marie de Raet demonstrate, Van Dyck's portraits at their most successful inspire a feeling of recognition across the centuries, often accompanied by a curiosity to know more about the sitter, Van Dyck draws us beyond the merely physical, beyond the two-dimensionality of a flat painted canvas, to contemplate the personalities and wider histories of the subjects he painted. Of course, the artist cannot hope to present the narrative of the sitter's personal history in his face, but he can, as we have seen, through skilful manipulation of dress, bearing and setting, provide us with an essence of the sitter's personality and aspirations that goes far beyond the prosaic rendering of a mere physical likeness. Like Charles I, Philippe Le Roy was quick to admire and recognise this power in Van Dyck's art and to turn it to his own propagandist use. Like a poem, such portraits transcend the restrictions of their medium and provide evocative images, which in their turn have inspired poetry. As Constantijn Huygens remarked: 'In men's talents do they live on. Head and hands / preserves Van Dyck, saying, the rest is for death'.[139]

Fig.71
Van Dyck, Pontius?, and an unidentified hand, *Portrait of Philippe Le Roy*, etching and engraving, seventh state, 1671, The British Museum

Fig.72
The Tomb of Philippe Le Roy and Family, before the altar, Parish Church, Broechem

FOOTNOTES TO CHAPTER II

1 FROMENTIN 1876, p.85.

2 As Philippe's grandfather, father and son were called Jacques, I have found it useful in the initial pages of this chapter to follow the example of DE RAADT 1891 and differentiate them with the numbers I, II, & III respectively. A detailed account of the historical events described in this chapter is found in the *Chronology* in Chapter VI.

3 The place names discussed in this Chapter are illuminated in red on the seventeenth-century map, taken from LE ROY 1678 between pp.52–3, illustrated here in fig.22. Many of the locations mentioned in Antwerp can be seen in the street map found pp.8–11.

4 For a description of the troubles in Antwerp in the seventeenth century, see Chapter I.

5 The map was chosen to illustrate the 1617 edition of Guicciardini's guidebook; see Chapter I and ANTWERP 1991, pp.172–3, no.24. The gunpowder factory is described as a "poÿer meulen" or powder mill.

6 Although he may well have been pragmatically dealing with both sides, as occasion demanded; see JONES 1997, pp.114–20. For the funerary inscription see note 8 below: the use of the word 'NAVAT' ('steer') may imply that Le Roy was providing gunpowder for the Spanish fleet to transport bullion, vital for the payment of their armies in the Low Countries.

7 For the Hoff family history, see DE RAADT 1891, pp.53–60.

8 This epitaph, inscribed on a white tomb stone behind the pulpit, was inscribed in Latin: 'SACRED TO GOD MOST GOOD AND GREAT, AND TO THE MEMORY OF JACQUES LE ROY WHO JUSTIFIED A KINGLY SURNAME BY NOBILITY OF FAMILY AND LIFE AND BY KINGLY SERVICES: WHILE JOHN III OF PORTUGAL AND PHILIP II OF SPAIN WERE KINGS, AND ALBERT AND ISABELLA WERE THE MOST SERENE ARCHDUKES OF AUSTRIA, BOTH IN THE INDIES AND IN BELGIUM, FOR 50 YEARS HE STEERED THE DIFFICULT WORK. HE DIED IN THE YEAR 1603 IN THE VERY LIGHT OF THE IMMACULATE CONCEPTION, IN HIS 72ND YEAR. [ERECTED BY] THE NOBLEMAN JACQUES LE ROY, KNIGHT AND LORD OF HERBAIX, WHILE PHILIP IV WAS KING OF SPAIN, WHO BY HIS COUNSELS AND AS PRESIDENT OF THE CHAMBRE DES COMPTES FOR BRABANT, WAS MOST LOYAL THROUGH CHRIST'; see LE ROY 1730, p.127.

9 'God knows the best King' – a pun upon the French meaning of Le Roy; See DE RAADT 1891, pp.3–10.

10 *Ibid.*

11 See DE RAADT 1891, p32.

12 For an explanation of the various Governmental Chambers and Councils at this period, see H. de Schepper 'Les archiducs et les institutions du gouvernement aux Pays-Bas espagnol, 1596–1621' in DUARLOO 1998, pp.221–32.

13 It was the *Chambre des Comptes*, of which Jacques II Le Roy was a key member, which, in an Ordinance of 1625, prescribed the layout of the street and the construction of the houses and walls bordering it. It is not difficult to imagine Jacques Le Roy reserving his future residence at the planning stage. For the construction of the rue Isabelle and its wider significance, see A. de Vos 'Jacques Francquart (1583–1651), Architect to the Court, and the Rue Isabelle in Brussels' in DUARLOO 1998, pp.210–13.

14 The inscription on the engraving it should be noted (perhaps without surprise), is longer than that on the actual monument. It was engraved in Philippe's own lifetime to illustrate a book by his son, the eminent historian Jacques III Le Roy, and so presumably devised according to Philippe's own instructions, and certainly with his knowledge; see LE ROY 1678, pp.180–1.

15 For the court and collection in Prague at this date see PRAGUE 1997.

16 When old enough Jacques II Le Roy's eldest legitimate son, Ignace Le Roy did indeed follow his father as President of the *Chambre des Comptes*, just as Philippe's eldest son inherited his post as member of the more significant *Conseil des domaines et finances*; see DE RAADT 1891, pp.28–9, and H. de Schepper, *ibid.*

17 See DE RAADT 1891, p.32.

18 All recorded in the *Chronology* in Chapter VI.

19 For the history of Ravels see KOYEN 1956.

20 See DE RAADT 1891, pp.53–60.

21 Elisabeth Hoff is also described as a widow in the obituary lists of the convent. The inscription, in Latin, on her monument is as follows: 'SACRED TO THE MEMORY OF HIM WHO TRIUMPHED OVER DEATH AND TO THE MEMORY OF LADY ELISABETH HOFF OF FREIBURG. SPRUNG FROM NOBLE STOCK OF BREISGAU. NOTABLE FOR HER BEHAVIOUR AND CHASTE LIFE AND HER CONSPICUOUS GENEROSITY TOWARDS THE POOR SHE LIVED 64 YEARS. SHE DIED 27TH SEPTEMBER 1627. PHILIPPE LE ROY, HER SON, LORD OF RAVELS AND EEL, ERECTED THIS IN MOURNING. ALSO TO THE MEMORY OF HIS/HER FATHER JACQUES, KNIGHT, BURIED AT TOURNEPPE'. The last line is left deliberately ambiguous in the Latin; presumably there were too many who knew his true history for Philippe to be too categorical. The way the line is left it could be seen as referring either to his father Jacques Le Roy, or to Elisabeth's father, Jacques Hoff; see DE RAADT 1891, pp.33–4 for the original Latin and further discussion.

22 'Postmeestershof' was built, as it name suggests, by the Master of the Post, Antoine de Tassis, who, together with his daughter, was also painted by Van Dyck (c.1629; both portraits now in Vaduz); see ANTWERP 1999a, pp.216–7, no.55.

23 'Fortes bella gerant. Tu felix Austria nube'; see DAVIES 1997, pp.524–5.

24 'To serve God is to rule'; for an explanation of the evolution of Le Roy's coat of arms, and of his mottoes, see below.

25 Information kindly supplied by Dr Horst Vey.

26 The Peeters collection was described as one of the two 'most considerable' private collections in Antwerp by Sir Joshua Reynolds, who saw and sketched the portraits of Philippe Le Roy and Marie de Raet during his visit there in 1781. Reynolds was obviously impressed, for he made a second visit in 1785; see H. MOUNT 1996, pp.79 and 164.

27 See M. Law Callcote, *Mistress of Riversdale. The Plantation Letters of Rosalie Stier Calvert 1795–1821*, Baltimore and London, pp.298, 333.

28 See E. Hinterding & F. Horsch, 'Reconstruction of the collection of Old Master Paintings' in exh. cat., *William II*, The Hague,1989, p.78.

29 For 40,000fr., according to a MS. note in the Wallace Collection. Nieuwenhuys's own account of the transaction reveals that he bought the pictures on behalf of the Prince of Orange from the outset; see NIEUWENHUYS 1843, p.147. The picture was seen in the collection of William of Orange, and sketched by the German artist Josef Danhausers, in 1842; see M. Poch-Kalous, 'Josef Danhausers Reiseskizzenbuch in der Albertina: Deutschland, Holland, Belgien', *Albertina Studien,* IV, 1966, p.34.

30 Both the 4th Marquess of Hertford and his agent, Mawson, appear to have been present at the William II of Holland Sale; for an account of this sale see chapter V.

31 WAAGEN 1854, II, p.158.

32 According to an invoice from the frame-makers, W. & P. Evans, preserved in the Wallace Collection archives.

33 Invoice from Nieuwenhuys dated 14 August 1863 in the Wallace Collection archives: 'Restauration complète & rentoilage des deux beaux portraits peint par Van Dyck £200'. The stretcher is stamped 'G MORRILL/ LINER'; Morrill was active in London 1858-65.

34 A detailed list of the prints, and their different states, is given in MACQUOY-HENDRICX 1991, I, pp.118–9, 202, 208–12, nos.C, 167, & 185; II, pls.17–18, 105, 115–7. For a recent discussion of the prints associated with Van Dyck's portrait of Philippe Le Roy, see ANTWERP 1999c, pp.132–5, no.13.

35 'To die well is to be reborn'; this reappears upon Le Roy's monument in the parish church at Broechem (fig.70), and upon the engraving of the monument by Richard Collin, 1670 (fig.69). For a discussion of the monument and Le Roy's various mottoes, see below notes 120, 129 and 135.

36 I am grateful to Mr Harlinghausen for alerting me to the existence of this mezzotint.

37 Ex-Kunsthistorisches Museum, Vienna; see GÖPEL 1940, fig.19. This is probably the picture which appears in an etching of the Gergensinn collection, Vienna, 1735; *op.cit.,* fig.16.

38 See VEY 1962, pp.249–50, no.179, fig.216.

39 Colnaghi's, *Exhibition of Old Master Drawings*, 27 June–29 July 1972, p.13, no.18, not illustrated; possibly the same as a drawing of the same subject belonging to M. Plucker, Brussels, illustrated in *Académie Royale de Belgique, Bulletin de la Classe des Beaux-Arts*, IX, 6–8, 1927, f.p.65.

40 See figs.113 and 126.

41 See WASHINGTON 1990–1, pp.196–200, no.45 and ANTWERP 1999a, pp.202, 205, no.48.

42 Although Peeter Stevens is dressed fashionably in black, his turned-down linen ruff and the pronounced epaulettes on his jacket announce the conservative, slightly old-fashioned, dress of a member of the middle-classes in contrast to the more obviously aristocratic fashion followed by Philippe Le Roy which will be discussed below.

43 For recent catalogue descriptions of this portrait , see WASHING-TON 1990–1, pp.207–9, no.48 and ANTWERP 1999a, pp.206–7, no.50.

44 WALPOLE 1888, I, pp.330–2.

45 See WETHEY 169–75, II, no.20, pl.55.

46 A closer analogy to Titian's portrait is the use Van Dyck made of the same pose of man and dog in his portrait of *Thomas Wentworth, 1st Earl of Strafford* (private collection), which would have been more appropriate considering Strafford's position in government; see ANTWERP 1999a, pp.248–50, no.68.

47 For a discussion of courtly etiquette and behaviour, see for instance J. Zijlmans, 'Life at The Hague Court' in KEBLUSEK 1998, pp.30–45. Rubens designed the title page for a similiar seventeenth-century treatise on courtly behaviour and Catholic ethics, *Politico Christianus* by C. Scribani, Antwerp, 1624; see J. Richard Jusdson and C. Van de Velde, *Corpus Rubenianum: Book Illustrations and Title-Pages*, London and Philadelphia, 1978, I, pp. 236-9, no. 54, II, fig.185.

48 CASTIGLIONE 1528, p.67.

49 CASTIGLIONE 1528, pp.134–6.

50 Thus, when the Duke of Buckingham was sent to escort Charles I's bride, Henrietta Maria, to England from France in 1625, he apparently took with him a wardrobe of 27 suits of clothes, including one outfit rumoured to be worth 800,000 guilders alone, although the trip only lasted eight days. See I. Groeneweg 'Court and City: Dress in the Age of Frederik Hendrik and Amalia' in KEBLUSEK 1998, pp.201–32.

51 For the adoption of French fashions in the Netherlands, see also GROENEWEG 1995.

52 See E. Gordenker, 'Beyond Fashion Plates. The Clothed Body in Anthony van Dyck's Portraits' in ANTWERP 1999d, pp.25–35.

53 Rapiers A579 and A567 are particularly close, and are on view in showcase E.

54 CASTIGLIONE 1528, pp.57–8.

55 Namely Henri III, Henri IV and Louis XIII. Pluvinel's teachings regarding riding were widely disseminated through the book by the Utrecht artist Crispijn de Passe, *Instruction du Roy en l'exercise de monter à cheval (The King's Instructions for Horse-Riding Drill)*, Paris, 1625.

56 See J. Zilmans, *op. cit.*, pp.44–5.

57 See WASHINGTON 1990–1, pp.124–6, no.17.

58 For further information on this picture, see GENOA 1997, pp.268–9, no.49.

59 See WASHINGTON 1990–1, pp.259–61 and ANTWERP 1999a, pp.257–9, no.71.

60 See VEY 1962, p.288, no.215, fig.264 and BROWN 1991, 230–1, no. 71.

61 It is worth noting that gentleness was another virtue required of Castiglione's perfect courtier; see Castiglione 1528, p.124.

62 This is in the centre of the Averoldi Altarpiece, c.1519–22, comprising scenes of *The Resurrection, The Annunciation, Saint Nazarius and Saint Celsus with Altobello Averoldi* and *Saint Sebastian*, Church of Santi Navarro e Celso, Brescia; see WETHEY 1969–75, I, no.92, pl.72.

63 Michael Jaffé argued thus in his *Burlington Magazine* review of the 1990–1 Washington exhibition.

64 I am grateful to Jan Kosten, Sam Segal and Nigel Taylor for their help in identifying the plant, and for their respective advice as regards its potential meaning.

65 See INGAMELLS 1992, pp.64–6.

66 CASTIGLIONE 1528, pp.60–1.

67 Quoted in E. Gordenker, *op.cit.*, p.25.

68 See MILLAR 1963, pp.96–7, pl.70.

69 CASTIGLIONE 1528, p.55.

70 'Here [on earth] sadness; happiness above [in heaven]'; for a discussion of the development of the coats of arms of Le Roy and his wife, and their respective mottoes, see below.

71 See MACQUOY-HENDRICX 1991, I, p.202, no.168, and II, pl.106. This was attributed to Llomelin by Göpel; see GÖPEL 1940, fig.48.

72 Mentioned in INGAMELLS 1992, p.104; I have been unable to trace this engraving.

73 For GUIFFREY 1882, f.p.134.

74 See figs.113 and 126.

75 Letter dated 18 December 1634; see MAGURN 1955, p.393.

76 See WASHINGTON 1990–1, pp.196–9, no.44 and ANTWERP 1999a, pp.201–2, no.49.

77 INGAMELLS 1992, pp.135–8.

78 This portrait, which also dates from Van Dyck's Second Antwerp Period, shows a member of the de Blois family, the Flemish offshoot of an aristocratic French family of the same name. A Jeanne de Blois married Philippe, duc de Croÿ, and died in 1585, but there is no record, other than the portrait, of Van Dyck's sitter. She was obviously of sufficient importance, however, for her portrait, engraved after Van Dyck by Pieter de Jode, to number among the few female sitters in one of the later editions of *The Iconography*; see SMITH, no.497; CUST 1900, p.253, no.13; GLÜCK 1931, no.425; MACQUOY-HENDRICX 1991, I, p.164, no.103 and II, pl.63.

79 Amalia van Solms's interest in clothes was so notorious that Constantijn Huygens produced the following anagram on her name: 'aime les modes', or 'she loves fashion'. For a full catalogue description of this picture and an explanation of the dating of the different versions, see THE HAGUE 1997–8, pp.118–23, no.6b.

80 See GROENEWEG 1995 and I. Groeneweg, *op. cit.*, in KEBLUSEK 1998.

81 See J.M. Muller, 'The quality of Grace in the Art of Anthony van Dyck', in WASHINGTON 1990–1, pp.26–36, especially p.33.

82 Pinacoteca di Brera, Milan, *Portrait of a Lady*, formerly identified as Amalia of Solms, Princess of Orange.

83 Similar rings are illustrated and discussed in LEUVEN 1998, pp.44–5, nos.40–2.

84 See Groeneweg, *op.cit*, in THE HAGUE 1997–8, especially pp.205–6.

85 Quoted in VEY 1960, p.195.

86 For the alternative dating of this picture to the beginning of the 1630s or to c.1639 see WHITE 1987, p.242 and JAFFÉ 1989, p.375, no.1400.

87 1542, Gemäldegalerie, Berlin; see WETHEY 1969–75, II, no.101, pls.106–8, 110 and colour plate.

88 A portrait attributed to a follower of Van Dyck and said to depict another son of Jacques Le Roy, Baron Arnould Le Roy, was sold at Sotheby's New York, 15 February 1973, lot 34. This identification would seem to be apocryphal, as Jacques is not recorded as having a son of this name, and it was only Philippe and his descendants who were created Barons of the Holy Roman Empire; see DE RAADT 1891, pp.26–7.

89 See GASKELL 1989, pp.122–5.

90 See GÖPEL 1940, p.43.

91 For a detailed look at the history of the *tabaard* in the seventeenth century, see DE WINKEL 1995.

92 See H. de Schepper, *op. cit.*, in DUARLOO 1998, p.223, fig.1 and 226.

93 CASTIGLIONE 1528, pp.141–2.

94 The print illustrated is from the British Museum and bears an inscription identifying Philippe as 'EQVES' or knight, a distinction he did not officially hold until 1647; for the history of the print and its varying states see MACQUOY-HENDRICX 1991, I, pp.118–9, no.C, pl.17 and ANTWERP 1999c, pp.132–5, no.13.

95 See VEY, *op.cit.*

96 For Philippe Le Roy's involvement with the Maagdenhuis, see VERHELST 1996, pp.72–6 & 96.

97 MAGURN 1955, p.185.

98 The monument includes Philippe's coat of arms yet his right to a coat of arms (and the title *chevalier* or knight) was only confirmed in 1647. The monument was obviously conceived with the coat of arms included from the outset, so it would seem logical to conclude that it was installed after 1647 to commemorate his earlier patronage of the institution.

99 For more information on the local Flemish sculptor Huybrecht van den Eynde (1594–1661) see VLIEGHE 1998, p.241.

100 'Sculpted on the wall here is the perfect copy after the antique/ The coinage symbol of a Roman princess/ In maiden aid so generous that she herself as mistress/ Erected a building, to provide for maidens.// If she to heathen people was so true/ What more honour and praise is due to our patrons/ And praise even more the Mother of God who is our advocate/ And the advocate of those who father-like have helped to build this house.// Say hail Mary may you keep your children safe/ Praise thee in whose honour this house here is built/ And like Faustina, be mindful of the poor.// Let every man extend his hand according to his power/ So that you may live in peace in the Father's heaven/ Oh, for the love of God, take mercy on these children'.

101 For a more detailed history of Van Diepenbeck's window see ANTWERP 1996, pp.78–81, no.19.

102 DE RAADT 1891, p.48.

103 *Ibid*, p.46.

104 See JONES 1997, pp.214–20.

105 For the unreliability of the Brussels government as paymasters see, for example, H. de Schepper, *op.cit.*, p.224 in DUARLOO 1998.

106 POELHEKKE 1948, p.119, 376–7.

107 For the history of Broechem see DE RAADT 1889 and ARREN 1986.

108 For the peace negotiations between the Northern and Southern Netherlands see ISRAEL 1982, pp.347–74; for the role of Philippe Le Roy in particular, see POELHEKKE 1948, especially pp.376–84, 386–8, and 445–9.

109 These are quoted in full in DE RAADT 1891, pp.36–7.

110 Granted on 21 January 1647 by the Emperor Ferdinand III.

111 *Argent a bend gules*: a red diagonal band on a silver background.

112 *Gules, etoile d'or à dextre et un croissant tourné du même à sen; en chef d'argent chargé de deux croisettes pattées de gules*: The bottom half red with a gold star on the left and a gold crescent facing toward the star; the top half silver with two red crosses of Lorraine. For a detailed description of Le Roy's armorial achievement, see DE RAADT 1891, pp.7–10, 37–9.

113 See INGAMELLS 1992, pp. 112 and 458 and THE HAGUE 1998.

114 See INGAMELLS 1992, pp.258–9 and MÜNSTER 1998, pp.122–5.

115 From a larger extract quoted in DE RAADT 1891, pp.38–9.

116 *Ibid*, p.41.

117 I would like to thank Mr Harlinghausen for alerting me to this fact.

118 One such engraving, derived from Van Hulle and Pontius (in reverse), published by P. Aubry for a series again entitled *Pacificatores,* is in the British Museum.

119 He was allowed to replace the *bourrelet* (twisted band) on his knight's *casque* (helm) with a golden crown surmounted with *lambrequins* (wings) in *argent* and *gules* and a double cross of Lorraine in *gules*; the whole flanked with *aisles* (attachments) of silver edged in red, and supported by two Swiss Guards carrying pikes with pennants: see DE RAADT 1891, *idem.* An example of

120 the first state of the engraving is in the Rijksmuseum, Amsterdam; see ANTWERP 1999c, p.135, fig.6.

120 Juan de Horozco y Ovarrubias, *Emblemas Morales*, Segovia, 1589, II, no.4: two angels holding a crown below which is the motto 'SERVIRE DEO REGNARE EST'. I would like to thank Dr Horst Vey for bringing this discovery by Professor Jutta Seyfarth of Cologne to my attention.

121 CASTIGLIONE 1528, pp.284–5.

122 See, for instance, MADRID 1993, p.205, no.196, or p.259, no.262a.

123 Seen on the title page of D. Teniers, *Theatrum pictorium*, 2nd ed., Antwerp, 1684; I wish to thank Professor Luc Duarloo for this identification. Some of Teniers' oil sketches made in preparation for the *Theatrum pictorium* can be seen in Galleries 18 and 19 of the Wallace Collection, and his painting of Archduke Leopold's successor as Governor of the Spanish Netherlands, *Don Juan of Austria's Triumphal Entry into Brussels in 1656,* is also on view in Gallery 18.

124 For architecture in Flanders in the seventeenth century, see VLIEGHE 1998, especially pp.270–1.

125 See LE ROY 1678, pp.171–91, especially the engraving of the monument by R. Collin facing p.180 (also reproduced here, fig.69).

126 The picture is now in the Church of the Zwartsusters, Antwerp, see LIER 1986, pp.195–7, no.70, and p.194, fig.70. The Le Roys also donated an unidentified painting bearing their arms to the Church of Saint Augustine in Antwerp, noted in DE RAADT 1891, p.48, the present whereabouts of which are unknown.

127 See MACQUOY-HENDRICX 1991, I, pp.167–8, no.112, II, pl.68.

128 See NIEUWDORP 1969, pp.95–8, nos.28–9, figs.4.3 & 4.4, and VAN LOON 1732, II, pp.294–5.

129 For the first motto see note 120 above; the second 'MAIS LE ROY S'ESIOVIRA EN DIEV PS LXII' refers to the first line of Psalm 62: 'Truly my soul waiteth upon God'. 'S'ESIOVIRA' is either a corruption of 's'esquira en ', meaning 'waits upon' or 's'esjouira en', meaning 'delights in'. 'LE ROY' is thus a pun referring both to King David, who wrote the Psalms, and to Philippe Le Roy himself.

130 See H. Oursel et al., exh. cat., *Donation Antoine Brasseur*, Musée des Beaux-Arts, Lille, 1981, pp.65–66, no.35.

131 For Victor Boucquet's place in Flemish art of the period, see VLIEGHE 1998, pp.104 and 144.

132 For comparison see a *Portrait of an Officer* in the Musées Royaux des Beaux-Arts de Belgique, Brussels and a *Portrait of a Standard Bearer* in the Louvre.

133 For extracts of the letters patent see LE ROY 1699, p.71.

134 Included in LE ROY 1678, between pp.180–1; the design for the companion monument to Jacques Le Roy's first wife and child, who died in 1668 and 1667 respectively, drawn by Diepenbeck and engraved by Collin in 1670, is included in the same volume,

between pp.186–7. Their monument stands opposite that of Le Roy and his wife in Broechem Parish church.

135 'HERE BEFORE THE ALTAR KNEELS THE NOBLEMAN PHILIPPE LE ROY, KNIGHT BANNERET, LORD OF BROUCHEM, EULEGHEM AND IN S. LAMBERT. OF THE COLLATERAL COUNCIL AND ADVISER OF DOMAINES AND FINANCES TO HIS MAJESTY SUPERINTENDENT OF CONTRIBUTIONS OF FRANCE [*sic*-should read 'finance'] AND GENERAL SUPPLIER TO HIS ARMIES: SON OF JACQUES, CHANCELLOR LORD OF HERBAIX, PRESIDENT OF THE ROYAL ACCOUNTING CHAMBER OF BRABANT, AND OF THE NOBLE LADY ISABEL HOFF DAUGHTER OF JACQUES AND GRANDDAUGHTER OF MARC HOFF CHANCELLOR GOVERNOR OF FREIBOURG IN BREISGAU; WHO FOR 50 YEARS SERVED THE MOST AUGUST HOUSE OF AUSTRIA IN MANY EMPLOYMENTS AS MANY MILITARY AS POLITI-CAL. FIRSTLY THE EMPEROR MATHIAS IN HIS COURT AT PRAGUE, AND IN THIS COUNTRY THE SERENE ARCH-DUKES ALBERT AND ISABELLA AND AFTER THEM THE MOST EXALTED AND ALL POWERFUL MONARCH PHILIP IV. KING OF SPAIN AND THE INDIES WHO SENT HIM AS ENVOY TO THE HAGUE IN 1646 WITH FULL POWERS TO THE ESTATES GENERAL OF THE UNITED PROVINCES IN ORDER TO ADVANCE THE PEACE WHICH WAS DRAG-GING OUT AT MUNSTER. HAPPILY HE SUCCEEDED IN THE YEAR 1648 FOR WHICH HE WAS HONOURABLY REMU-NERATED BY THE KING, AND ALSO BY THE EMPEROR AND ALL THE STATES OF THE EMPIRE FOR THE PART THAT HE PLAYED IN THIS PEACE TREATY SO THAT HE OF HIS OWN ACCORD MADE HIM AND ALL HIS CHILDREN BARONS AND BARONESSES OF THE SELF SAME EMPIRE, WHICH HIS CATHOLIC MAJESTY WAS PLEASED TO APPROVE AND CONFIRM: MEDITATING ON THIS HE RETIRED FROM AFFAIRS AND LEFT THE COURT, CEDING HIS DUTIES TO HIS ELDEST SON AND CHOOSING THIS GOOD LAND TO FINISH THE REST OF HIS DAYS. HE DIED THE [Left blank, as the engraving was produced during Le Roy's lifetime] AND TO THE NOBLE AND MOST VIRTUOUS LADY MARIE DE RAET HIS WIFE LADY OF THE AFOREMEN-TIONED WHO PASSED AWAY THE 20 AUGUST 1662 AGED 48. MAY GOD REST THEIR SOULS'.

136 On the left: 'THE LAVISH CONSTRUCTION OF MONU-MENTS IS THE CONSOLATION OF THE LIVING.' Aug. Serm.14 [from the Sermons of Augustine?; I have been unable to trace the exact reference]; 'AND FOR THE YOUNG AN EXCELLENT SPUR TO VIRTUE.' Polyb. [Polybius].
In the centre: 'ON THE OTHER HAND, HE HAS BUILT ABOVE HIS GRAVE, WHEN ONE SEES THE POLISHED STONE, A MONUMENT WITH ARMS ABOVE THE COLUMNS, TO HIS ETERNAL MEMORY' Mach. L.1.c.13 [Referring to Macabees I, chapt.13, lines 27 and 29].

On the right: 'LOYALTY IN FRIENDSHIP IS SO RARE AND THE DEAD SO EASILY FORGOTTEN THAT WE OUGHT TO SET UP OUR OWN MONUMENTS' Plin. L.6.ep.10 [Pliny's Letters].

137 And bears a slightly shorter inscription, where it is implied that Le Roy retired from public life soon after 1648.

138 MACQUOY-HENDRICX 1991, I, pp.118–9, no.C, II, pl.18.

139 This was written by Constantijn Huygens (1596–1687; poet, composer, and diplomat at the Court of Frederick of Orange and Amalia van Solms) for Van Dyck's *Iconography*, in which Huygens himself was represented by a print by Pontius; see *De gedichten van Constantijn Huygens, naar zijn handschriften uitgegeven*, J.A. Worp ed., IX, Groningen, 1892–1899; and MACQUOY-HENDRICX 1991, I, p.138, no.53, II, pl.36.

III

'Truly a genius for history-painting', Reynolds[1]
An Artistic Dilemma: The Shepherd Paris

So much for the wish-fulfilment on canvas of his clients' ambitions, but what of Van Dyck's own artistic aspirations? Already, in his earliest works Van Dyck had clearly demonstrated his desire to be a great history-painter. His youthful creations were impressively inventive, many surviving drawings attesting to their careful preparation.[2] Consequently, according to Bellori, 'it occurred to Rubens that his disciple was well on the way to usurping his fame as an artist, and that in a brief space of time his reputation would be placed in doubt. And so, being very astute, he took his opportunity from the fact that Anthony had painted several portraits, and, praising them enthusiastically, proposed him in his place to anyone who came to ask for such pictures, in order to take him away from history painting'.[3] To be praised as a portraitist was effectively to be denigrated as a painter of history or narrative pictures at a time when portraiture was always considered the lesser genre. According to the humanist theory of painting it was only in history painting, depicting scenes from legend and literature, both sacred and profane, that painting could hope to rival or surpass the profound and morally edifying effects of poetry.[4] The Shepherd Paris is one of only a few surviving secular narrative works by the artist. Not surprisingly this aspect of Van Dyck's work is less well known: out of one hundred and five paintings on show in Antwerp and at the Royal Academy this year only four depict non-religious historical subjects. Yet among this select group number some of Van Dyck's greatest artistic achievements, including the delectable *Amaryllis and Myrtillo* (1631–2; Pommersfelden),[5] and the stunning *Cupid and Psyche* (1638–40, Royal Collection).[6]

Van Dyck's ambition as a painter of historical subjects was as great as his talent, and throughout his life he made conscious attempts to further this aspect of his career. His first commission for Charles I was a history painting,[7] and Van Dyck obviously hoped that the artistic prince would continue to order similar works, thus enabling him to rival Rubens on the international stage. Instead, like Gainsborough after him, Van Dyck was doomed by his own special talent and early renown to paint mostly portraits. His lavish lifestyle tied him even more firmly to the lucrative trade of capturing people's likenesses, while ironically his frustrated wider ambitions probably fuelled the inventive brilliance of his portraits, making them all the more popular. Yet, as Bellori states, even towards the end of his life: 'he hoped to dedicate himself to a more tranquil type of work, far removed from the business of the court, which would bring him both honour and profit and thus leave a record and memorial of his talents for posterity'. To this end he planned a series of contemporary allegorical tapestries for Whitehall, clearly intended to rival Rubens' ceiling designs in the same palace.[8] Unfortunately, 'the price seemed excessive to King Charles, but the problem would have been resolved if the death of Van Dyck had not

Fig.73
Van Dyck, *The Shepherd Paris*, detail, c.1628, The Wallace Collection

79

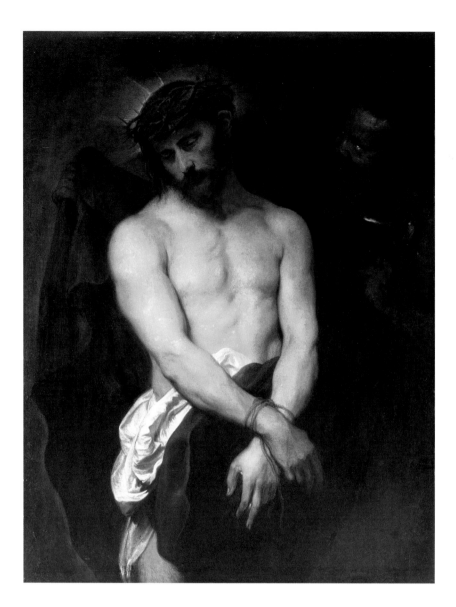

Fig. 74
Van Dyck, *Ecce Homo*, c. 1625–6, The Barber
Institute of Fine Arts, University of
Birmingham

It is a mark of the ambiguous nature of *The Shepherd Paris* that both its subject and date
have been argued over for generations. John Smith, writing in 1831, inadvertently dated
the picture to the Second Antwerp Period by describing it as a self-portrait, in the guise
of Paris, painted 'when about twenty-seven years of age'.[19] At the turn of the century
the art historian Lionel Cust re-dated it to the Italian period, 1621–7, noting in particu-
lar the plasticity of the human form which in his eyes made Van Dyck 'the Donatello of
Painting'.[20] Following Cust's example, the earliest catalogues of the Wallace Collection
described the picture as a self-portrait painted in Italy. Generally, however, the picture
has been seen as a product of the Caroline court, because of its Arcadian subject matter,
and dated to Van Dyck's second English period, c. 1632, by authorities such as Glück,
Larsen and Ingamells. Its identification as a self-portrait has also been rejected by most
commentators.[21] The recent exhibitions on Van Dyck's work in Washington (1990–1) and
Genoa (1997) led to further re-evaluations of the chronology of the artist's *oeuvre*. The
Wallace Collection, however, was unable to lend its pictures, which were consequently
largely ignored by the exhibition organisers and their public. Sir Olivar Millar, however,

in a review of the Genoa exhibition, noted the similarity of the head of *Paris* to Van Dyck's *Saint John the Baptist* (Los Angeles Museum of Art), suggesting that, after all, 'perhaps that puzzling work [Paris] may have been painted in Genoa or very soon after Van Dyck had returned to Flanders'.[22]

In fact, if we turn to examine Van Dyck's work produced in Italy, between 1621–7, we find more than a passing resemblance to *The Shepherd Paris*. Indeed there is a disturbing similarity between the intense religious imagery of the Italian period, especially that which focuses upon the inner torment of a single male figure, be it Christ or Saint Sebastian, and the treatment of the profane subject of *Paris*. The *Ecce Homo* (fig.74) is a prime example of the way in which Van Dyck concentrates our attention, even in a history painting, upon the subject and his psychological state.[23] Our gaze is transfixed by the pale three-quarter-length figure imprisoned in a shallow space against a flat dark background. The semi-naked body increases the sense of vulnerability and essential humanity: Christ and Paris are real people, and we sympathise with them as such. We can read the subjects' emotional stories in their skilfully posed bodies: Christ's head and arms hang heavy in a pose of resigned martyrdom, while Paris, as we shall see, betrays his doomed effeminate nature with the gesture of an arm, and his desire with parted lips and intoxicated gaze (fig.76). Both torsos display a surprising sense of monumentality. Rather than the svelte classical ideal of the young male body as seen in works such as the *Apollo Belvedere*, both

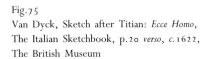

Fig.75
Van Dyck, Sketch after Titian: *Ecce Homo*,
The Italian Sketchbook, p.20 *verso*, c.1622,
The British Museum

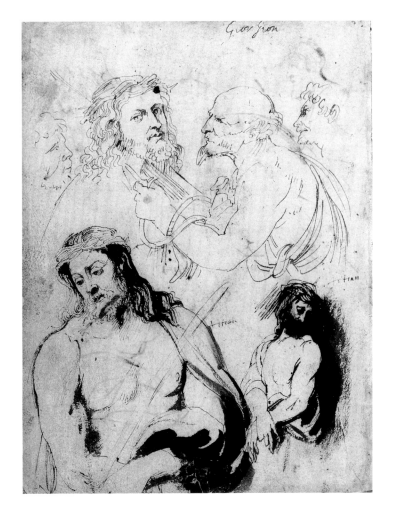

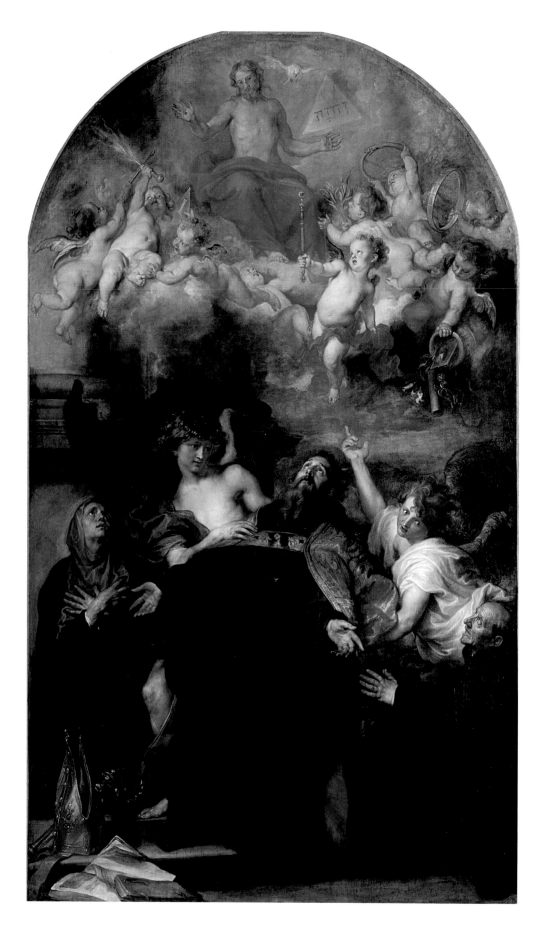

Fig. 80
Van Dyck, *Saint Augustine in Ecstasy*, 1628,
Koninklijk Museum voor Schone Kunsten,
Antwerp, on loan from the Augustijnenkerk

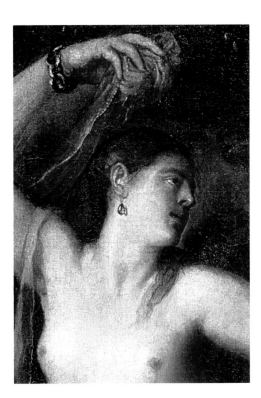

links *The Shepherd Paris* to the smaller devotional works of the early-mid 1620s, but the physical evidence provided by the painting itself implies a later date. Firstly, it does not appear to be painted on the fine canvas Van Dyck habitually used in Italy. Secondly, the tonality is cooler than the majority of his Italian works: gone are the dramatic reds, and in their place we see a silvery palette more characteristic of the paintings Van Dyck produced in Antwerp on his return from Italy. We can compare, for instance, *The Shepherd Paris* with the central angel in *Saint Augustine in Ecstasy* (fig.80), which was painted in 1628 for the Augustinians of Antwerp. The two figures share the same silvery flesh and dramatic blue drapery allied to a plasticity of form which became less evident in the works produced later in England. Thirdly, the way the paint is actually applied to the canvas in *The Shepherd Paris* differs from the majority of the works painted in Italy. This difference is made clear through a comparison of the treatment of the flesh (fig.73) with that of the *Ecce Homo* (fig.74). In the latter Van Dyck was clearly experimenting with the dry dragged surface effects obtained by Titian, whose approach in turn can be seen in a detail from Titian's *Perseus and Andromeda,* which once belonged to Van Dyck himself and is now on view in Gallery 22 of the Wallace Collection (fig.81).[30] Boschini is right to imagine Van Dyck looking at Titian's work and exclaiming: 'This is a mixture of flesh that can be moulded'.[31] Nevertheless Van Dyck's style in *The Shepherd Paris* is smoother still. He has tempered his earlier emulation of Titian's use of paint with something of the oily quality evident in Rubens' smooth surfaces. Yet the detail of Rubens' *Christ's Charge to Peter*, which can be seen in Gallery 22 (fig.82),[32] shows how Rubens, unlike Van Dyck, also gave form to flesh with contrasting colours which can be easily distinguished: blue-grey shadows, the pink mid-ground, lighter highlights and red reflected shadows. In *The Shepherd Paris* the flesh tones are both painted on very smoothly to efface virtually all texture, and painted in, or blended, very smoothly from the light tones to the darker shadows, hiding all such

Fig.86
Rubens, *The Judgement of Paris*, 1631–35, oil
on panel, The National Gallery, London

protection, carried off Helen, the wife of King Menelaus of Sparta, thus precipitating the Trojan War. In the ensuing struggle, Minerva and Juno proved implacable enemies of Troy, and the city was indeed destroyed as foretold before Paris's birth.

Many classical authors, including Euripides, Pausanias, Apuleius, Ovid and Lucian touch upon the story of Paris's fateful judgement.[37] In medieval times the story was reinterpreted according to an account by the late-classical author Dares Phrygius, *De excidio Troia*, who envisaged the whole incident as a dream; such an approach was more acceptable to the fledgling dynasties of Europe, including the French, who were in the habit of tracing their ancestry back to the Trojans. By the time of the Renaissance, and the work of writers like Marsilio Ficino, the story of *The Judgement of Paris* was seen in humanist terms as a parable of the dangers and responsibilities of choice. This aspect of the tale had already been wittily underlined by Apuleius when his hero Lucius exclaimed: 'are you really surprised that modern judges are so corrupt, when here you have proof that in the earliest ages of mankind, in this first court-of-law ever convened, the simple shepherd, who had been appointed by Jupiter himself to give judgement in a question that was troubling heaven and earth, succumbed to a barefaced sexual bribe (which was to prove the ruin of his entire family) and sold his verdict in open court?'.[38] But for artists, Paris's choice of Venus, or Beauty, could hardly be seen as an entirely negative choice. This is made clear in a famous Renaissance depiction of *The Judgement of Paris*; Raimondi's engraving after Raphael (fig.85). Paris, identifiable in his Phrygian hat, sits on the left and offers the golden apple to Venus. While the cosmic nature of Paris's decision is emphasised by the presence of the gods who control man's destiny, the inscription at the bottom left stresses that 'Before Beauty, wit, virtue, kingdoms and gold seem worthless'.

The subject, with its parallel themes of artistic and moral judgement, was bound to appeal to a man with Rubens' interests, and there are no less than six known paintings by Rubens on the same theme; the earliest dates to before his departure for Italy in 1601 (National Gallery, London), and the last was painted for Philip IV in 1639, the year before Rubens' death (Prado, Madrid). Indeed an entire book has recently been dedicated to Rubens' fascination with the story.[39] A late picture in the National Gallery, c.1631–5, is typical of Rubens' grand epic manner (fig.86). Paris, seated, as in the Raimondi print, proffers the golden apple to Venus who returns his rapt gaze. All the elements of the narrative are skilfully woven into this one visual image: Mercury, the messenger, stands behind Paris; Eris hovers in the sky; each goddess is identified by her attributes (Minerva by her Gorgon shield; Venus by the rose in her hair and the presence of Cupid; Juno by her peacock) and the whole is set in a pastoral landscape appropriate to the location of the story. By making the goddesses as desirable as possible, Rubens emphasises the difficulty of Paris's decision while the landscape, which looks suspiciously like Rubens' vision of his beloved Flanders,[40] gives the picture a contemporary resonance. Rubens' picture has since been interpreted as a parable of man's responsibility for decision-making in contemporary society; the viewer is thus invited, through the artist's brilliant imagery, to reflect upon the broader implications of the narrative.

Van Dyck's earliest known interpretation of the subject is seen in a drawing in the Museum Fodor in Amsterdam (fig.87),[41] where Paris is shown, quite conventionally, accompanied by Mercury, assessing the beauty of the three goddesses who stand before him. The idea of separating the goddesses from Paris may have occurred first to Rubens. An intriguing page of the Antwerp sketchbook contains two inserted drawings by an unidentified hand which separately depict Paris with the apple, and a standing female nude, which we can identify as a study for Minerva after Raimondi's print (fig.88).[42]

Fig.87
Van Dyck, *The Judgement of Paris*, black chalk, pen and brown ink, Museum Fodor, Amsterdam

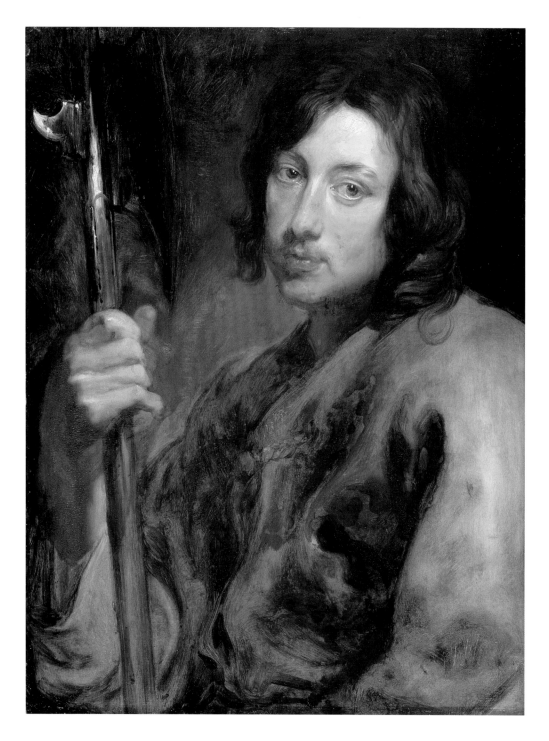

Fig.91
Van Dyck, *St Matthew*, 1618, photo courtesy
of Colnaghi's

Van Dyck the artist thus identified with Paris, the arbiter of Beauty. But this self-identification may have run even deeper. In the *Iliad* Homer describes the Trojan prince as 'Paris, appalling Paris! Our Prince of beauty mad for women'.[47] Van Dyck's personal vanity has already been remarked upon, and his biography is peppered with amorous anecdotes. In history painting he was constantly drawn to lyrical themes involving love. Karel van Mander used the story of Paris as a warning to young artists who might be lured into unsuitable attachments by the fatal power of beauty.[48] Van Dyck's early biographers implied that he revealed an early tendency to be thus distracted so it is not surprising that

Fig.92
Van Dyck, *Paris*, black and white chalk on
light brown paper, photo courtesy of
Christie's

he empathised with Paris's dilemma. There is an element of Rowland's 'thing of beauty
and a boy forever' in both Van Dyck and Paris's natures.[49]

 So perhaps it is empathy that lies at the root of the peculiar depth with which Van
Dyck invests his characterisation of Paris. He treats the person of Paris as seriously as any
saint. The picture's similarity to the devotional works of the Italian period has already
been noted, but an even earlier precedent for the format and focus on a single male figure
can be seen in the *Heads of the Apostles*, which Van Dyck painted, *c*.1618, in Antwerp
before his departure for Italy. One head, that of *Saint Matthew* (fig.91),[50] bears a certain

recalls those of Venus in Van Dyck's copy of Titian's *Venus at her Toilet* in the Italian Sketchbook (fig.94).[53] Certainly, this approach allows Van Dyck to marry two divergent ideals of Beauty in one image. Despite his broad shoulders, the goddess's beauty, implied in Paris's rapt gaze, has so transfixed the shepherd that he no longer has the strength to hold his staff, which merely balances in the crook of his arm. Indeed the only action is one of looking, whether it be Paris toward the imagined goddesses beyond the canvas, or our own gaze directed at Paris himself. The mood of languorous sensuality Van Dyck evokes lends the scene an odd sense of suspense, of a moment suspended in time, when Paris first savours the beauty before him, the decision momentarily deferred as the golden apple lies forgotten in his palm. The fact that we cannot see the beauty that so enthrals him renders the image yet more compelling; our curiosity is aroused but never satisfied.

This curiosity has led some commentators to try and complete the image by maintaining that Paris must have had a pendant depicting Venus, at whom the admiring shepherd might direct his gaze. In the absence of an appropriate historical canvas, it has been proposed that the *Portrait of Margaret Lemon*, Van Dyck's English mistress, might serve the purpose (fig.95) .[54] The portrait, in the Royal Collection, is now rather damaged and may even have been purchased from the artist's estate unfinished and later completed by another hand.[55] The tempestuous romance between Van Dyck and Margaret Lemon somewhat scandalised contemporaries. Wenzel Hollar described Margaret as 'a dangerous woman, this demon of jealousy who caused the most horrible scenes when Ladies belonging to London society had been sitting without a chaperone to her lover for their portraits and who on one occasion in a fit of hysterics had tried to bite Van Dyck's thumb off, so as to prevent him from ever painting again'.[56] It is amusing to contemplate the union of the fey Paris with such a tartar, but Margaret's portrait was painted many years after *Paris*, which in any case stands quite happily alone as a meditation on art and beauty. Whether it was later twinned with another picture we will probably never know.

Paris: Portrait or Saint?

The success of Van Dyck's ambivalent but intensely personal image of this mythical character is paradoxically reflected in the picture's subsequent misinterpretation. We have seen how the character and predicament of Paris had particular resonance for the artist. From at least the eighteenth century, however, there was an increasing tendency to identify this highly personal image with the artist himself. Quite understandably it was felt that such an idiosyncratic portrayal must mean that the picture was a self-portrait. This is a view that has persisted in some quarters right up to the present day, and it has to be admitted that it lends the picture an extra allure in our eyes. But can we really regard the picture as a self-portrait? Bellori's description of Van Dyck certainly does not accord with the model in the Wallace Collection painting: 'despite his small stature, he was well proportioned, graceful, and handsome, with the typical pale skin and fair hair of his native climate'.[57] We can also examine the appearance of the artist as he appears in the self-portraits he produced throughout his career.[58] We have already seen what Van Dyck looked like as a teenager (figs.5 and 6), and this catalogue opens with Van Dyck's self-portrait etching which shows a man thinner-faced than Paris (fig.1). As a young man in

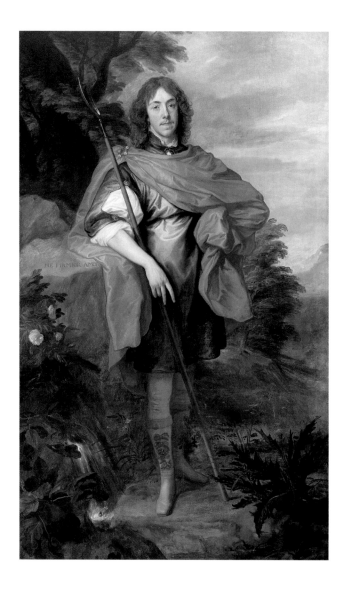

his mid-twenties in Italy, Van Dyck cut a more robust figure (fig.96),[59] and with his fuller face, Van Dyck, as depicted in the Hermitage picture, comes closer than in any other self-portrait to the image of Paris, although his reddish curls and longer face and neck clearly mark him appart.

Van Dyck's increasing use in England of the *portrait historié*, or portrait of a sitter in the guise of a mythical character, has been used as a further argument for treating *Paris* as a self-portrait, and for dating it to this later period. The *Portrait of James Stuart, Duke of Lennox and Richmond* holding a yellow fruit, which looks suspiciously like a common lemon or orange, is traditionally described as a portrait of the sitter in the guise of Paris (fig.97). Pastoral subject matter is again to the fore in a series of portraits Van Dyck produced of prominent members of the Caroline court in the guise of shepherds and shepherdesses, such as the *Portrait of Lord George Stuart, the 9th Seigneur d'Aubigny* (fig.98).[60] While Richmond and D'Aubigny are portrayed in the relatively informal attire of Van Dyck's more imaginative English portraits, they do not transgress the bounds of propriety by appearing semi-naked, and it is unlikely that the image-conscious Van Dyck would have done so either. The intensity of Paris also seems entirely out of place in the company

above right: Fig.97
Van Dyck, *Portrait of James Stuart, Duke of Lennox and Richmond, as Paris*, c.1634, The Louvre, Paris

above left: Fig.98
Van Dyck, *Portrait of Lord George Stuart, the 9th Seigneur d'Aubigny*, 1638, National Portrait Gallery, London

of these colourful courtiers, as does the heavy sculptural modelling of his torso and drapery which is stylistically far removed from the flatter and more superficially elegant figures of the two Stuarts.

Nevertheless the myth of *Paris* as self-portrait gathered momentum in the eighteenth century. This is hardly surprising, perhaps, when images such as Alexander Bannerman's etching and engraving after Van Dyck were current (fig.99). Bannerman's print is based upon a portrait, now in Munich, which was then in Walpole's collection, and which depicts the artist's head in the same pose as in the Hermitage picture. One has only to compare the engraving with the Hermitage picture (fig.96) to see what a travesty Bannerman made of Van Dyck's image; without the benefit of Van Dyck's colouring, there is then indeed a resemblance between the head in Bannerman's engraving and that in the engraving of *Vandyk, as Paris*, made by Schiavonetti in 1807 when the picture was in the Hope Collection (fig.100).

The wider dissemination of Van Dyck's image through Schiavonetti's engraving, and the essential ambiguity of the image itself, are probably responsible for an even more

below left: Fig.99
Alexander Bannerman after Van Dyck, *Portrait of Van Dyck*, engraving, Courtauld Institute of Art, London

below right: Fig.100
Luigi Schiavonetti, *Vandyck, as Paris*, engraving, 1807, Ashmolean Museum, Oxford

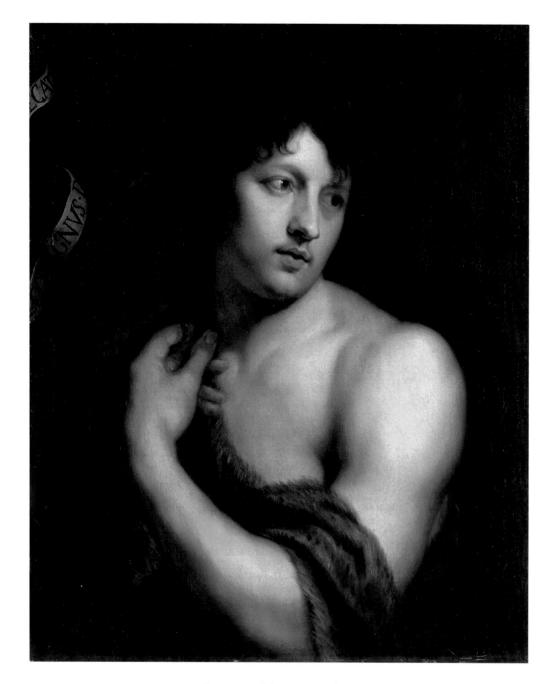

imaginative misinterpretation of Van Dyck's picture, for on at least two occasions *Paris* was converted into *Saint John the Baptist* (fig. 101).[61] This transfiguration was effected quite simply by replacing Paris's silken drapery with a rough animal pelt, and his shepherd's staff with a Cross, complete with holy banner proclaiming the coming of Christ. Whether a profane image of beauty and desire or a sacred image of annunciation, Van Dyck's figure retained its contemplative mystery.

Conclusion

Bellori maintained that Van Dyck 'won the greatest praise for his portraits, in which he was unrivalled, and sometimes he was marvellous as Titian himself. In history painting,

however, he did not show himself so accomplished and steady in design, nor were his basic conceptions altogether satisfactory, so that in this and other respects he lacked the qualities needed for devising elaborate compositions'.[62] Yet a detailed examination of Van Dyck's *Paris* shows how truly original Van Dyck's approach to history painting could be, a fact sometimes lost on his near contemporaries. The relatively small number of known history paintings by Van Dyck led to unfamiliarity with, and sometimes incomprehension of the Van Dyckian idiom, concerned as it so often is with interior rather than exterior drama. Roger de Piles was right in his judgement that Van Dyck was less minded to be a scholar than Rubens, but the idiosyncratic portrayal of Paris in many ways brings us closer to the human essence at the centre of the myth than does Rubens' more dramatic and classically accurate narrative. Despite Bellori's comments, Van Dyck's painting reveals an artist as sensitive to visual *Poesie* as Titian himself.[63] Many writers, starting with Bellori, have characterised grace as the essential quality of Van Dyck's art.[64] Yet, as Castiglione pointed out, for grace to exist one must be unaware of its existence. For this reason Van Dyck deliberately concealed his artistry behind a seeming nonchalance of technique and interpretation. So successful are Van Dyck's resulting images that we will never know how hard he had to work to achieve these aims. We have already seen the success of this approach in Van Dyck's portraits, whereby the viewer attains a far more immediate connection with the sitter. In his history paintings, however, the nature of Van Dyck's achievement is less clear. One takes for granted the natural brilliance of execution and seemingly straightforward interpretation, and one is still unaccountably moved. The apparent simplicity of approach brings a new emotional depth to the tale, akin to the affecting, but not always explicable power of poetry. For, in paring down the story and loosening the bond between subject and dramatic narrative, Van Dyck prompts the viewer's curiosity and imagination.[65] We are thus all involved in this essentially human dilemma of desire, choice and consequence, and so feel closer to the artist himself, for whom the subject would have had both personal and professional resonance. There are few better visual testimonies to a great artist's originality than this enigmatic meditation upon the power of art and beauty.

1 Quoted in Reynolds' *Journal* of his travels through Flanders and Holland, see MOUNT 1996, p.24.

2 See C. Brown, 'Van Dyck as a Draughtsman', in BROWN 1991.

3 BELLORI 1672, p.17.

4 See LEE 1967.

5 See ANTWERP 1999a, pp.232–3, no.62 and WASHINGTON 1990–1, pp.239–42, no.60.

6 See ANTWERP 1999a, pp.326–9, no.100 and WASHINGTON 1990–1, pp.316–9, no.85.

7 The *Rinaldo and Armida,* painted in 1629, now at the Baltimore Museum of Art; see fig.84, and below.

8 'The individual compositions and the general theme were related to the election of the King, the institution of the Order of the Garter by Edward III, the procession of the knights in their robes and the civil and military ceremonies, and other royal functions'. See BELLORI 1672, p.21–2.

9 The price asked was three thousand scudi; *ibid.*

10 BELLORI 1672, p.22. For a comparison between Poussin and Van Dyck's work, see Poussin's *Dance to the Music of Time, c.*1632, in Gallery 22 of the Wallace Collection.

11 In whose collection it was seen by DESCAMPS 1753–4, II, p.23.

12 The picture was in Hope's collection when engraved by Schiavonetti.

13 According to an invoice from W. & P. Evans in the Wallace Collection archives. Evans was also responsible for providing many of the frames in the Wallace Collection.

14 Cited by M. Jaffé in 'Anthony van Dyck' in *The Dictionary of Art,* ed. J. Turner, Vol.9, London, 1996, p.486.

15 GLÜCK 1931, p.558, and illustrated in *Les Arts*, October 1909, p.6.

16 According to a letter on file at the Wallace Collection.

17 The Dhikeos Collection has recently been dispersed in the sale-rooms, and the present location of this version is unknown.

18 Royal Academy, 1825, no.454; the original identified as in the collection of Lord Hertford. Bone was granted permission on other occasions to copy works from the collection; for instance a copy of *A Boy in Fanciful Costume,* then thought to be by Rembrandt (INGAMELLS 1992, p.295–6), was recently brought to my attention, and a copy of Lawrence's portrait of the 3rd Marquess of Hertford now belongs to the Library of Hertford House; see REYNOLDS 1980, no.MA3, pp.343–4 and fig.118 below.

19 SMITH 1829–42, III, p.102, no.359.

20 Van Dyck was in Italy 1621–7; see CUST 1900, pp.45–6 and the *CHRONOLOGY* in chapter VI.

21 The beginning of the English period, *c.*1632, seems to be the most popular date; see for example INGAMELLS 1992, pp.104–6.

22 See MILLAR 1997, p.502 and GENOA 1997, no.68, pp.332–3. This attribution of the Los Angeles picture was, however, doubted by J. Douglas Stuart in a review of the same exhibition who noted its similarity to 'Stanzione's signed picture of the same subject in the De Vita Collection, Naples'; see *Apollo*, July 1997, p.53.

23 For more information on the *Ecce Homo,* see GENOA 1997, pp.320–1, no.67. Similar comparisons might be made with other depictions of *Ecce Homo* by Van Dyck such as the example, *c.*1622–5, in the Courtauld Institute.

24 *La Carta del Navegar Pitoresco*; extract quoted in J.M. Muller, 'The Quality of Grace in the Art of Anthony Van Dyck', WASHINGTON 1990–1, p.27.

25 For Van Dyck's Italian Sketchbook see ADRIANI 1940 and Brown, *op.cit.*, pp.30–4.

26 *Ibid*, pp.37, 20v.

27 The original painting by Titian is now lost, but works on the same subject by the artist can be seen in WETHEY 1969–75, I, nos.33–4, pls.98–100.

28 Titian's original was unknown to Van Dyck as it was in Spain when he was in Italy. It was engraved by Martin Rota and Van Dyck probably also knew of the picture from a painted copy (such as the one now in Modena), for the similiarity in colouring of Christ's clothing in both pictures seems too great to be a coincidence; see GENOA 1997, pp.324–5, no.69 and ANTWERP 1999a, pp.178–9, no.38. Van Dyck also seems to have been inspired by Titian's composition for the motif of the servant handing Christ the Palm of Martyrdom found in Van Dyck's *Ecce Homo* now in Princeton.

29 Although Brown dates the drawing 1635-7, see BROWN 1991, pp.259–61, no.82.

30 See INGAMELLS 1985, pp.349–60.

31 J.M. Muller, *ibid.*

32 INGAMELLS 1992, pp.317–20.

33 BELLORI 1672, p.22.

34 See H. Vleighe, 'Images of Piety and Vanity: Van Dyck in the Southern Netherlands 1627–32, 1634–5, 1640–1', in ANTWERP 1999a, pp.67–6, fig.48.

35 For further information on the *Rinaldo and Armida* see WASHINGTON 1990–1, pp.221–3, no.54.

36 BELLORI 1672, p.22.

37 Euripides, *Iphigenia at Aulis*, 1302, 1298; Pausanias, *Travels round Greece*, v, 19, 1; Apuleius, *The Golden Ass*, x; Ovid, *Heroides*, v, xvi, xvii; Lucian, *Dialogi Decorum*, xx. This last work is by far the most elaborate account and was well known in the Renaissance.

38 Apuleius, *The Golden Ass*, R. Graves trans., London, 1950, pp.265–6.

39 In her fascinating book Fiona Healey traces the background of the subject, its cultural and artistic significance in the age of Rubens, and how the artist re-interpreted the subject throughout his career; see HEALEY 1997.

40 One may compare, for instance, Rubens' great *Rainbow Landscape* in Gallery 22 of the Wallace Collection which was painted soon after this version of *The Judgement of Paris*, c.1636; see INGAMELLS 1992, pp.309–13.

41 See VEY 1962, I, no.138, II, fig.177.

42 See JAFFÉ 1966, p71, no.CLXVIII.

43 See J. Muller Hofstede, 'Van Dyck's Authorship Excluded: The Sketchbook at Chatsworth', in BARNES 1994, pp.49–60.

44 See HEALEY 1997, pl.6.

45 The drawing was made in 1610, and is now in the Leiden Prentenkabinet der Rijksmuseum; see PRAGUE 1997, p.115.

46 Shakespeare, *Love's Labours Lost*, Act II, Scene 1, l.15.

47 Homer, *The Iliad*, trans. R. Fagles, New York 1990, repr. London 1998.

48 Karel van Mander, *Den Grondt der Edel vry Schilder-const*, Amsterdam, 1618, p.43, verses 62–3; see HEALEY 1997, p.158.

49 H. Rowland, *A Guide to Men*, New York, 1922, p.25.

50 It has even been suggested that *St Matthew*, like *Paris*, might be seen as a self-portrait of the artist; see LONDON 1984, no.41.

51 Formerly in the collections of Jonathan Richardson, Thomas Hudson and Sir Joshua Reynolds, the drawing was sold in the Woodner Sale at Christie's, 2 July 1991, lot 200.

52 Indeed, Van Dyck was an avid collector of Titian's work; his 'cabinet de Titian', for example, was admired in Antwerp by Marie de Medici's secretary Puget de la Serre in 1631. For further information on Van Dyck as a collector of Titian's work see BROWN 1990 and WOOD 1990.

53 Thought to be a copy after a painting described in the collection of Niccolò Crasso, Venice, in 1648 by Ridolfi, known today only through workshop replicas; see ADRIANI 1940, p.243, no.L–26, pl.126.

54 For instance see DAMM 1966, pp.178–82, no.46.

55 See MILLAR 1963, p.101, no.157, pl.81.

56 Quoted in URZIDIL 1942, p.46.

57 BELLORI 1672, p.22.

58 See GLÜCK 1934.

59 For further information on the Hermitage self-portrait see WASHINGTON 1990–1, pp.167–9, no.33 and ANTWERP 1999a, pp.164–5, no.31.

60 See LONDON 1982–3, no.61.

61 See COPIES above.

62 Bellori's account of Van Dyck's life was based on information supplied by the latter's friend, Sir Kenelm Digby; see BELLORI 1672, p.22.

63 Michael Jaffé maintained that Van Dyck was of northern artists the most sensitive to the example of Titian's *poesie*; see JAFFÉ 1996, p.475.

64 See in particular J. M. Muller, *op. cit.*, in WASHINGTON 1990–1, pp.26–36.

65 A similar process may be observed in Watteau's *Fêtes Galantes*, which so delight the eye with their charming subjects, ravishing palette and brush work that their metaphorical dimension may easily be overlooked by the viewer; indeed Watteau was criticised by contemporaries for painting pictures without a subject. Yet the element of poetic ambiguity in Watteau's art has ensured its longevity and excited the imaginative curiosity of generations of art historians, keen to interpret his works in their own image; see T. Crow, *Painters and Public Life in Eighteenth-Century Paris*, New Haven and London, 1985, pp.45–74.

'I worked a long time for my reputation, now I do it for my kitchen', Van Dyck[1]
Studio Practice, Copyists and Followers

So far we have been discussing pictures solely from the brush of Van Dyck, but as the artist's fame grew and his need for cash increased, Van Dyck not only altered his technique to enable him to step up his artistic output, but also increasingly relied upon the help of studio assistants. Van Dyck grew up with the example of Rubens' impressive studio always before him. At the time a distinction was made between the artist's creative intellectual activity – his *invenzione* – and the manual work required to bring the work into existence. The true work of the artist was to invent a composition, which embodied his ideas; the execution of the work was of secondary importance and could be left to trained assistants. The final work would then be checked and touched up as necessary by the master, before it was allowed to leave the studio. The name 'Rubens' thus operated like a trademark, ensuring a certain quality of conception and standard of production. Of course, the master might execute especially important commissions himself, but in general Rubens' studio allowed him to take on a greater number of orders for more profit. Van Dyck himself had been part of this team, providing tapestry cartoons according to Rubens' designs, and acting as his assistant on important decorative commissions.[2] At the age of 17, the enterprising young artist set up his own studio, engaging Herman Servaes and Justus van Egmont as his assistants.[3] On his return to Antwerp in 1627, Van Dyck almost certainly developed a workshop to help him carry out the numerous large altarpieces he was commissioned to paint. His portrait practice at this date, however, appears to have operated independently of this system, probably, as he himself stated, because he was eager to establish his artistic reputation among the influential international elite. This may explain the comments recorded in chapter II regarding the lengthy time he took to paint Nicolas Lanier's portrait (fig. 24).

The hard work paid off, and Van Dyck was invited to become court painter to Charles I. In England the situation changed. Van Dyck's own lifestyle became ever more lavish, and the orders for portraits increasingly numerous. According to Bellori, Van Dyck 'at once began to accumulate the rewards and resources he needed to maintain his ostentatious style and splendid way of life. However, he spent his new riches liberally, since his house was frequented by the highest nobility, following the lead of the king, who used to visit him and took pleasure in watching him paint and spending time with him. In magnificence he rivalled Parrhasius, keeping servants, carriages, horses, musicians, singers, and clowns, who entertained all the dignitaries, knights, and ladies who visited his house every day to have their portrait painted. Moreover, he had lavish dishes prepared for them at his table, at the cost of thirty scudi a day'.[4] Descamps relates an incident where Charles

Fig. 102
Giovanni Bernardo Carbone (1616–83),
Portrait of a Nobleman, The Wallace
Collection

Imitations of Royalty: Charles I and Queen Henrietta Maria after Van Dyck

Oil on canvas, 122.8 × 97.2cm (Charles I) and 122.2 × 97.3cm (Henrietta Maria).[12]

PROVENANCE
The 3rd Marquess of Hertford; Dorchester House inventory 1842; seen in 1854 in Hertford House by Waagen;[13] Hertford House inventory 1870; bequeathed by Lady Wallace, as part of The Wallace Collection, to the British nation in 1897.

LITERATURE
The Portrait of Henrietta Maria alone: LARSEN 1980, no.870, and 1988, no.872, and I, p.312. Both pictures: INGAMELLS 1992, pp.113–5.

The evidence of the portraits issuing from Van Dyck's studio during the later English period also tells us that his assistants were required to produce independent copies that bore a competent resemblance to the original. Van Dyck could not hope personally to satisfy all the demands for portraits, particularly of the Royal Family. Even portraits of the King and Queen by Van Dyck were not always from life, and we find that the artist repeatedly copied himself. Van Dyck may, for example, have based the head of his portrait of *Charles I in Robes of State* (1636, Royal Collection; fig.105) on a head study from life which he then re-used soon afterwards for a portrait of *Charles I in Armour,* now in a private collection, and then again two years later for a picture of *Charles I in Armour* painted at the Queen's expense for Lord Wharton (now in the Hermitage).[14] Most of the portraits Van Dyck made of the King and Queen during the later part of the 1630s were commissioned as gifts for relatives, friends, and supporters. The more important the recipient, the more lavish the gift, and the greater the care Van Dyck would take with its execution. Conversely the studio assistants would produce copies for recipients of lesser importance. An official image, such as the portrait of the *King in Robes of State*, would have been copied again and again, becoming the most widely known image of the King, both at home and abroad. The *Portrait of Charles I* in the Wallace Collection is one of many known copies (fig.103), of widely varying quality, after Van Dyck's original.

The Wallace Collection copy reduces the full-length format of the original to three-quarter length, and abandons all attempt to replicate the monumental background with its pillar and atmospheric sky. The copyist concentrates on the figure of the King himself; his crown is indicated in a most perfunctory fashion on the right. Charles's face may appear competently painted at first glance, but on comparison with Van Dyck's characterisation, it appears hard and lacking in finesse. At least an effort has been made with the face; the drapery, however, is even less successfully transcribed. Gone is the softness and supreme understanding of material texture, seen in Van Dyck's depiction of the ermine cloak and

above left: Fig.103
After Van Dyck, *King Charles I*, The Wallace Collection

above right: Fig.104
After Van Dyck, *Queen Henrietta Maria*, The Wallace Collection

silken sleeves, and in their place a costume so wooden that it is difficult to believe Van Dyck's assistants, trained and working with the master, were capable of such a travesty. The complete misunderstanding of the form of the right hand, bent back and resting upon the hip of the subject in the original, further leads us to conclude that the Wallace Collection copy is not even good enough to ascribe to Van Dyck's studio. If that is the case, when might it have been painted? This is a difficult question to answer without further assessment of the technical make-up of canvas and paint: analysis which the quality of the image hardly seems to merit. Following Charles I's execution and the restoration of his son Charles II to the throne, images of the late King again became popular. The present picture was acquired by the 3rd Marquess of Hertford, and listed in his inventory in 1842. It seems probable that the copy was painted in the eighteenth century by an artist capitalising on the current popular romanticising fashion for images of the martyred King. The prototype was certainly engraved in the eighteenth century by Strange in 1770, and George Vertue is known to have made a drawing after the King's head in the original portrait.[15]

The copy of *Charles I in Robes of State* in the Wallace Collection is twinned, not with a matching state portrait of the Queen, but with a portrait of a very different type showing *Queen Henrietta Maria* in a blue dress (fig.104). Two portraits of 'the Queen in blue' were listed in the memorandum Van Dyck sent to Charles I in 1638.[16] No original portrait by Van Dyck is known, but it is generally accepted that the picture in the San

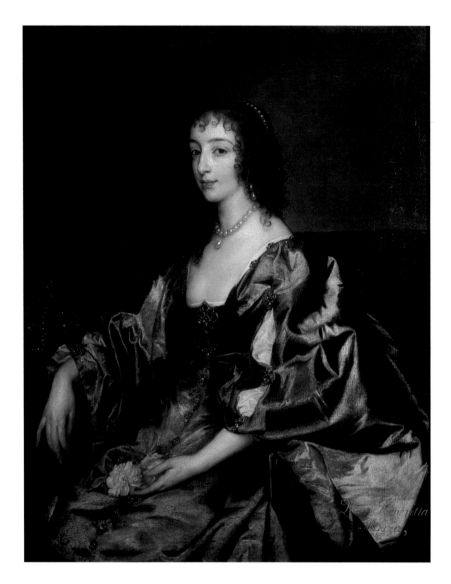

Fig. 106
Studio of Van Dyck, *Queen Henrietta Maria*,
c.1638–9, San Diego Museum of Art

Diego Museum of Art is the best of all known versions (fig. 106). It is unusual in depicting the Queen in the imaginary costume of 'Careless Romance' which Van Dyck invented for his female sitters in England.[17] She appears to be wearing a kind of informal silk gown, rather like the so-called nightgown that ladies wore at home. Her neckline is extremely low, and all lace trimmings have been removed so as not to distract the viewer from the fluid lines of the garment and the charms of the lady. The billowing silk seems entirely plausible in the picture and lends the costume a sense of airy elegance, although in reality the heavy gold jewellery with which it is adorned would have dragged the fabric down. The mood of languorous repose such a presentation evokes was extremely popular and continued late into the century in the work of Lely and his followers, who adopted a similar idiom for their portraits of female sitters. It is ironic to note that while the original of the Queen's portrait may be lost, Van Dyck's image of *Anne Crofts, Countess of Cleveland,* wearing the same dress, is known in a private collection in England (fig. 107).[18] If we compare the Wallace Collection picture with the portrait of *Anne Crofts* and the San Diego picture we are again disappointed by the contrast in quality. It is difficult to agree with the commentator who observed 'intrinsic excellence' in the Wallace Collection picture[19].

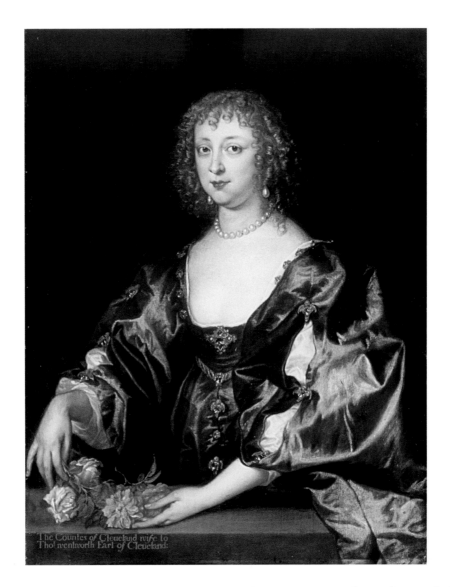

Fig.107
Van Dyck, *Anne Crofts, Countess of Cleveland*, c.1635, photo private collection, courtesy of Anna Sandén

The face is lifeless compared even to the San Diego studio replica, and the drapery is frankly crude. If we examine, for instance, the transition between the sleeve and right arm in all three portraits, we can see how in the Wallace Collection picture the transition between flesh and silk is so harshly conceived that one loses all sense of the arm continuing beneath the drapery. In the other two pictures this is suggested by the use of shadow to mould the form of the arm and soften the line between material and flesh. It has to be admitted, however, that the position of the arms and hands is awkward in all three pictures, and in fact may betray the existence of studio assistance in the *Portrait of Anne Crofts*, previously attributed in full to Van Dyck. The Wallace Collection portrait of *Queen Henrietta Maria*, however, is far below the standard even of a studio reproduction. In fact its format and handling suggest that it was painted by the same copyist who executed the pendant of Charles I, and thus probably in the eighteenth century. The fact that the copyist decided to depict the Queen more informally than her husband should not surprise us too much as this depiction of the Queen provides an image very much in keeping with the later century's romantic view of the Caroline court.

The Virgin and Child after Van Dyck

Oil on canvas, 107.2 × 82.3cm.[20]

PROVENANCE

Cardinal Fesch (1763–1839) by 1815; his sale, Rome, 17 March–15 May 1845 (lot 65), bt. Artaria, 1,400 scudi, for the 4th Marquess of Hertford; framed in Hertford House 1859;[21] Hertford House inventory 1870; bequeathed by Lady Wallace, as part of The Wallace Collection, to the British nation in 1897.

EXHIBITIONS

Bethnal Green, 1872–5 (96, as Van Dyck).

LITERATURE

INGAMELLS 1992, pp.115–6.

Van Dyck's reputation was not confined to his portraits. Another important aspect of his work not yet touched upon is his continuing fascination with the Virgin and Child whom he painted throughout his career. The admiration engendered by his interpretations of the theme is clearly demonstrated by the large number of prints and copies they inspired. As in his history paintings, Van Dyck's characterisation of the Virgin and Child was heavily dependent upon the example of Venetian High Renaissance painting, and Titian in particular.[22] Van Dyck adopted a characteristically pared down emotional approach, focusing upon the mother-child relationship, and investing these scenes with a mood of heightened intimacy entirely appropriate to the subject. The resulting images also convey something of the sweetness of Correggio, and may be seen as part of Van Dyck's continual search for grace in his art. *The Virgin and Child* in the Wallace Collection (fig.108) is copied after a picture now in the Royal Collection, painted *c.*1630–2,[23] which was clearly inspired by Titian's *Madonna and Child with Saints Stephen, Jerome and Maurice* (*c.*1520, Louvre), which Van Dyck drew in part in his Italian sketchbook.[24] Van Dyck's composition proved a popular one, and a number of copies are known, including paintings at Ugbrooke, Charlecote and in the collection of Lord Harrington. The picture was also copied in grisaille and converted into a *Rest on the flight into Egypt,* with the addition of a landscape background including Joseph and a mule, by Abraham van Diepenbeck (private collection), and then engraved by Hendrick Snyers (*c.*1642).[25] Unfortunately little of the charm of Van Dyck's original remains in the rather pedestrian Wallace Collection copy. One has only to compare the execution of this work with the true Van Dycks in the Collection to see how *invenzione* alone is not sufficient to make a painting succeed artistically.

Fig.108
After Van Dyck, *The Virgin and Child*, The Wallace Collection

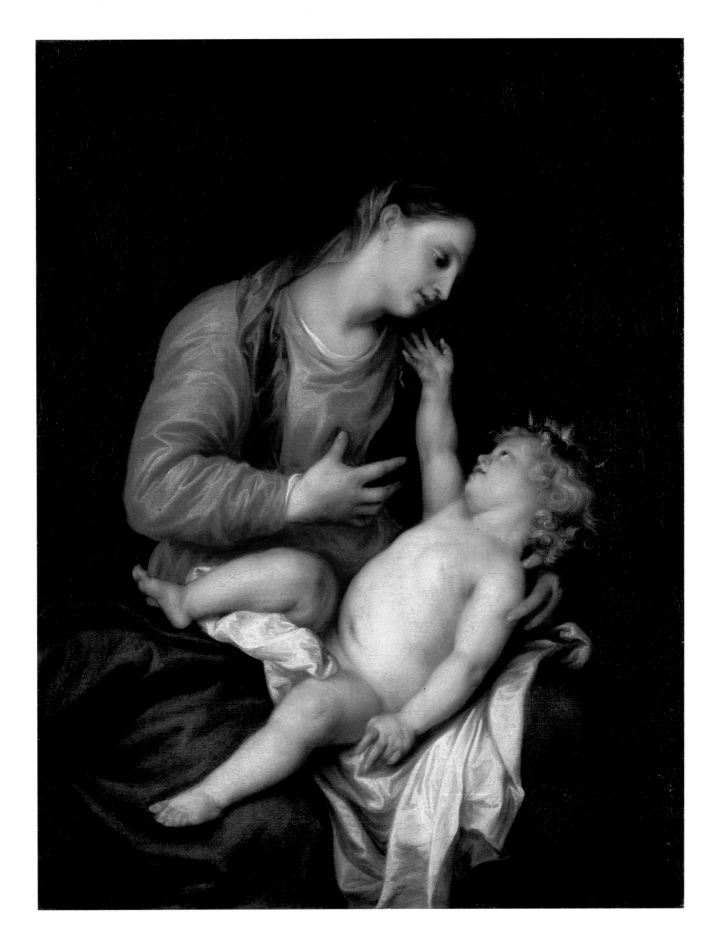

Imitating Van Dyck's style: Giovanni Carbone (1616–83), a follower of Van Dyck in Genoa[26]

Oil on canvas, 204.5 × 135.5cm.

PROVENANCE

Bought Genoa, 1808,[27] by the dealer Le Brun;[28] Schamp d'Averschoot, Ghent, by 1822;[29] his sale, Ghent, ff.14 September 1840 (22, Van Dyck, *Portrait de l'Ambassadeur Gonsalvi*), bt. Farrer, 10,000fr.; Henry Artaria sale, Phillips, 23 April 1850 (86, as of the Spanish Minister Gonzalves), 358gn.; the 4th Marquess of Hertford before 1854 when the picture was seen in Hertford House by Waagen;[30] Hertford House inventory 1870, as '*Vandyck, a Spanish Nobleman*'; bequeathed by Lady Wallace, as part of The Wallace Collection, to the British nation in 1897.

PRINTS

Anon. 1809 engraving, as unknown man by Van Dyck (fig.121).[31]

EXHIBITIONS

Manchester, *Art Treasures*, 1857 (saloon H, no.9, Van Dyck, *Male Portrait*).
Bethnal Green, 1872–5 (91, Van Dyck, *Male Portrait*).

LITERATURE

SMITH 1829–42, no.605 and *Supplement*, no.9; CUST 1900, pp.43, 245, no.141; WATSON 1950; LARSEN 1980, no.417, and 1988, no.A64; INGAMELLS 1992, pp.112–3.

Van Dyck's work had an influence with far wider results than the production of mere copies. His portraits in particular were unlike anything seen to date. With their peculiar blend of compositional elegance and technical brio they were to influence the practice of society portraiture even up to the present century, as can be seen in the work of artists such as Sir John Singer Sargent and Sir John Lavery. More immediately, Van Dyck's vision of the elites of Europe, subtly attuned to the concerns and fashions he discovered in each location he visited, profoundly influenced their respective local schools of painting. Indeed, with the passage of time the brilliance of Van Dyck's achievement has tended to obscure the lesser-known names who followed after him, forging their own styles, albeit in the prevailing Van Dyckian idiom. This has certainly been the case with many of the portraitists of the Genoese school of the seventeenth-century. It is only recently, following the groundbreaking exhibitions on Baroque painting and Van Dyck in Genoa, that we have been able to distinguish between the different artistic personalities who inherited Van Dyck's legacy in that city.[32]

The connection between Genoa and the *Portrait of a Nobleman* (fig.109) in the Wallace Collection has long been recognised. The subject is portrayed in the conservative Spanish style dress affected by the nobility in Genoa at that time. He wears a black costume with a plain stiff collar and cuffs, similar to the outfit worn by *Marcello Durrazzo* in the portrait painted by Van Dyck in Genoa in 1624 (fig.110).[33] Like Durrazzo the sitter is portrayed

Fig.109
Giovanni Bernado Carbone, *Portrait of a Nobleman*, The Wallace Collection

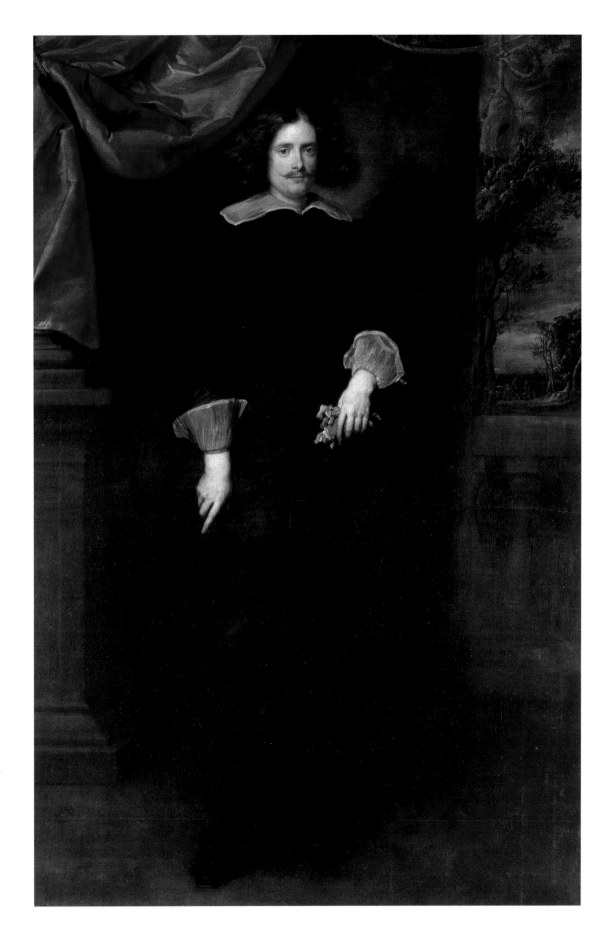

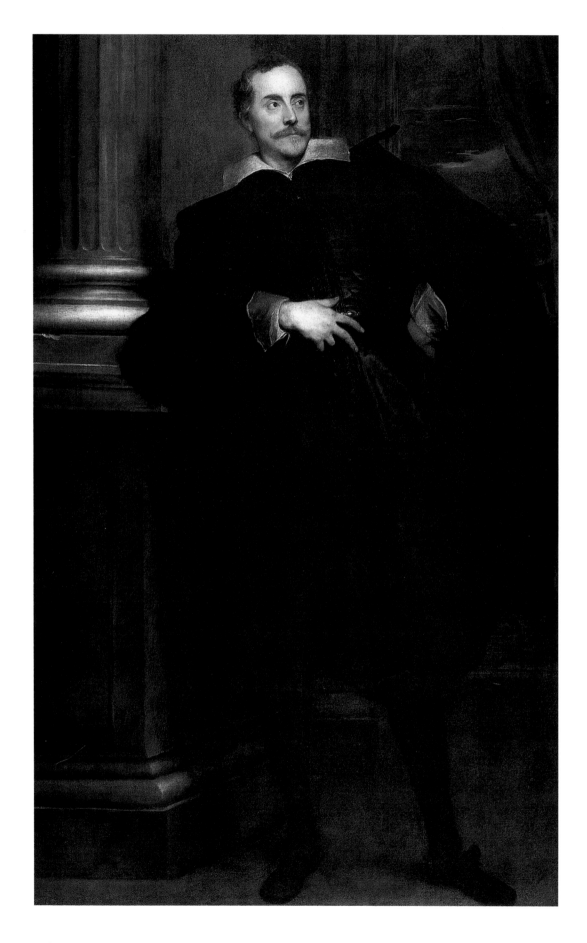

full length on a grand terrace with a draped curtain: the base of a massive column to the left, and to the right a balustrade looking out over a park. Both pictures share a similar sombre palette, a use of dark shadow to give relief to form, and a concern to blend the flesh tints of the face and hands. In view of what we have mentioned above, it is hardly surprising to discover that the Wallace Collection portrait was long thought to be an autograph work by Van Dyck.[34] If we compare the two paintings more closely, however, it soon becomes clear that such an attribution is untenable. One is immediately struck by the elegant spontaneity of Durazzo's contra-posto pose, which makes the *Portrait of a Nobleman* seem static and prosaic by comparison. Similarly the face of the Wallace Collection picture, while evidently painted by an artist of ability, appears coarse when set against the superior characterisation of the other man's features. The hands, too, betray a weaker talent in the unsure articulation of the fingers, especially of the right hand where the fingers curl under at an impossible angle. The fetishistically tapered fingers of the other hand clutch a bundle of what look like ill-defined rags, which we are meant to understand are gloves. One has only to turn back to look at the wonderfully painted glove of *Peeter Stevens* (fig.23) to realise that Van Dyck could not be the author of something so poorly painted.

So, if not by Van Dyck, who did paint the Wallace Collection *Nobleman*? If we compare the portrait with identified works by Van Dyck's followers in Genoa, the same

Fig.112
Carbone, *Portrait of a Gentleman*, Indianapolis
Museum of Art, photo courtesy of
Colnaghi's

stylistic features can be found in the paintings of an artist called Giovanni Bernardo Carbone (1616–83). Carbone was one of the finest, but now least known of Van Dyck's Italian followers.[35] Most of Carbone's works are still in Italy, many in private collections, which explains in part the artist's relative obscurity today. He specialised in ambitious portraits, often depicting his subjects full-length on palatial terraces, recalling Van Dyck's Genoese manner. One such work by Carbone is still in Genoa today and shows *A Young Lady on a Terrace* (fig.111). Here we can see the same treatment of drapery, curtain and hands as in the Wallace Collection picture. Both pictures reveal a highly distinctive handling of landscape, typical of the work of Carbone (fig.102). Further telling comparisons with the Wallace Collection picture are provided by the *Portrait of Lorenzo Raggio* in the Galleria d'Arte Antica, Rome, also by the *Portrait of a Gentleman* in the Galleria Corsini, Rome,[36] and the *Portrait of a Gentleman*, now in the Indianapolis Museum of Art (fig.112). All these works exhibit characteristics similar to the Wallace Collection portrait: similar modelling in the face and hands, an almost excessive use of dark shadow around the characteristically tapering fingers, and a monumental treatment of setting, including trademark heavy tasselled curtains and massive columns. More than any number of copies, Carbone's reinterpretations of Van Dyck's compositional ideas, and his adoption of Van Dyck's stylistic techniques, provide an eloquent testimony to the continuing power of Van Dyck's legacy in Italy throughout the seventeenth century.

FOOTNOTES TO CHAPTER IV

1 R. de Piles, *Abrégé de la vie des peintres*, 1699, trans. 1750.

2 Cf. the *Decius Mus* tapestry series and the ceiling of the Jesuit Church in Antwerp; see *CHRONOLOGY* for the years 1618–20.

3 Servaes and Van Egmont testified to this effect in a court case in 1661, which disputed the authenticity of a number of Van Dyck's early works.

4 BELLORI 1672, p.20.

5 DESCAMPS 1753–4.

6 BELLORI 1672, p.22.

7 See O. Millar, 'Van Dyck in London', in WASHINGTON 1990–1, pp.53–8, for a general account of this period, and p.56 for Wentworth's quote.

8 A painter from Dunkirk, Jean de Reyn, is also said to have accompanied the artist to England, and Thomas Willeboirts, Theodor Boeyermans and Pieter Thys have all been described as Van Dyck's pupils in Antwerp.

9 For more information on this portrait and its date, see BROWN 1982, pp.214, fig.223.

10 Bellori, however, gives a different account, perhaps related to the way in which more important clients were treated, namely: 'Regarding his method of painting, he was in the habit of working without a break, and when he made portraits he would begin them in the morning to gain time, and without interrupting his work, would keep his sitters with him over lunch. Even though they may be dignitaries or great ladies, they came there willingly as though for pleasure, attracted by the variety of the entertainments. After his meal he would return to the picture, or else do two in a day, adding the final retouching later. This was his usual practice for portraits'; BELLORI 1672, p.22.

11 DE PILES 1708, pp.137–8.

12 Both portraits are numbered on the *verso* of the stretcher in the same hand: the *Portrait of Charles I* is numbered *16*, and the portrait of *Henrietta Maria* is numbered *20*.

13 WAAGEN 1854, IV, p.87.

14 A related drawing for the King's head is in the Rijksprentenkabinet, Rijksmuseum, Amsterdam; for this and the various related paintings see BROWN 1991, pp.226–7, no.69; MILLAR 1963, pp.95–6, pl.71 and WASHINGTON 1990–1, pp.294–5, no.77.

15 According to Vertue his drawing was praised by Frederick, Prince of Wales, who 'spoke to me in commendation of the work I was upon'; quoted in MILLAR, *op.cit.*

16 Described as 'Une Reyne vestu'en blu, £30' and 'Une Reyne en blu donne au Conte d'Ollande, £60'; see LARSEN 1980, p.312, and *CHRONOLOGY* under 1638.

17 See E. Gordenker, 'Beyond Fashion Plates. The Clothed Body in Anthony van Dyck's Portraits', in ANTWERP 1999d, pp.25–35.

18 See LONDON 1983, p.75, no.31, pl.VII.

19 LARSEN 1980, *op.cit.*

20 The stretcher bears, *verso*, an old inscription *No4*; two Roman customs stamps: RCA/DOG.DI/ROMA and the inscription *No 150.du C.*, probably referring to a Fesch catalogue; see D. Thiébaut, *Ajaccio, musée Fesch, Les primitifs italiens*, 1987, p.26.

21 Evans invoice in the Wallace Collection archives.

22 There are numerous copies by Van Dyck of different paintings of the *Madonna and Child* by Titian in the Italian Sketchbook; see for example ADRIANI 1940, pp.22, 27–8, 30–1, nos.3v, 4, 8v, 9, 9v, 11v, 12.

23 See MILLAR 1963, pp.102–3, no.161.

24 See WETHEY 1969–75, I, no.72, pl.15 and ADRIANI 1940, pp.30, no.11v.

25 See ANTWERP 1999c, p.228, figs.30–1.

26 I would like to thank Piero Boccardo and Clario di Fabio for confirming the attribution to Carbone.

27 As stated in the Schamp d'Averschoot sale catalogue.

28 J.-B.-P. Le Brun, *Receuil de gravures au trait*, Paris, 1809, II, p.43, no.145.

29 Where it was seen by G.A. Ellis, *Catalogue of the principal Painters in Flanders and Holland*, London 1826, p.11, and H. Smithers, *Observations made during a Tour through that part of the Netherlands which comprises Bruges, Ostend, Brussels, Malines, and Antwerp*, 3rd ed., n.d. [c.1822], p.26.

30 WAAGEN 1854, IV, p,86.

31 Engraved for J.-B.-P. Le Brun, *op.cit.*

32 See GENOA 1992 and 1997: in particular the chapter 'L'eredita di Van Dyck a Genova' by F. Boggero and C. Manzitti.

33 For further information on the *Portrait of Marcello Durrazzo*, see GENOA 1997, pp.252–5, no.44. The Wallace Collection picture can also be compared to Van Dyck's *Portrait of a Young Italian Nobleman* in the Staatliche Kunstsammlungen, Kassel; see BROWN 1991, pp.174–5, no.48, fig.1.

34 The *Portrait of a Genoese Nobleman* was acquired as a work of Van Dyck by the 4th Marquess of Hertford, and accepted as such by Waagen, Cust, and Watson. Rejected by omission by Glück in 1931, it was described as a product of Van Dyck's Genoese workshop by Larsen. Ingamells, the most recent commentator before the present catalogue, described it as the work of a 'Follower of Van Dyck'; see LITERATURE above.

35 For further information on Carbone see GROSSO 1927–8, PARIS 1988–9, pp.147, no.31, GENOA 1992, pp.111–4, nos.20–1. The present picture might also be compared to the work of Luciano Borzone (1590–1645). Borzone's work, however, is somewhat more sophisticated than his younger colleague, without the awkwardness displayed in some passages of the present work; see DI FABIO 1996.

36 See GROSSO 1927–8, p.124 and 126 respectively.

V

'We are all going to heaven, and Van Dyck is of the company' Gainsborough[1]

The Fashion for Van Dyck in England: The Hertfords as Collectors of Van Dyck

With the death of Rubens in 1640, and of Van Dyck the following year, Antwerp lost two of her most famous sons. Their hometown was quick to celebrate their twin achievement and a cult grew up which indissolubly linked the two artists and set the tone for many subsequent critical evaluations of their work. They were respectively characterised as 'The Princes of Painting' in a commemorative double portrait (fig. 114) designed by Erasmus Quellinus, and engraved by Pontius c. 1650, which incorporated Van Dyck's self-portrait and his portrait of Rubens from the *Iconography*.[2] Each artist is described as a 'Knight and Painter of Antwerp' thus stressing their common nobility and nationality. Between the two a lion is tamed by the genius of the arts, then a common motif for the artist's triumph over Nature and her unbridled passions. The most revealing visual details lie in the different attributes with which each artist is associated. Rubens is characterised by Jupiter's thunderbolts, and a profusion of fruit referring to his fertile imagination and productivity; Van Dyck, in contrast, is presented in a more sensitive feminine light, linked as he is with the doves of Venus and the delicate bouquet of flowers. This implicit subordination of the

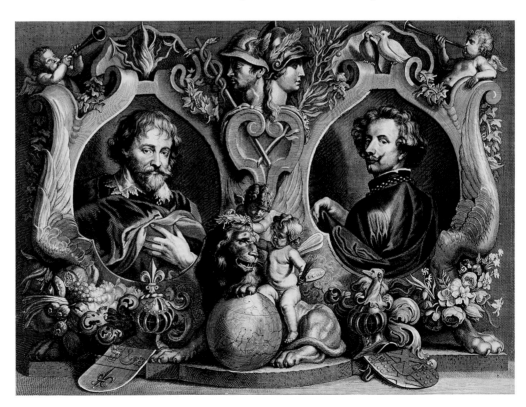

opposite: Fig. 113
Henry Jamyn Brook (1865–1925), *Private View of the Old Masters Exhibition, Royal Academy, 1888*, detail, 1889, National Portrait Gallery, London

right: Fig. 114
Pontius after Van Dyck and Erasmus Quellinus, *Peter Paul Rubens and Anthony Van Dyck*, engraving, first state, The British Museum

graceful Van Dyck to the more masculine vigour of Rubens is reinforced by the Latin verses which accompany the final state of the engraving:

> Behold RUBENS, the Netherlands' brightest star,
> Whom Nature, rich as she is in manifold gifts,
> Diligently brought forth. Such was his mien,
> The friend of Mercury, Apollo and Minerva.
>
> Nonpareil of the Netherlands, and the divine Apelles,
> In whose very breast the graces lived, the peerless artist VAN DYCK.
> Thus did he appear, and you who loved him, wondered, all amazed,
> If he was a full-fledged Cupid or the pious Apollo.[3]

From the outset, therefore, Van Dyck's achievement, while recognised and applauded, was nearly always qualified by comparison with his more prolific contemporary.[4]

In England Van Dyck and Rubens had been the only two artists to date deemed worthy of a knighthood. Even at the moment of his death, Van Dyck had demonstrated his determination to ensure his continuing fame, for, with a weather eye on posterity, he requested that he should be buried in the Anglican cathedral of Saint Paul's despite his supposedly strict Catholic beliefs. Charles I, who was driven from London the following year and died upon the scaffold only eight years later, nevertheless found time to honour his court painter with a lavish monument representing Van Dyck as the Genius of Painting. Unfortunately, despite the efforts of both artist and monarch, the statue and tomb perished with the old cathedral in the Great Fire of London in 1666, and Van Dyck was not commemorated in Sir Christopher Wren's new cathedral until our own century, when a monument designed by H. Poole RA was erected in his honour in 1928.[5] Van Dyck's renown in England at the time of his death is still clearly demonstrated by Abraham Cowley's poem *On the Death of Sir Anthony Vandike, The famous Painter*, written in 1642, which eulogises the artist's achievement in the following terms:

> *Nature* her self amaz'd, does doubting stand
> Which is *her own*, and which the *Painters Hand*,
> And does attempt the looke with less success,
> When her own work in *Twins* she would express.
> His All-resembling *Pencil* did out-pass
> The mimick *Imag'ry* of *Looking-glass.*
> Nor was his *Life* less perfect than his *Art,*
> Nor was his *Hand* less erring than his *Heart.*
> There was no false, or fading *Colour* there,
> The *Figures* sweet and well proportion'd were.
> Most other men, set next to him in view,
> Appear'd more *shadows* then the Men he drew.[6]

Cowley's poem reveres Van Dyck primarily as a portraitist, and it was through his

portraits that Van Dyck's popularity continued unabated in England in the seventeenth and eighteenth centuries. As Fromentin later observed, 'he gave rise to a whole foreign school – the English School'.[7] There was hardly a great country house that did not boast of its Van Dyck, and as Fromentin went on to claim: 'I might add almost all the genre painters who followed the English tradition – and the best landscape-painters are the direct descendants of Van Dyck and indirectly of Rubens through Van Dyck'.[8] Van Dyck's unofficial successor as royal portrait painter, William Dobson (1611–46), modelled his style on Van Dyck, as did Sir Peter Lely (1618–80) who assumed Van Dyck's role after the Restoration. As Van Dyck had collected Titian, so Lely did Van Dyck. His collection included the *Italian Sketchbook* and twenty-five paintings, of which Lely himself described *The Three Eldest Children of Charles I* and *Cupid and Psyche* as his 'best pieces'.[9] The variety of elegant poses contained in Van Dyck's portraits of the English period were widely appreciated and disseminated by print series such as the *Twelve Beauties* or *Countesses*, a project initiated by the Frenchman, Pierre Lombart, made around 1661–2, and first published in Paris and London.[10] The series proved so popular it was still being offered for sale in the English newspapers in 1743. In addition it led to imitative series such as the *Windsor Beauties* commissioned from Lely by the Duchess of York in the 1660s, and the *Hampton Court Beauties* commissioned by William III from Sir Godfrey Kneller (1646–1723). A further series of portraits after Van Dyck, entitled the *Decem Pictas Effigies* and published in 1716 by Pieter van Gunst of Amsterdam (1659–1731), was sold with a survey of the artist's life and work.[11] By 1715 it was accepted by the portraitist Jonathan Richardson that 'When Van Dyck came hither he brought face-painting to us; ever since which time, that is for about fourscore years, England has excelled all the world in that great branch of art'. As far as portrait painting was concerned, Richardson believed that 'next to Rafaelle, perhaps, no man has a better title than Van Dyck; no, not Titian himself, much less Rubens'.[12] By the end of the same century Horace Walpole, in his *Anecdotes of Painting*, acknowledged Van Dyck's 'peculiar genius for portraits' and claimed that his 'works are so frequent in England that the generality of our people can scarce avoid thinking him their countryman'.[13]

Unsurprisingly, the two greatest portrait painters of the English school, Thomas Gainsborough (1727–88) and Sir Joshua Reynolds (1723–92), fell beneath their Flemish predecessor's spell. Gainsborough owned at least three portraits by Van Dyck, and made full-scale copies of Van Dyck's portraits of the *Duke of Richmond* (whereabouts unknown) and the *Lords John and Bernard Stuart* (1789, Saint-Louis Museum of Art). He paid obvious homage to Van Dyckian dress and elegance in his compositions, while his scintillating technique betrayed a more profound appreciation of Van Dyck's artistry, as can be seen in works such as the portrait of *Jonathan Buttall (The Blue Boy*, c.1770, Huntington Gallery, San Marino, California) and *The Hon. Mrs Graham* (1775–7, National Gallery of Scotland, Edinburgh). The association between Gainsborough and Van Dyck's manner was recognised by contemporaries such as Reynolds who, according to Northcote, 'said that he [Gainsborough] could copy Vandyke so exquisitely, that at a certain distance he [Reynolds] could not distinguish the copy from the original, or the difference between them'. Northcote immediately goes on to describe Reynolds examining Gainsborough's own technique, which 'he considered as...one producing great effect and force; and one day whilst

Fig. 115
Joshua Reynolds (1723–92), *Portrait of Lord George Seymour-Conway in Van Dyck Costume*, 1777, private collection, photo courtesy of Agnew's

examining a picture of his with considerable attention, he at last exclaimed, 'I cannot make out how he produces his effect!'.[14] The following century, the Redgraves in their seminal work, *A Century of British Painters*, recognised that 'it is quite evident that he dwelt much upon the works of Van Dyck, whose influence pervades the style of Gainsborough, giving it that tendency to silvery freshness which contrasts so strongly with the warmer more golden tones of Reynolds'.[15] Unlike Gainsborough, however, Reynolds was a slower convert to complete admiration of Van Dyck's art. In portraits such as *Lord Rockingham and his Secretary Edmund Burke* (c. 1766–70, Fitzwilliam Museum, Cambridge)[16] or the portrait of *Lord George Seymour-Conway* in Van Dyck costume (1770, private collection; fig. 115),[17] Reynolds recognised the usefulness of Van Dyck's elegant timeless costumes and varied portrait patterns as compositional models. He was initially wary, however, of the artist's sensual technique, as he was of the Flemish school in general, which he characterised in his Discourse IV as the 'ornamental style'.[18] Reynolds was keen to raise the status of painting as a liberal art in England, and preferred the abstract Italianate ideal, with its more intellectual approach, as opposed to the Netherlandish School with what he believed to be its slavish adherence to Nature and stress upon material and sensual appearances. Moreover, portraiture, as we have already seen, was regarded as one of the lesser

genres, so, although Reynolds as a portraitist found Van Dyck's innovations useful, as a theoretician he was bound to think less of an artist who, on the evidence of the works then preserved in England, appeared to have devoted so little of his time to history painting. Reynolds' conversion to Van Dyck came with his journey through Flanders in 1781. Here he encountered the artist's great Flemish altarpieces; the Mechelen *Crucifixion* (Saint Romboutskathedraal, Mechelen) in particular he described as 'one of the finest pictures in the world...it shews he had truly a genius for history-painting, if it had not been taken off by portraits'.[19] In addition there could be no more poignant evidence of the reconciliation of England's two great portraitists, and their acknowledgement of a common ancestor, than the words addressed by the dying Gainsborough to his old adversary Reynolds: 'We are all going to heaven, and Van Dyck is of the company'.[20]

Reynolds' re-evaluation of Van Dyck's position as an artist coincided with a general growth in the taste for Netherlandish art among English collectors.[21] In 1783–4 the Emperor Joseph II abolished the monasteries in the Netherlands, and their pictures were sold in Brussels in 1785. The pictures of the remaining Flemish religious houses were sent to Paris in 1794 following the French invasion of the Low Countries, where they were joined the following year by the collection of the Prince of Orange from The Hague. Some private collections were sent abroad to escape expropriation by the French. These included the collection of the Hope family, which contained Van Dyck's *Paris* and was sent to England, and that of the Peeters family from Antwerp, which included the *Le Roy* portraits and found its way to the United States. At the same time the sale of numerous French private collections both before and after the Revolution released an unprecedented number of high quality Dutch and Flemish pictures onto the open market.[22] Thus the interest in Netherlandish art was further stimulated. In particular, Van Dyck's history paintings, previously little known in England, but recently praised by Reynolds, became increasingly sought after. This was further fuelled by the continuing production of prints after Van Dyck's works. Indeed, at a time when Van Dyck's coveted paintings were the objects of fierce battles between rival collectors and dealers, a Van Dyck on paper provided the only alternative available to the more modest art-lover; a situation which was astutely exploited by the enterprising print publishers.[23]

Soon buyers were looking even further afield to satisfy the demand for Van Dyck's work. By 1803 the buccaneering art dealer William Buchanan was advising his agent, James Irvine, in Italy: 'It must...be taken into consideration that Vanity principally prompts the English to buy...Of the popular Masters at present, Titian and Rubens take the lead...In the same list I shall likewise rank Leonardo da Vinci, the Carracci – Vandyck's Compositions, Historical – Guido's fine pictures, Claude's very capital pictures – Domenichino – Murillo's capital pictures – Albano's very fine pictures – Rembrandt, and beyond this short list I hardly think it safe to go unless for a highly celebrated and well known Correggio, Raffaelle, or M. Angelo...'.[24] As to preferred subject matter, Buchanan wrote that: 'It would be better to confine ourselves to Compositions which are the present rage – disagreeable subjects you must certainly avoid – and brown dark pictures of Saints and the like must likewise be left out – pictures of a moderate size you must prefer where of equal merit, and choice occurs, to those of larger size, and Capital Cabinet pictures are always to be wished for'.[25] Although Buchanan admitted that 'Rubens

Fig. 116
Henry Bone (1755–1834) after Thomas
Lawrence, *Francis Seymour-Conway, 3rd
Marquess of Hertford (1777–1842)*, enamel,
1824, The Library of Hertford House

is the Michael Angelo of the English, and carries all before him'[26] still 'Fine portraits and compositions however of Vandyck are capital speculations, provided the first are not too large, and the second pleasing and correct in all their parts. The Vandyck for instance of the Brignole, the Tribute Money, is a Capital subject for speculation'.[27] By the time he published an account of his adventures as a dealer in 1824, Buchanan considered that: 'In sublimity and delicacy of sentiment, in the elegance and grace of his characters, and in the correctness of his design, this amiable painter has probably surpassed his master', claiming that if Rubens 'is to be regarded as the Michael Angelo of the Flemish school, so with equal justice, may Vandyck be considered as the Raphael;- less powerful, but more chaste; less aspiring to the grand, but with more refinement of expression'. Buchanan's comments are revealing in that they show what aspects of Van Dyck's work particularly appealed to the early nineteenth-century connoisseur. It is interesting to note that, like Reynolds, Buchanan laments the fact 'that this accomplished painter had not bestowed more of his time and attention upon those works of an historical nature in which he has given such proofs of distinguished talent; and that the greater part of his time was devoted to the painting of portraits,– for however admirable these may be, and certainly no master ever excelled Vandyck in that particular department, yet such must always be considered as holding a second place, when compared with historical painting or the happy union of landscape with figures. Had Raphael never painted but portrait, the name of Raphael would only have been known to us as that of Moroni, or of any other excellent painter

of portrait'.[28] This, then, was the background against which Francis Seymour-Conway (1777–1842), Earl of Yarmouth, and later 3rd Marquess of Hertford (fig.116), began collecting pictures in 1801.

The 3rd Marquess of Hertford and Van Dyck

The pictures of the Wallace Collection as it exists today were principally acquired by the 3rd and 4th Marquesses of Hertford and by the latter's illegitimate son, Sir Richard Wallace.[29] Each man had very distinct tastes, but all acknowledged the importance of Van Dyck, either through purchasing fine examples of his work or by lending pictures by Van Dyck to prestigious public exhibitions. Although the Hertfords claimed descent from Edward Seymour, who became Lord Protector of England in 1547, their wealth and power was of relatively recent date. The 1st Marquess, Francis Seymour-Conway (1719–94) ascended the social ladder, becoming successively Ambassador to France 1762–5, Lord Lieutenant of Ireland 1765–6, and Lord Chamberlain 1766–82. As the aristocrats of the early seventeenth century had turned to Van Dyck to immortalise their status and power, Francis Seymour-Conway turned to the fashionable eighteenth-century equivalent, Sir Joshua Reynolds, for portraits of himself (1785, Ragley Hall) and his family.[30] Owning no original Van Dyck family portraits, Lord Hertford partially rectified this deficiency with portraits of his younger sons, *Henry*, *Robert* and *George* (fig.115)[31] all portrayed in Van Dyck costume. The family fortunes improved further under the 2nd Marquess of Hertford (1743–1822), whose second wife became the favourite confidante of the Prince Regent in 1807, a position she retained until the Regent ascended the throne as George IV in 1820, and replaced her advice with that of a mistress, Lady Conyngham.

Fig.117
After Giuseppe Macpherson (1726–c.1780), *Six Artists: Raphael, Annibale Carracci, Van Dyck, Andrea del Sarto, Titian and Rubens*, ivory, The Wallace Collection

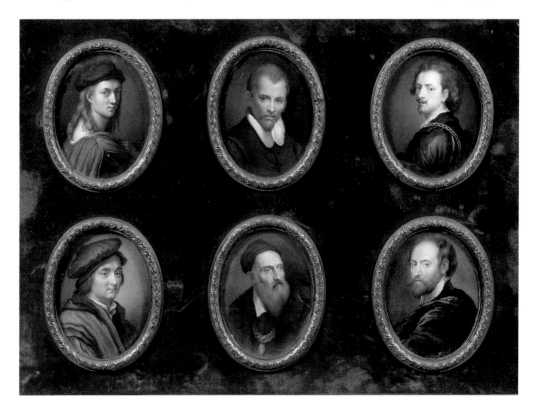

In the meantime her son, Lord Yarmouth, the future 3rd Marquess of Hertford, became firm friends with the Prince, with whom he shared a passion for art. The interest of both men in the increasingly fashionable Netherlandish schools can be seen as a natural consequence of the developments in taste and the art market described previously.[32] Indeed, Yarmouth, acquiring pictures on both his own and the Prince's account between 1809–19, was behaving as little more than an up-market Buchanan. In common with the views expressed by Buchanan, Yarmouth collected pictures in good condition of distinguished pedigree, and his annotated sale catalogues reveal him to have been a knowledgeable and astute operator.[33]

Van Dyck's prominent place in the Hertford canon of Old Masters is made clear from a set of miniature portraits of *Raphael, Annibale Carracci, Van Dyck, Andrea del Sarto, Titian and Rubens* in the Wallace Collection (fig.117) which relate to a similar much larger series by Giuseppe Macpherson (1726–c.1780) in the Royal Collection.[34] For Lord Cowper, Macpherson copied the complete series of two hundred and twenty-three artists' self-portraits in Grand Duke Cosimo's gallery in Florence. Lord Cowper then presented the copies to George III in two batches in 1773 and 1786. The Wallace Collection group obviously derive from Macpherson's copies, and were listed in the Hertford House 1834 Inventory, so it seems logical to assume that they were made for the 3rd Marquess of Hertford after the miniatures in the Royal Collection. The set recalls the courtesan Harriette Wilson's visit to the private apartments of the 3rd Marquess, where 'After dinner, he showed us miniatures, by the most celebrated artists...these were all beautifully executed; and no-one, with any knowledge of painting, could hear him expatiate on their various merits, without feeling that he was qualified to preside at the Royal Academy itself! The light, the shade, the harmony of colours, the vice of the English painters, the striking characters of Dutch artists – Ma foi! No such thing as foisting sham Vandykes or copies from Rubens, on Lord Hertford'.[35] Harriette was of course specifically referring to the 3rd Marquess's collection of 'lovely women, black, brown, fair, and even carrotty, for the amateur's sympathetic *bonne bouche*'. Nevertheless the anecdote also demonstrates Lord Hertford's artistic knowledge and implies that he must have laid the basis of the Wallace Collection's holdings of miniatures.

Unsurprisingly, therefore, Van Dyck figured prominently among the purchases made by the then Lord Yarmouth. It is worth considering both the works he acquired for himself, and those bought on behalf of the Regent, as taken together they reveal a clearer picture of the type of Van Dyck which appealed. Firstly it should be noted that the English portraits, on which Van Dyck's fame had rested for so long in his adopted country, were rare upon the market at this period. The English were active at the beginning of the nineteenth century as buyers rather than sellers; it was not until a century later that the impoverished English aristocracy were forced to relinquish their painted ancestors to the new generation of entrepreneurial dealers and collectors such as Duveen or Frick and Huntington. It is also questionable, had the opportunity been available, whether collectors at this period would have been as keen to purchase works similar to those they often already owned. Certainly the rarity value of Van Dyck's history paintings and the glamour of the illustrious provenances of his Italian portraits added to their allure. Yarmouth's first Van Dyck, *Christ healing the Lame Man* (fig.118), acquired for the Prince of Wales at

Fig.118
Van Dyck, *Christ Healing the Lame Man*,
*c.*1619, The Royal Collection

the Lafontaine Sale at Christie's in 1811, is a paradigm of the qualities required of a good Van Dyck by Buchanan. Not overly large at 120.7 × 149 cm., it is an early historical work, *c.*1619, whose bright colours and technique demonstrate close affinity to the popular style of Rubens; indeed it had been sold as a work of Rubens in the eighteenth century.[36] The Prince paid the enormous price of 3000 guineas for the work, which was delivered on 13 June 1811, and hung in pride of place in the Audience Room at Carlton House by 1816.

In 1815 Lord Yarmouth showed himself sensitive to another artist in Buchanan's canon when he purchased Titian's *Perseus and Andromeda* (figs.81 and 93) for £362 at the sale of Sir Gregory Page Turner's pictures at Phillips'. It would be nice to think that Van Dyck's previous ownership of Titian's *Poesie* might have influenced the purchaser, but it appears more likely that Lord Yarmouth was impressed by the erroneous report then current that the damaged picture had once formed part of the collection of Charles I.[37]

Lord Yarmouth's most impressive Van Dyck acquisitions were made at the sale of the collection of the Dutch banker Henry Hope (1736–1811) which took place at Christie's in 1816. The Hopes were a wealthy banking family of Amsterdam, who, it may be remembered, moved their collection of pictures to England following the French invasion of the Netherlands.[38] Yarmouth bought no fewer than four Van Dycks at the sale; indeed he seems to have been carried away by the opportunities for speculation such an occasion presented. Of his purchases he kept only one for himself. A portrait of *Gaston de France, duc d'Orléans*, probably that painted by Van Dyck in 1631 and bought by Charles I in 1632,[39] found a ready purchaser in the Prince, who must have been impressed by its royal connections (fig.119). Unfortunately the more modest portraits of *Paul de Vos* (see figs.13–14) and *Isabella Waerbeke* (figs.8, 17, 19), which Yarmouth bought for 85 and 100 guineas respectively, were not so easy to place. If he had hoped to sell them to the Prince he was disappointed; they were obviously not flashy enough for Prinny's ostentatious tastes, nor did they particularly appeal to Lord Yarmouth himself, for he sold them on to George Watson Taylor, in whose sale they appeared at Christie's in 1821.[40] The only picture Lord Yarmouth did retain was *The Shepherd Paris*, then regarded as a self-portrait of the artist (figs.73 and 76).[41] Again it has been suggested that this was bought with the Prince Regent in mind, who later declined its purchase.[42] In his will, however, Lord Yarmouth, now 3rd Marquess of Hertford, stated 'I bequeath to my Most Gracious Sovereign King George the fourth a Picture by Vandyke of himself as Paris humbly craving His Majesty's acceptance of this mark of my humble attachment'. It seems unlikely that he would thus bequeath a picture already rejected by his royal master; rather it is more probable that he would mark their relationship for posterity with the best picture in his collection, or at least one that he knew his patron coveted.[43] In addition to the glamour of its identification as a self-portrait, and its illustrious provenance, *Paris* exemplifies all the qualities required of a 'capital' Van Dyck as described by Buchanan: sublimity and delicacy of sentiment, elegance and grace of character, correctness of design and manageable 'cabinet-picture' size. No wonder the great nineteenth-century cataloguer of Dutch and Flemish painting, John Smith, described it in 1831 as 'an exceedingly fine picture'.[44] Today it provides a wonderful visual link between Van Dyck's poetic vision and the *Poesie* of Titian as seen in Lord Yarmouth's other purchase: Titian's *Perseus and Andromeda*.

On the 3rd Marquess of Hertford's death in 1842, the Inventory of his pictures kept at Dorchester House, Park Lane, describes Van Dyck's *Paris* hanging in the 'Green Room'.[45] Two further Van Dycks are also listed in the 'Bow Drawing Room': namely the portraits of *Charles I* and *Henrietta Maria* discussed in the preceding chapter.[46] The frames in which both pictures can still be seen are of a pattern used by the 3rd Marquess of Hertford, which suggests that he acquired the paintings rather than inherited them.[47] That Lord Hertford believed the two works to be by Van Dyck says little for his connoisseurial acumen: the pictures were soon afterwards criticised by Dr Waagen, the curator of the Royal Picture Gallery in Berlin, who described them as 'decidedly not entirely by Van Dyck's hand. Portions of the execution are weak; for instance the dress of the king'.[48] Bearing in mind, however, the fact that English period portraits were rare upon the market, and the fact that Hertford had no such portraits to inherit, the portraits of *Charles*

Fig.119
Van Dyck, *Gaston de France, duc d'Orléans,*
1631, Musée Condé, Chantilly

I and *Henrietta Maria* may have been all he was able to acquire to represent Van Dyck's achievement in England. Other works in the Wallace Collection attest to the 3rd Marquess's taste for historical portraits. Also, by hanging such pictures upon his walls he was copying the style of longer established picture collections such as the royal collection, and making his own family appear less parvenu as a result.

The 4th Marquess of Hertford's taste for Van Dyck

The excellent opportunities for buying works of art continued when Richard Seymour-Conway (fig. 120) succeeded to his father's title in 1842. The new Marquess of Hertford possessed one of the premier fortunes of Europe: he inherited an estate of £2 million and enjoyed an income of at least £250,000.[49] Leisured and immensely wealthy, Lord Hertford devoted his life from the 1840s onwards to his collection; it is the impression of his personality and taste which the Wallace Collection most clearly bears today. His peculiar character and obsessive pursuit of art was described on his death by Charles Yriarte in the following terms: 'A mysterious person...he lived retired from the world, invisible, always ill, he never entertained, he opened his doors only to a few intimate friends, and was so indifferent to the outside world that he would not even have drawn back his curtain to watch a revolution pass in the street...in the midst of his sufferings he had but one glimmer of satisfaction, the only joy that remained to him, the only emotion he felt was that which arose when one recounted the details of a defeat where the Emperor, the Queen of England, the King of the Belgians, the King of Holland or the d'Orléans had fallen to his power in the sale rooms'.[50] Independent of the contemporary mid-nineteenth-century fashion for the 'primitive' art of the early Renaissance, then collected (for example) by the National Gallery and the Louvre, his tastes tended to favour the same seventeenth and eighteenth-century artists as had been popular during the ancien régime. In addition to his passion for eighteenth-century French painting, which we can see throughout the Collection, the 4th Marquess of Hertford was attracted to seventeenth-century Grand Gallery pictures of excellent quality, condition and provenance from the major European Schools. Moreover, he was fortunate in being able to indulge his passion for collecting at a series of remarkable contemporary sales such as those of Napoleon's uncle, Cardinal Fesch (Rome, 1845), and William II of Holland (The Hague, 1850); many of the works he acquired at such sales were won against fierce competition, resulting in record prices which in turn rendered the paintings themselves famous.[51]

Lord Hertford preferred to buy pictures in the sale room rather than from dealers, and often bid through an agent in an attempt to preserve his anonymity. The most revealing source of information regarding his taste and character is provided by the correspondence he conducted with his favourite agent in London, Samuel Moses Mawson (1793–1862).[52] In his own words the 4th Marquess of Hertford defined his taste principally in terms of pleasure, for as he wrote in 1854, 'as you well know I only like <u>pleasing</u> pictures',[53] or again, the same year, pictures which are 'pretty and good'.[54] Hertford claimed that 'with me fancy plays a great part and sometimes a very fine picture does not please me'.[55] A quick trip round the Wallace Collection today reveals that Lord Hertford's 'fancy' was inspired by pictures of a sentimentalising feminine vein; indeed, he

Fig. 120
Etienne Carjat, *Richard Seymour-Conway, 4th Marquess of Hertford (1800–70)*, photograph, 1855, The Wallace Collection

declared a conscious aversion to 'male subjects'. It is hardly surprising, therefore, that he should have been attracted to Van Dyck's work. At the same time he worried about the size of potential purchases, where to hang them, and even their format; preferring horizontal to vertical pictures. Good condition was of prime importance to him when deciding upon a purchase; thus he was nervous of purchasing sight unseen and insisted that his purchases should be of 'first rate quality'. Repeatedly he stressed the need for secrecy to his agent, and showed a certain cynicism regarding auction house practices. Despite his enormous wealth he bemoaned the rising prices he was often partly responsible for inflating: like many collectors before and since he pursued the holy grail of the 'beautiful' painting 'sold cheap'.[56] Once they were in his possession Hertford showed an interest in the framing, restoration, and general well-being of his pictures: thus typically ending a letter to Mawson in 1853 with the wish 'I hope you continue to extend your kindness de temps en temps, to our Manchester children'.[57]

Despite his father's dealings in Van Dyck the 4th Marquess inherited only one true Van Dyck, *The Shepherd Paris*, plus the two copies *Charles I* and *Henrietta Maria*. It was thus inevitable, considering his ambition to create a great picture collection, that he would soon start to acquire more works by the artist. Lord Hertford's first purchase, however, made in 1845, only three years after his father's death, reveals a collector still finding his feet: for he made an uncharacteristic mistake in acquiring for 1,400 scudi the copy of Van Dyck's *Virgin and Child* (fig.108) thinking it to be an original work by the artist.[58] In his defence it might be argued that the composition was exactly the sort of attractive sentimental historical subject so keenly sought after by his father's generation, and comparable as well to the Murillos he himself was to acquire later in his collecting career. The picture also had an excellent provenance, appearing as it did in the sale of Cardinal Fesch in Rome, where it was compared to Snyers' engraving by the auctioneer who took this as 'proof that the artist was so satisfied with the composition that he painted it two times'. Contemporaries, however, were less easily swayed as is clear from the comments of the author of *Le Cabinet de l'Amateur* who immediately characterised the work as a 'very doubtful picture'.[59] Nevertheless *The Virgin and Child* was still described as a work of Van Dyck in the time of Richard Wallace, when sent for exhibition at the Bethnal Green Museum from 1872–5.

Thereafter the 4th Marquess took even greater care in selecting his purchases, for all his subsequent Van Dyck acquisitions are all impressively described in the relevant critical literature of the period, especially in Smith's catalogue. Thus when the portrait of *Isabella Waerbeke* reappeared on the market in the sale of William Wells in 1848, this time without the pendant portrait of Paul de Vos, Lord Hertford snapped it up for 750 guineas: 650 guineas more than his father had paid for it thirty-two years earlier. A clue to the 4th Marquess's enthusiasm is supplied by the entry on the portrait in Smith, who described it as 'one of the artist's matured productions, painted at a period when fame alone was the object of his pursuit'.[60]

Similar positive endorsement is found in Smith for the Marquess's next two Van Dyck purchases: the portraits of *Philippe Le Roy* and *Marie de Raet*, which Smith characterises as 'of the highest excellence and beauty, in the artist's Flemish manner'. They appeared in the sale of William II of Holland; the same sale in which Lord Hertford's

agent Mawson carried off Rembrandt's portrait of his son, *Titus,* for a mere 4000 florins. The purchase of the Le Roy portraits was considerably more spectacular, and deemed worthy of record by Charles de Leutre who wrote up the sale in the *Revue Belgique*: 'From the outset the portraits of Philippe Le Roy, Seigneur of Ravels, and of his wife were considered the capital pieces of the sale. There was much movement when they were offered for sale. At the beginning a great number of competitors entered the fray, but these fell by the wayside, and by the time the bidding had reached around 40,000 florins, only four serious contenders were left: M. Passavent, Director of the Institute of Frankfurt; Heris, from Brussels, acting on behalf of M. Rothschild; Brunnit acting for the Tsar, and Lord Hertford. At 45,000 florins, M. Passavent stopped and retired from the field of battle. At 50,000 florins it was the turn of M. Heris to admit defeat. The combat now continued all the more furiously, and fiercely, between M. Brunnit and Lord Hertford; at 55,000 florins, M. Brunnit seemed defeated; he hesitated, he sat down…at 55,000 florins; 'Going once' not a word; 'Going twice', no one?; the fatal hammer rose…; but Brunnit jumped up; M. Roos stayed the arm of M. Brondgeest…M. Brunnit added another bid, and the battle recommenced. 56,000 florins, 58,000, 60,000. M. Brunnit, overcome, sat down again, hesitated again, then stood up again. 61,000 florins…; but it was obvious to all that Lord Hertford would win the day. Smiling and calm, he deflected each blow with a mere signal, by a riposte as prompt as lightning, he answered each of his adversary's rival bids. M. Brunnit who had all the treasure of the Tsar at his disposal, hesitated and lost his nerve; Lord Hertford, who had but a large private fortune, was determined to go to a million, to two millions if necessary. At 63,000 florins M. Brunnit admitted defeat; the two portraits belonged to My Lord, and the entire room applauded this private individual who had just won a shining victory over the master of two thirds of Europe'.[61] An echo of the particular appeal *Marie de Raet's* portrait may have exerted upon her famously libidinous owner[62] is gleaned from Thoré-Bürger's contemporary description of the portrait's power of arousal: 'Oh! The delicious right hand, not an Italian hand, but a hand of Antwerp, fresh and plump! The naïve face, in full bloom, with its dimples of love…When Lady Le Roy let down her hair, it must have been like an avalanche…'.[63] Certainly there could be no greater testimony to the 4th Marquess's determination as a collector, or to his admiration of Van Dyck as an artist, than his behaviour at the King of Holland's sale.

That same year Lord Hertford made a rather different purchase; that of the portrait of a Genoese *Nobleman,* now attributed to Carbone.[64] This acquisition seems to confirm that Hertford, as can be detected elsewhere in the collection and in his letters to Mawson, was adopting a comprehensive collecting policy aimed at representing the major phases of a great artist's career through the different pictures in his collection. He already had, as he thought, a profane historical subject, a religious subject, a pretty three-quarter length portrait from the Antwerp period plus two stunning full-lengths, and two so-called English period portraits. What he lacked, therefore, was a good Italian-period portrait, and the portrait of a *Genoese Nobleman* must have been intended to fill this gap. Again the picture had a good provenance; it had been engraved in 1809 when in the collection of the famous dealer Le Brun (fig.121),[65] and was described by Smith as the 'portrait of Gonsalvez, Ambassador from the Court of Spain to Venice'.[66] When it appeared in the dealer Henry

Fig.121
Anon. after Carbone, *Portrait of a Nobleman by Van Dyck*, engraving, 1809, from *Le Brun, Recueil de graveurs au trait*, Paris, 1809, no.145

Fig.122
Van Dyck, *The Bolingbroke Family*, c.1634-5,
The Detroit Institute of Arts

Artaria's sale at Phillips in 1850 the auctioneer's catalogue described it enthusiastically as 'From the celebrated collection of Van Schomps; this picture has ever been considered one of the master's finest productions in portraiture – engraved in the small Gallery of Le Brun'. In the light of such positive publicity we cannot blame the 4th Marquess of Hertford's judgement, especially considering the fact that even a century later a Director of the Wallace Collection was continuing to uphold the attribution to Van Dyck in an article in *The Burlington Magazine*.[67] Despite the craze for Italian Van Dycks at the beginning of the nineteenth century, in actual fact very few left Italy, and it is only recently that we have been able to differentiate more clearly between the styles of the master and of his skilful Italian followers.

In view of the 4th Marquess of Hertford's taste for 'pretty pleasing pictures' and for the portraits of Gainsborough and Reynolds, it is rather surprising to see Van Dyck's more highly-coloured elegant English period unrepresented in the collection. The comments made with regard to the scarcity of good English Van Dycks on the market at the time of the 3rd Marquess would appear to apply in this instance as well. Lord Hertford's letters to Mawson reveal that he was indeed an admirer of this period of the artist's career, and keen to acquire suitable examples for his collection. In 1851 he expressed interest in 'A

Fig. 123
Camille Roqueplan (1800–55), *Van Dyck in London*, Musée du Petit Palais, Paris

very fine Van Dyck (the sleeping nymph)'[68] he had heard report of in the Christie's sale of the late Sir J. Murray. The description recalls the *Cupid and Psyche* Van Dyck painted for Charles I; Hertford did not acquire the Murray picture, which might indicate that it was in fact found to be a copy after the Royal Collection picture. Certainly that appears to have been the case with another so-called Van Dyck that whetted the Marquess's appetite in the Earl of Shrewsbury's sale at Alton Towers in 1857: 'The three children of Charles 1st. Vandyck – have you heard whether this is the original? If so it must be a charming picture'.[69] As Van Dyck painted only two compositions featuring the three eldest children of Charles I, and the originals are still at the destinations for which they were intended: the Royal Collection and Turin, it can be safely assumed that Shrewsbury's picture was indeed a copy. In 1861 Hertford came very close to purchasing the portrait of *The Bolingbroke Family*, now in the Institute of Arts, Detroit (fig. 122). He was put off: probably more by his doubts regarding its condition than by its high estimate, which he customarily enjoyed bemoaning: 'I must say your first communication concerning the

Vandyke made my mouth water & I was seriously, very seriously, thinking of begging you to purchase it for our collection at what you considered a proper price, not <u>then</u> supposing that it would fetch 3500£. Your second opinion, of course the best, as you had examined the Picture attentively & in a good light has of course entirely changed my determination & your account of it is so very unsatisfactory that, holding your judgement as high as I do, I would not have it at any price notwithstanding the reputation it enjoys'.[70] The picture was bought in at the Morley sale at Christie's in 1861 for £1,942.10, and one has to admit, looking at it now, that some of the heads appear rather crude and the composition stilted.

Lord Hertford's most active years as a buyer of old master pictures also coincided with an upsurge of continental interest in the more gallant aspects of Van Dyck's biography, often linked to a romanticised view of the English court and the doomed history of Charles I. The French artist, Camille Roqueplan's (1800–55) vision of *Van Dyck in London* (fig. 123) is typical of this new trend: the artist, distinguished by his red hair and beard,

is shown making music with an elegant company, while in the background we see how Bellori's thirty scudi a day are being spent feeding the crowd assembled at the artist's table.[71] Roqueplan was one of the 4th Marquess's favourite contemporary artists,[72] and Lord Hertford, who was brought up and lived most of his life in France, and whose taste is often considered closer to French rather than English collectors of the period, cannot have been insensible to the fact that even Van Dyck's life was now considered a worthy subject for art. Another of Lord Hertford's favourite artists, who straddled the French and British schools, displayed a fondness for historical anecdote and professed open admiration for Van Dyck's work, was Richard Parkes Bonington (1802–28). Perhaps the work that brings us closest in spirit in the Wallace Collection today to the scintillating colours and delicate touch of Van Dyck's English period is Bonington's delightful watercolour *A Souvenir of Van Dyck* (fig.124).[73] The composition, probably painted in 1826, derives from two paintings by Van Dyck: *John, Count of Nassau-Seigen, with his Family* (1634, Firle Place, Sussex), and *Portrait of a Lady and Child* (c.1628–32, Louvre, Paris)[74] and was described in the Villot sale in 1864 as a 'watercolour in which the artist has attempted to imitate Van Dyck'. With this purchase Lord Herford was at least able to enjoy the fruits of Van Dyck's influence on British art in the nineteenth century.

Considering the 4th Marquess of Hertford's tenacity in the salerooms, it comes as something of a surprise to learn that he kept none of his Van Dycks with him in Paris, where he was chiefly resident. In keeping with the English taste they reflected, all were housed in Hertford House, the present home of the Wallace Collection, which, however, he used as little more than a storehouse of art. Lord Hertford, once he had acquired a picture, often unaccountably lost interest in it. The thrill of acquisition and ownership seems to have been greater than any subsequent enjoyment. Nevertheless he did visit his 'Manchester children' in 1855. In 1857, prompted by the special pleading of Mawson, and probably in large part to satisfy his own personal vanity, Lord Hertford agreed to lend a substantial group of pictures to the Manchester *Art Treasures* exhibition. Out of forty-four paintings, four were by Van Dyck, and all had been purchased by the 4th Marquess: the portraits of *Philippe Le Roy, Marie de Raet, Isabella Waerbeke* and the *Genoese Nobleman*. With an insouciance, of which Van Dyck and Le Roy would have been proud, Lord Hertford told Charles Blanc that the exhibition 'will be for me an opportunity to see them [my own paintings]'.[75] Blanc, in very different vein, rhapsodised about the Hertford Saloon in Manchester claiming that 'never in my life have I seen anything like it. Imagine what a wall decorated in the way I am about to describe to you would be like: firstly in the centre, *The Rainbow*, by Rubens...On either side the famous full-lengths of *Philippe Le Roy* and his wife, by Van Dyck...' – his words, if nothing else, should remind us now of how lucky we are to be able to see such a sight every day in the Wallace Collection. In Manchester in 1857 the Le Roy portraits again stole the show, and fully justified their high purchase price: 'What distinction! What presence! What types of nobility without haughtiness, and of elegance without pretension'.[76]

Although Lord Hertford claimed 'I shut it [sensation] up in my breast and nobody perceives it but myself and I must say it does not trouble me much',[77] his correspondence over the ensuing water damage problems at Manchester reveals him to have been extremely emotional, often capricious, demanding and petulant when it came to his collec-

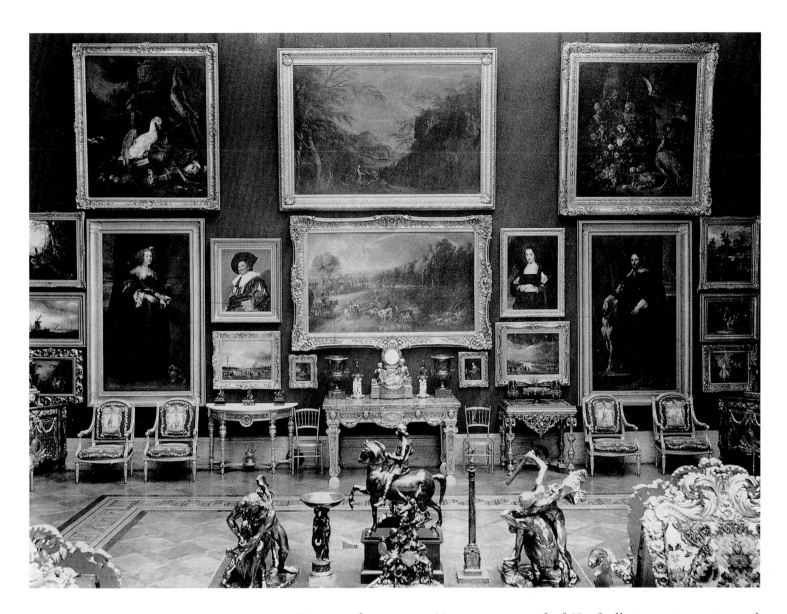

Fig.125
J.J. Thomson, *View of the East Wall of the Long Gallery of The Wallace Gallery* (Gallery 22 today), photograph, *c.*1890, The Library of Hertford House

tion. We can only pity poor Mawson as we read of Hertford's increasing anxiety and bitter recriminations when he feared his pictures might have been damaged. He wrote at the beginning of July with thinly veiled alarm to Mawson about the portrait of a *Genoese Nobleman* saying 'I hear one of my articles is in a terrible state – some parts ready to fall off the canvas. They say it has been ill lined & will be entirely destroyed before it leaves its present abode. I wonder whether such is the case?'.[78] By the end of the same month his tone had become despondent: 'I cannot say how miserable it makes me…For once you gave me bad advice and I am punished for having followed it'.[79] As he explained, 'my collection is the result of my life'[80], and his normal lassitude was spurred into action if he felt it to be threatened in any way.

Richard Wallace and Van Dyck

Nevertheless it was left to Sir Richard Wallace to provide a setting worthy of his father's magnificent collection of Old Masters. He inherited all the unentailed property of the 4th

Fig.126
Henry Jamyn Brook (1865–1925), *Private View of the Old Masters Exhibition, Royal Academy, 1888*, 1889, National Portrait Gallery, London

Marquess on the latter's death in 1870. Soon afterwards he showed great courage in the Siege of Paris, for which he received the *Légion d'Honneur* and a baronetcy from Queen Victoria in 1871. The uncertainty of the French political situation prompted him to move to London in 1872. Initially he and his wife lived temporarily at 105 Piccadilly and he sent a large part of the collection, including all the major works by Van Dyck, to the newly established Bethnal Green Museum while Thomas Ambler remodelled Hertford House, the present home of the Wallace Collection, in 1872–5. 'The Long Picture Gallery', as Gallery 22 was then known, was designed to display the major pictures in the collection, with a glass roof to provide top lighting. Although this original ceiling was replaced in the 1970s, when artificial lighting was introduced, the gallery retains much of its nineteenth-century feel. A comparison with Thomson's photograph, dated *c.*1890, shows a similar dense picture hang on dark fabric-covered walls, complemented by the display of sculpture and furniture placed on a parquet floor (fig.125). The photograph also shows the resting place on the East wall of Van Dyck's great Le Roy portraits, alongside such illustrious companions as Rubens' *The Rainbow Landscape*, and Hals' *The Laughing Cavalier*, all of which can ordinarily be seen in the same gallery today. Other photographs in the same series show the portrait of a *Genoese Nobleman* occupying a similarly prestigious position.

Although Wallace did not acquire any pictures by Van Dyck, the esteem with which he regarded the artist's work is shown by his loans of Van Dyck's pictures to major exhibitions. The most prestigious of these was the Royal Academy exhibition of Old Masters which took place in 1888, which is commemorated in a painting now in the National

Portrait Gallery by Henry Jamyn Brooks (1865–1925; fig.126). Brooks' painting shows the main Gallery of the Royal Academy during the show. On either side of Rubens' equestrian portrait of *The Duke of Buckingham* (c.1625; formerly Collection of the Earl of Jersey, Osterley Park, destroyed) hang the two great Van Dyck portraits of *Philippe Le Roy* and *Marie de Raet*, with Van Dyck's study of *A White Horse* (then in the Collection of Mr T. Gambier Parry) to the right. In the foreground the proud owner, Sir Richard Wallace, stands between Lord Wantage and the Countess of Jersey, with the glamorous President of the Royal Academy Sir Frederic Leighton to the right. Wallace was moving in the best circles, partly as a result of his wealth, public-spirited generosity, and famous collection; his contribution to exhibitions such as the Royal Academy show raised his profile yet further as the quality of his loans attracted laudatory comments in the press. Thus the journalist of the *Athenaeum*, while dismissing Rubens' portrait of *Buckingham* as 'a glorification of Vanity...an ultra-demonstrative example of Rubens when he was working against the grain', devoted over a column in fulsome praise of Sir Richard's Van Dycks: 'that shy bride of sixteen, Madame Le Roy, who seems to have shrunk from the gaze of Sir Anthony Van Dyck while he painted her. Though girlish, she is plump and handsome, and no one can fail to see that her timidity will before long vanish...The features could not be better drawn. The picture deserves admiration because it is manifestly wholly by the master, from the fair golden auburn hair in its French dressing to the hem of her rich black gown. The hands are vigorously painted and very choice, and the cuffs are finely treated...The picture and its companion, the almost as telling likeness of the Lady's husband, who is twice her age and somewhat world-worn...are mentioned by Smith and have long been reckoned among the masterpieces of the artist...That of the lady the majority of experts would, we believe, agree on calling Sir Anthony's finest work, not surpassed even by the best of his efforts when he lived in Genoa, Rome, or London...No doubt, as P. Le Roy was a lover of art and collector of pictures, he had much influence with the master...He is dignified without being demonstrative, and austere without hardness...If any portion of this picture is worthy of the face it is the admirably painted hands, every touch of which, like those of Madame Le Roy, is Van Dyck's'.[81]

There is a certain poignancy in seeing the dapper Richard Wallace, the epitome of Victorian philanthropy, standing proudly before the image of another man who, over two centuries before, had also used art and charity to veil the stigma of illegitimacy. Philippe Le Roy, however, had not had the propriety of Queen Victoria to contend with, and Sir Richard was ultimately unsuccessful in his attempt to found a Wallace dynasty in England.[82] Not that Sir Richard would have made the connection, for it was only in the year after his death that the Belgian historian, Jean-Théodore de Raadt, published an obscure paper revealing the truth of Le Roy's birth. Indeed art has legitimised them both: today it is Van Dyck's image that we remember, and the magnificent collection that bears Wallace's name.

1 Quoted in CUNNINGHAM 1843, p.232, and REDGRAVE 1866, p.73.

2 For the wider dissemination of Van Dyck's reputation through the medium of prints published after his death see ANTWERP 1999c, pp.291–304.

3 The final state of the engraving, including inscription is illustrated *ibid*, fig.1.

4 This is true of all the major accounts of Van Dyck's work from the seventeenth century up to the nineteenth century when Fromentin, in 1876, described Van Dyck as 'a Prince of Wales dying as soon as the throne was empty, and who was not to reign…we may ask what Van Dyck would be without Rubens'; see FROMENTIN, pp.81–6.

5 All mortal remains found following the fire at Saint Paul's were placed in an unmarked communal grave in Burnhill Road near the Barbican; see P. Burman, *The New Bell's Cathedral Guide, Saint Paul's Cathedral*, Cambridge, 1987, p.133.

6 See A. Cowley, *Poems*, A.R. Waller ed., Cambridge, 1905, p.25.

7 FROMENTIN 1876, p.85.

8 *Ibid*.

9 Lely bought these at the 'Sale of the late King's Goods' in 1650, and returned them to Charles II after the Restoration. Today they are still in the Royal Collection. Lely also owned the *Portrait of Lady Elizabeth Thimbelby and Dorothy, Viscountess Andover* (National Gallery, London), on which he modelled his own portrait of *Mary Capel (later Duchess of Beaufort), and her Sister Elizabeth, Countess of Carlisle* (Metropolitan Museum, New York), plus the sketch for the *Garter Procession* (Duke of Rutland, Belvoir Castle) and thirty-seven *grisaille* oil sketches for the *Iconography* (Duke of Buccleuch, Boughton House).

10 Lombart was resident in London 1650–63, and the series consisted of ten female and two male portraits; see ANTWERP 1999c, p.296.

11 See ANTWERP 1999c, pp.296–7, figs.16–7.

12 J. Richardson, *An Essay on the Theory of Painting*, London, 1715, pp.101–2.

13 WALPOLE 1888, I, p.330.

14 J. Northcote, *Memoirs of Sir Joshua Reynolds*, 1813–15.

15 REDGRAVE 1866, p.67.

16 Inspired by Van Dyck's portrait of *Strafford and Mainwairing* (1639–40, private collection).

17 Lord George Seymour-Conway (1763–1848), son of Francis Seymour-Conway, 1st Marquess of Hertford (1719–94); Reynolds' portrait was obviously influenced by Van Dyck's half-length portraits from the *Iconography*, a copy of which we know was in Reynolds' possession. The portrait is remarkable for the accurate depiction of the 1630s costume; see LONDON 1986, pp.120, 244–245, no.76. An exceptionally fine mezzotint was made after Reynolds' portrait by Edward Fisher, and published in 1771.

18 J. Reynolds, *Discourses on Art*, R.R.Wark ed., New Haven and London, 1975, pp.62–8.

19 MOUNT 1996, p.24.

20 See note 1.

21 See MOUNT 1996, pp.LXVII–IX.

22 See HASKELL 1976, pp.24–44.

23 See ANTWERP 1999c, pp.291–365.

24 Letter from William Buchanan to James Irvine 3 June 1803; see BRIGSTOCK 1982, p.78.

25 *Ibid*, p.79.

26 Buchanan to Irvine, 30 April 1805, *ibid*, p.397.

27 Buchanan to Irvine, 6 August 1803, *ibid*, p.99–100.

28 BUCHANAN 1824, pp.180–1.

29 See HUGHES 1992.

30 Ragley Hall, the country seat of the 1st Marquess and still the residence of the Marquesses of Hertford, houses three further portraits of Hertford's family: his eldest son, *Francis, Viscount Beauchamp*, afterwards 2nd Marquess of Hertford, and bust portraits of his brothers *Lord Henry* and *Lord Robert*; see LONDON 1986, pp.244–5. Also listed at Ragley in 1865 were three compositions associated with the name of Van Dyck: Portrait of *Van Helmont* (sold Christie's, 14 July 1921, lot 135, as Lely); *The Holy Family*; and *The Rape of Helen* after Van Dyck (sold Christie's, 20 May 1938, lot 37); see INGAMELLS 1992, p.459. The portraits of Hertford's daughters *Lady Elizabeth Seymour-Conway* (1781) and *Frances, Countess of Lincoln* (1781–2) by Reynolds are on view in Gallery 5 of the Wallace Collection today; see INGAMELLS 1985, pp.140, 143–4.

31 See note 17.

32 See also INGAMELLS 1992, pp.9–10.

33 Preserved in the Wallace Collection Library.

34 See WALKER 1992, pp.232–48, nos.484–707.

35 The incident is related in Hariette Wilson's *Memoirs*, published 1825, and quoted in HUGHES 1992, p.20.

36 See MILLAR 1963, pp.103–4, no.164, pl.87.

37 See INGAMELLS 1985, pp.349–60.

38 *The Farington Diary* records the Hope family's reaction to the troubles and move in 1795; see J. Grieg ed., *The Farington Diary*, I, London, 1922, pp.88–9.

39 The picture is now in the Musée Condé, Chantilly; see *CHRONOLOGY* chapter VI.

40 See chapter I for further details.

41 See chapter III for further details.

42 See INGAMELLS 1992, p.101, n.6.

43 The will, dated 25 February 1823, is in the Wallace Collection archives. In the event the 3rd Marquess outlived George IV by twelve years.

44 SMITH 1829–42, III, p.85, no.359.

45 *Inventory and Valuation of Dorchester House, Park Lane. The Property of The Late Marquis of Hertford*, April 1842, p.85; Wallace Collection archives.

46 *Ibid*, pp. 112 & 118.

47 The same frame type is found on other pictures acquired by the 3rd Marquess of Hertford in the Wallace Collection today, includ-

ing paintings by Brouwer, Teniers and Netscher which can be seen in Gallery 19, and a work by Metsu in Gallery 20. John Smith's *Day Book* records the repair and gilding of two French frames for Lord Yarmouth "w⁴ middles corners & sweep backs 8ⁱⁿ wide for Pictures by Albano & Vandyke" on 12 July 1816; see J. Smith and Successors, *Day Book A: l.i. 1812–20.iii.1821.* f.427, no.139.

48 WAAGEN 1854, IV, p.87.

49 To get an approximate idea of the value of these sums in modern terms, multiply the figures in sterling by approximately 100. At the same time a guinea was worth 21 shillings, or £1.05, and the exchange rate was about 25 francs to the pound.

50 C. Yriarte, 'Souvenirs anecdotiques du marquis d'Hertford', *Le Moniteur des Arts*, 2 September 1870.

51 For example the saleroom rivalry in 1865 between Lord Hertford and baron James de Rothschild over Frans Hals' *The Laughing Cavalier* led to a hammer price more than six times the estimate. The purchase price may have astounded critics at the time but the picture has maintained its iconic status to the present day and remains one of the best-known and -loved images in the Collection.

52 See INGAMELLS 1981.

53 Hertford to Mawson, 27 June 1854, *ibid*, p.57.

54 Hertford to Mawson, 11 May 1854, *ibid*, p.53.

55 Hertford to Mawson, 13 May 1852, *ibid*, p.36.

56 Hertford to Mawson, 30 July 1857, *ibid*, p.103.

57 Meaning the pictures kept at Manchester House, home of the Wallace Collection today, one of the London residences he inherited from his father and where most of the London collection was stored while he was resident in Paris; Hertford to Mawson, 11 December 1853, *ibid*, p.50.

58 For more information on this work see chapter IV.

59 *Le Cabinet de l'Amateur*, IV, 1845, p.281.

60 SMITH 1829–42, III, p.16, no.356; for further details about the portraits see chapter I.

61 C. de Leutre, 'Vente de la Galerie de Guillaume II, Roi de Hollande', *Revue de Bélgique*, VI, 1850, pp.49.

62 Hertford talking about another female portrait exclaimed 'she has cost us pretty well. All pretty girls have that fault, more or less', perhaps remembering the one million francs he is alleged to have paid the comtessa di Castiglione for a night of 'all kinds of voluptuousness'; see Hertford to Mawson 18 June 1861, INGAMELLS 1981, p.132.

63 BÜRGER 1860, p.220 ff.

64 For further details about the picture see chapter IV.

65 J.-P. Le Brun, *Receuil de graveurs au trait*, Paris, 1809, no.145.

66 SMITH 1829–42, III, pp.175, no.605.

67 See WATSON 1950.

68 Hertford to Mawson, 10 July 1851, INGAMELLS 1981, p.33.

69 Hertford to Mawson, 5 July 1857, *ibid*, p.100.

70 Hertford to Mawson, 30 May 1861, *ibid*, p.129.

71 BELLORI 1672, p.20; see chapter IV for accounts of Van Dyck's lavish lifestyle, and ANTWERP 1999d for more examples of this

nineteenth-century genre approach to the life of Van Dyck.

72 Examples of Roqueplan's work can be seen in Gallery 23 of the Wallace Collection.

73 For further information on Bonington's watercolour see INGAMELLS 1985, pp.52–3.

74 For further information on Van Dyck's portrait see ANTWERP 1999a, pp.268–9, no.76.

75 BLANC 1857, p.101; Lord Hertford did not, in the event, make it to the Manchester exhibition, excusing himself, as ever, on grounds of ill-health.

76 See *ibid*, pp103–5.

77 Hertford to Mawson, 9 May 1856, *ibid*, p.83.

78 Hertford to Mawson, 5 July 1857, *ibid*, p.100.

79 Hertford to Mawson, 30 July 1857, *ibid*, p.102.

80 Hertford to Mawson, 26 March 1857, *ibid*, p.91.

81 ATHENAEUM 1888, pp.90–1.

82 Sir Richard broached the idea that his illegitimate son Edmond Richard Wallace might inherit his baronetcy in the spring of 1875. The Prime Minister, Disraeli, forwarded the matter to the Queen whose Keeper of the Privy Purse, Sir Thomas Biddulph, quashed the idea saying 'It would open the door to many such applications, and such creations are not very creditable…many wealthy people are not Baronets and it would not be for the Sovereign to confer such an honour on such an understanding'; see HUGHES 1992, p.47 and D. Mallett, *The Greatest Collector*, London, 1979, pp.168–9.

ANTVERPIA

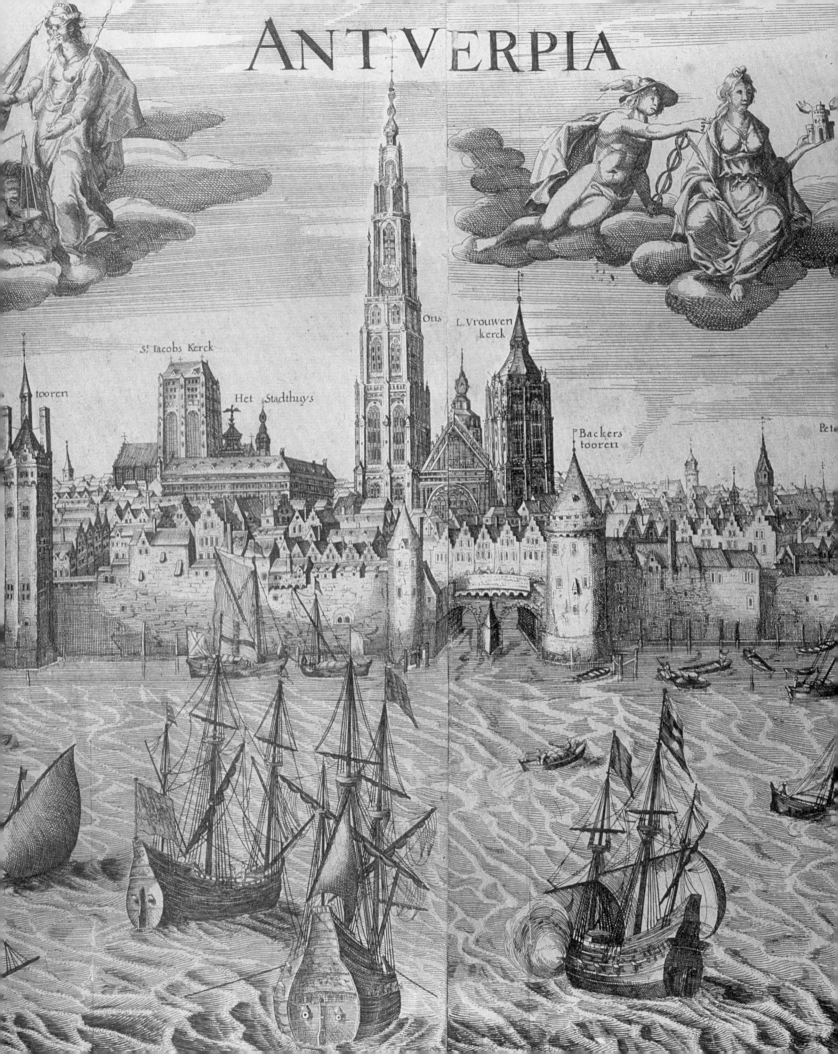

tooren

St. Iacobs Kerck

Het Stadthuys

Ons L. Vrouwen kerck

Backers tooren

Pete

Chronology

Many of the locations listed in and around Antwerp can be seen on pp.8–11 and in figs.2, 4, 21 and 22.
Van Dyck's Chronology is based on ANTWERP 1999a.
The Le Roy family Chronology is based on LE ROY, DE RAADT, and documentation kindly indicated by the Le Roy Genootschap.

KEY
MAJOR HISTORICAL EVENTS
THE LIFE OF VAN DYCK
THE HISTORY OF THE LE ROY FAMILY

MAJOR EVENTS BEFORE VAN DYCK'S BIRTH IN 1599

1554
The Hapsburg Empire is split when Charles V, King of Spain, Duke of Burgundy and Holy Roman Emperor, abdicates in Madrid. The Netherlands and the Kingdom of Naples are ceded to his son Philip.

1555
Charles V's brother Ferdinand I is elected Holy Roman Emperor and rules from Prague.

1556
Philip II succeeds to the Spanish throne. His domain includes Spain, Burgundy and the Netherlands, much of Italy (including Naples and Sicily, Milan, Genoa and Savoy), and colonies in the North and South Americas, the East Indies and Africa.

1558
Death of Charles V. Emmanuele Filiberto I, Duke of Savoy, is made Governor of the Netherlands.

1563
The last session of the Council of Trent lays down guidelines for the representation of religious themes in art.
Van Dyck's grandfather, Anthony, 'who has also been a painter', testifies for Jan van Cleve in Antwerp.
Jacques I Le Roy, a thirty-two year old merchant and entrepreneur, and future grandfather of Philippe, buys the house and land of 'ter Willigen' ('The Willows') between Antwerp and Eeckeren. He exploits the saltpetre found in the polders of Steenborgerweert to make gunpowder. Birth of Elisabeth Hoff, future mother of Philippe Le Roy, daughter of Jacques Hoff and Marguerite Schalkens, and granddaughter of Max Hoff, who was 'Obristmeister' (Guild Master) of Freiburg in 1522, 1525, 1526–7.

1564
Death of Emperor Ferdinand I, and accession of his son Maximilian II.

1566
Iconoclasm: Protestant rioters attack churches and religious houses in Antwerp and elsewhere in the Netherlands. The Revolt of the Netherlands begins, which is not resolved until over eighty years later with the Peace of Westphalia.
Jacques I Le Roy acquires the property of 'Craendijck' ('Crow Dyke'), with its alluvial land, in the area of Steenborgerweert.

1567
The Duke of Alva, arriving as Regent in the Netherlands with an army of 20,000, imposes heavy taxation and the Inquisition. Antwerp suffers further riots and iconoclasm.

1568
Van Dyck's grandfather, described as a merchant 'dealing in silk and fancy goods', requests exemption from his duty of lodging soldiers due to lack of space.

1569
Birth of Jacques II Le Roy, eldest son of Jacques I, and future father of Philippe.

1572
Jacques I Le Roy builds a new house at Sotteghem, on a site inherited from his parents.

1573
Jacques I Le Roy purchases a quarter of the dyke called 'Olmendijck' ('Elm Dyke') at Steenborgerweert. He uses his 'fine house with powder mill, courtyard, pasture land' as security.

1576
Death of Emperor Maximilian II, and accession of his son Rudolf II. The Pacification of Ghent: all the Provinces of the Netherlands unite against the Spanish. The Spanish Fury: mutinous Spanish mercenaries sack Antwerp in November, burning the city and murdering thousands.

1577
Birth of Rubens in Siegen in Westphalia.

1579

The Union of Utrecht formed by the Northern provinces of the Netherlands (The United Provinces of Holland, Zeeland and Utrecht) to resist the Spanish.

Van Dyck's grandfather buys a house 'Den Berendans' ('The Bear Dance') close to the new city hall on the Grote Markt in Antwerp (fig.3).

1580

Death of Van Dyck's grandfather.

Jacques I Le Roy acquires more land in Steenborgerweert from Jacqueline Hart.

1581–3

William of Nassau, 'the Silent', declares the Sovereignty of the United Provinces and renounces the authority of the Spanish King. He governs Antwerp, and the Calvinist city council removes the few surviving works of religious art. Baptism of Frans Hals in Antwerp.

1584

Assassination of William the Silent.

Jacques I Le Roy acquires three gunpowder mills, with their lands, stables etc. at Sint Willebroortsvelt, near Antwerp, from the gunpowder manufacturer, Corneille Michielssen.

1585

Antwerp is recaptured by the Spanish Governor, Alessandro Farnese, Duke of Parma. This leads to the emigration of about 35,000 Protestants, the blocking of the river Scheldt by the United Provinces and the economic decline of Antwerp.

1590

Marriage of Van Dyck's parents, Franchois Van Dyck and Maria Cuypers, in Antwerp.

1594

Jacques I Le Roy 'merchant of this town' of Antwerp testifies that he instructed Mathieu de Limborch to buy saltpetre and transport it to Antwerp.

1596

Albert, Archduke of Austria and brother of Emperor Rudolf II, is appointed Regent of the Netherlands. He establishes his court at Brussels, where he is joined in 1599 by his bride, the Archduchess Isabella Clara Eugenia, daughter of Philip II of Spain. Under the Archdukes the Southern Netherlands enter a period of sorely needed recovery and renewal. The rebuilding of Antwerp attracts artists, printers and scholars, and the city gradually regains its importance as a centre for the arts and luxury trades.

Birth of Philippe Le Roy, natural son of Jacques II Le Roy (aged 27) and Elisabeth Hoff (aged 33).

1598

Death of Philip II of Spain and succession of Philip III, his son by Anna Maria of Austria (elder sister of Archduke Albert). Accession of Henri IV in Paris.

1599

Birth of Diego Velázquez in Seville.

VAN DYCK'S BIRTH AND EARLY YEARS 1599–1620

22 March: Birth of Anthony van Dyck, seventh child of Franchois van Dyck and Maria Cuypers, in 'Den Berendans' on the Grote Markt in Antwerp. In February his father purchases a new house 'Het Kasteel van Rijsel' ('The Castle of Rijsel') in the Corte Nieu Straet, and the family move in December.

1600

Rubens travels to Italy and is appointed Court Painter to Vincenzo Gonzaga, Duke of Mantua.

1603

Jacques I Le Roy, 'Merchant...of the town of Antwerp' makes his will, 22 February, in his house in the 'Minnerbroersstraet'. He requests that he be buried in the Franciscan church of the Recollets. Jacques II erects a monument in his father's honour, to which Philippe Le Roy later adds his own coat of arms.

1604

Aged thirty-five, Jacques II Le Roy enters the service of the King of Spain in the capacity of Commissioner General of Saltpetre and Gunpowder to the Artillery of the Spanish Netherlands.

1605

Jacques II Le Roy, 'Commissioner General of Saltpetre and Gunpowder to Their Highnesses the Archdukes Albert and Isabella', inherits, among other property, the land and powder mills at Steenborgerweert, where he repulses an attack by the troops of Maurice of Nassau, Prince of Orange, the same year.

1606

Rubens in Genoa. Birth of Rembrandt in Leiden.

1607

7 March: Van Dyck's parents buy neighbouring property in the Corte Nieu Straet, including a large house called 'De Stadt van Ghendt' ('The Town of Ghent'). 17 April: Death of Van Dyck's mother.

Jacques II Le Roy's uncle Philippe writes to his nephew about the Le Roy family history. Disregarding the information from his uncle, Jacques II appropriates a different coat of arms from a more illustrious French family. Marriage at Saint George's Church, Antwerp, of Jacques II Le Roy to Jeanne Maes, daughter of Guillaume Maes, almoner of Antwerp, Seigneur of Millegem, and part owner of

the château of Zevenbergen at Ranst. Daughter also of Marguerite van den Nieuwenhuijsen, and sister of Jean Maes, Lord of Cantecrode, Mortsel, Edegem etc. On the eve of his wedding, Jacques Le Roy settles an annuity of 75 florins on his natural son Philippe, to be administered by Elisabeth Hoff, during her lifetime. This is secured on the property of Steenborgerweert and its gunpowder factories, which number five at this period.

1608

Rubens returns to the Netherlands as Court Painter to Archduke Albert, with special dispensation to live in Antwerp rather than at the court at Brussels.
Guillaume, first child of Jacques II Le Roy and Jeanne Maes, is born and baptised in Antwerp in the Cathedral of Our Lady.

1609

The Twelve Year Truce (1609–21) between Spain and its dominions, including the Northern and Southern Netherlands.
The 10 year-old Van Dyck is registered with the Saint Luke's Guild in Antwerp as the apprentice of Hendrik van Balen, one of the most prominent artists in the city, a painter of small figures, who often collaborated with the landscapist Jan Breughel I, his next-door neighbour in the Lange Nieu Straet.
A daughter, Marie, is born to Jacques II Le Roy and Jeanne Maes, and baptised in the Church of Saint George, in which parish they appear then to be living.

1610

Assassination of Henri IV. His widow, Marie de Medici, becomes Regent of France.
2 May: Marriage of Van Dyck's eldest sister Catherina to the notary Adriaen Diericx. 15 December: Jacobmyne de Kueck banished from Antwerp for slandering and threatening to kill Van Dyck's father.
Jacques II Le Roy, now auditor of the Chambre des Comptes (the Accounting Chamber) of Brabant, receives the annual Lent tribute from the water-toll collectors. The Chambre des Comptes meets in Brussels where Jacques II Le Roy and his family appear to be resident from now on. The same year Le Roy and his wife have their third child, a son, Jacques. A further nine children are born to the couple (the last in 1625), seven of whom are recorded in the baptismal records of the Cathedral Church of Saint Gudule in Brussels.

1611

Emperor Rudolf forced to abdicate as king of Bohemia in favour of his brother Mathias, as Prague is plundered by the troops of Archduke Leopold, whom Rudolf himself had invited into the city.

1612

Death of the Emperor Rudolf II in Prague. His brother Mathias succeeds him, and moves the Imperial Court to Vienna the same year.
Philippe Le Roy, now aged 16, 'serves the Emperor Mathias in Prague'.

1614

Marriage of Van Dyck's second sister Maria to the merchant Lancelot Lancelots.
Baptism of Marie de Raet, future wife of Philippe Le Roy, in Saint Jacob's Church, Antwerp. She is the daughter of François de Raet, almoner of the city of Antwerp, Lord of Couwensteyn, proprietor of the fiefdom of Ten-Noele and the château of 'Postmeestershof' ('Post Master's Court': built by the Master of the Post, Antoine de Tassis) at Berchem; and of Marguerite Maes, sister of Jacques II Le Roy's wife Jeanne.

1615

June-July: Van Dyck's brothers-in-law try to keep the estates of his mother and grandmother out of the hands of his father's creditors, and the following month refer to the financial disgrace that has befallen Franchois van Dyck. A sale is held of Van Dyck's grandmother's paintings, and Diericx and Lancelots sue Van Dyck's father for the restitution of his children's inheritance. Franchois van Dyck's assets are inventoried and sold.

1616

Van Dyck complains to the aldermen of Antwerp of his brothers-in–laws' administration of his grandmother's estate. 1616/18 Van Dyck sets up his own studio in 'Der Dom van Ceulen' ('Cologne Cathedral') in the Lange Minnerbroerssstraet. Herman Servaes and Justus van Egmont become his assistants.

1617

Marie de Medici forced to abdicate as Regent. Louis XIII becomes sole ruler of France.
Van Dyck's father's assets auctioned at the Vrijdagmarkt (Friday Market) in Antwerp. Van Dyck's elder brother Franchois, who is running the tavern 'de Goublomme' ('The Sunflower'), is also in financial trouble. Van Dyck appeals to the aldermen to restore his possessions and protect those of his younger brothers and sisters from their guardians. Commission for the cycle of paintings of *The Mysteries of the Rosary* for Saint Paul's Church, Antwerp. Van Dyck receives the same fee as Rubens and Jordaens, 150 guilders, for his *Christ Carrying the Cross* (still *in situ*). His former master Van Balen receives 400 guilders for his work.

1618

The Protestant nobles of Bohemia, anxious to protect their religious and political liberties, offer the crown of Bohemia to the Protestant Elector Palatine, Frederick V, thereby precipitating the Thirty Years' War. Archduke Ferdinand of Styria, cousin to Emperor Mathias and potential candidate for the throne of Bohemia and position of Emperor, objects and moves to defend Imperial interests. Tensions escalate. The conflict eventually involves most of Europe, with Germany and the

Spanish Netherlands providing the principal battlegrounds. The population of central Europe is decimated in a war of great destruction and brutality.

11 February: Van Dyck enrolled as a master in the Guild of Saint Luke. Four days later, with his father's consent, Van Dyck is declared to be of age, and receives an annuity on the proceeds of the mortgage taken out by his father on 'De Stadt van Ghendt'. Van Dyck also working for Rubens during this period: on 28 April Rubens offers Sir Dudley Carleton a painting 'done by my best pupil' – Van Dyck – and retouched by himself: *Achilles among the Daughters of Lycomedes* **(Pommersfelden). On 26 May Rubens writes to the same patron that the tapestry cartoons for** *The History of Decius Mus* **(Vaduz) are in Brussels; in 1661 Gonzales Cocques, Jan Carlo de Witte and Jan Baptiste van Eyck state that these were executed by Van Dyck after designs by Rubens.**

On the death of François Verleijsen, Jacques II Le Roy is created Councillor and Master of the Chambre des Comptes. In the same year Philippe Le Roy is named Commissioner General of Saltpetre and Gunpowder to the King.

1619

Emperor Mathias dies without issue. Archduke Ferdinand of Styria is elected Ferdinand II, Holy Roman Emperor. Aware of the impending end of the truce with the United Provinces, Ambrogio Spinola, Genoese general of the Spanish army, begins to plan an attack using manpower and Spanish bullion transported to the Spanish Netherlands by way of Genoa and the Val Telline. Access via the Palatinate is crucial to this plan.

1620

The Battle of the White Mountain drives Frederick, Elector Palatine and King of Bohemia, and his wife Elisabeth, daughter of James I of England, from Prague into exile. Spinola marches on the Palatinate. By the end of the year the Palatinate and the passes of the Val Telline are open to Spain.

29 March: Rubens signs a contract for 39 ceiling paintings for the Jesuit Church in Antwerp to be designed by Rubens and executed by 'Van Dyck and certain other of his pupils'. 30 May: 'De Stadt van Ghendt' is sold, and its contents auctioned on successive Fridays at the Vrijdagmarkt. 17 July: Vercellini writes to his master the Earl of Arundel that 'Van Dyck is still with Signor Rubens'.

VAN DYCK'S FIRST VISIT TO LONDON 1620–1

20 October: Thomas Locke writes from London to William Trumbull that 'the young painter Van Dyke is newly come to towne'. 25 November: Toby Matthews writes to Sir Dudley Carleton that James I has given Van Dyck a pension of £100 per annum.

Birth in Brussels of Ignace Le Roy, eldest surviving legitimate son of Jacques II Le Roy.

1621

Death of Philip III of Spain, who is succeeded by his son Philip IV. Death of Archduke Albert. The Southern Netherlands once again lose their independence as sovereignty reverts to Spain, although the Archduchess Isabella continues to act as Governor until her death in 1633. End of the Twelve Year Truce. The United Provinces contract an alliance with the King of Denmark and agree to subsidize the exiled King of Bohemia and his allies in their attempt to regain the Rhine. The King and Queen of Bohemia are received in The Hague.

BRIEF RETURN TO ANTWERP
AND TRIP TO ITALY 1621–7

28 February: Van Dyck receives an eight-month passport from the Earl of Arundel, returns to Antwerp in March, and leaves for Italy in October. He arrives in Genoa in late November and lodges with his compatriots Lucas and Cornelis de Wael.

Jacques II Le Roy sells the property of Steenborgerweert, with its gunpowder factories. As a result of this sale Elisabeth Hoff receives the capital of the annuity originally settled on her son Philippe Le Roy. She testifies to this effect before the Aldermen of Antwerp, and the document is later defaced to conceal this official reference to the irregularity of Philippe's birth. Philippe Le Roy, acting for the heirs of Guillaume Maes and Marguerite van den Nieuwenhijsen (parents of his father's wife Jeanne, and grandparents of his own future wife) arranges the sale of a farm at s'Gravenwezel to Mathieu de Cnoddere.

1622

Spinola besieges the key Dutch fortress of Bergen op Zoom, which is relieved by the arrival of General Mansfield and Christian of Denmark in October.

Van Dyck in Rome, where he paints the Portraits of *Sir Robert Shirley* **and** *Teresia, Lady Shirley* **(Petworth House) between 22 July and 29 August. From there he goes to Venice where he meets the Countess of Arundel, whom he accompanies to Turin. His father dies, in December, in Antwerp.**

1623

Van Dyck returns to Genoa, visits Rome over the summer and then remains in Genoa until the following spring.

Philippe Le Roy, acting as agent, sells the house 'het cleyn vleeschhuys' ('the little butchers') next to the church of Saint Walpurgis, to the Antwerp merchant Balthasar van Nispen.

1624

Cardinal Richelieu becomes first minister in France. Archduchess Isabella, starved of financial support by the government in Madrid, concentrates her forces on the Dutch border.

Van Dyck travels to Palermo in the spring at the invitation of Emanuele Filiberto of Savoy, whose portrait he paints (Dulwich) before the sitter's death of plague that same year. Due to the plague the city is soon under quarantine. Saint

Rosalie's cult grows and Van Dyck receives commissions to represent her as an intercessor against the plague. 12 July he records his visit to the aged court painter Sofonisba Anguissola in his sketch book (British Museum). In November he acts as guarantor for Jan Breughel the younger in Palermo, while back in Antwerp his brother-in-law informs the magistracy of his absence abroad. He receives payment for the portraits of members of the Genoese Durrazzo family (see fig.110) in December.

Councillor Jacques II Le Roy charges his son, Philippe Le Roy, Commissioner General of Saltpetre and Gunpowder to His Majesty, to receive money on his behalf from Henri Stock, member of the Pupils' Chamber of Antwerp.

1625

The Archduke Leopold, brother of the Emperor, suffers heavy losses. With the Val Telline blocked by Protestant forces, and the English patrolling the seas, the Spanish are unable to send bullion to pay their army in Flanders. Spinola redoubles his efforts in the Netherlands. He is assisted by the Great Frost and lays siege to Breda, the key fortress on the frontier of the United Provinces and the Spanish Netherlands. Wedding of Frederik Hendrik of Nassau, youngest son of William the Silent, and Amalia van Solms, maid-of-honour to the Queen of Bohemia. Death of Maurice of Nassau, Prince of Orange. His half brother, Frederik Hendrik, succeeds him. Death of James I of England and accession of Charles I, who marries Henrietta Maria, sister of the French king Louis XIII, later the same year.

Van Dyck is recorded living in Palermo in April, receives payment on 18 August for a portrait painted in Genoa of a member of the Cattaneo family (possibly fig.32), and four days later receives a commission to paint an altarpiece of *The Madonna of the Rosary* (in situ) for the Oratory of the Compagnia del Rosario in Palermo. Van Dyck is again declared to be living abroad by his family before the Antwerp magistrate in December.

Elisabeth Hoff transfers an annuity to her son Philippe Le Roy, 'citizen of Antwerp'.

1626

Philippe Le Roy presents an authorisation for the seizure of goods of Hermann Antoine de Marneffe, Lord of Gesves. Philippe, now aged 30, acquires the village of Ravels near Turnhout, together with its feudal rights, thereby acquiring the right to term himself 'Lord of Ravels'.

1627

The bankers of Genoa, and Antwerp are badly affected by Spain's near bankruptcy.

SECOND ANTWERP PERIOD 1627–32

18 September Van Dyck's sister Cornelia dies and Van Dyck returns to Antwerp, where he paints a *Portrait of Peeter Stevens* (fig.23). He receives payment in December for a group

of portraits he painted in Genoa of the Brignole-Sale family.

Death of Elisabeth Hoff, mother of Philippe Le Roy, aged 64 years. She is interred in the Carmelite convent under a tombstone erected in her honour by her son. She is described as a widow in the obituary lists of the convent, and her tombstone implies the same.

1628

The strain of the war begins to take its toll on the unstable finances of the Spanish Netherlands. The flow of subsidies from Madrid to Brussels is checked by the English war against Spain. Rubens is sent to Spain and England on diplomatic missions for the Archduchess Isabella Summer 1628–April 1629.

Van Dyck makes his will in March, stating his wish to be buried in the choir of the Beguinage church in Antwerp. In May he joins the Jesuit Confraternity of Bachelors in Antwerp, and the same month the Earl of Carlisle records meeting Rubens at Van Dyck's house. According to the eighteenth-century biographer Houbraken, Van Dyck makes his first visit to the Court of Frederik Hendrik of Orange where he paints the Stadholder, and his wife Amalia van Solms (see fig.40). In Antwerp he paints the wife of Peeter Stevens, *Anna Wake* (fig.42), and an altarpiece for the church of Saint Augustine, *The Ecstasy of Saint Augustine* (fig.80). He paints *The Rest on the Flight into Egypt* (fig.12) with Paul de Vos for the Confraternity of Bachelors, a *Portrait of the City Council of Brussels* (destroyed), and a *Portrait of Nicholas Lanier* (fig.24). In December Van Dyck receives a gold chain for a portrait of the *Archduchess Isabella*.

1628–30

PORTRAIT OF ISABELLA WAERBECKE

THE SHEPHERD PARIS

Philippe Le Roy receives a reply from the Magistrate of Freiburg concerning the origin of his mother's family. The Magistrate conflates the history of Le Roy's great-grandfather Max Hoff, with an aristocratic family of the same name, and includes a sketch of a coat of arms, which Philippe will later quarter with his father's to create his own coat of arms. Marie de Raet, aged 13, acts as godmother at the baptism in Saint Gudule, Brussels, of Theodore, son of her aunt and uncle, Jeanne Maes and Jacques II Le Roy.

1629

In the Netherlands Frederik Hendrik of Orange captures Wesel and Hertogenbosch. These and other defeats demoralise the army and civilian population of the Spanish Netherlands and undermine the once popular rule of the Archduchess among her subjects. The unpaid Spanish troops mutiny, and the Archduchess staves off disaster by pawning her jewellery and later raising exceptional levies from the people.

Van Dyck paints *The Coronation of Saint Rosalie* (Vienna) for the Jesuit Confraternity of Bachelors, and *The Crucifixion with Saint Dominic and Saint Catherine of Siena* (Antwerp) for the convent of the Dominican nuns in Antwerp. He refers to the *Rinaldo and Armida* (Baltimore) in a letter to Endymion Porter in December.

1630

Rubens, in London, is knighted by Charles I and given the commission for the Banqueting Hall Ceiling, Whitehall, after which he returns to Antwerp. 'Day of the Dupes' in Paris. Louis XIII's mother and brother discredited. Marie de Medici goes into exile in Brussels, where her younger son, Gaston d'Orléans, later joins her.

PORTRAIT OF PHILIPPE LE ROY

Van Dyck also does an etching of Le Roy's head and shoulders (see fig.49) recalling the painted portrait. This is the only one out of eighteen portrait etchings by Van Dyck not to be included in the *Iconography*, probably because the plate was retained by the sitter and re-used. The same year Van Dyck paints *The Vision of the Blessed Herman Joseph* (Vienna) for the Jesuit Confraternity of Bachelors in Antwerp and *The Crucifixion* (in situ) for the Brotherhood of the Sacred Cross at Saint Michael's Church, Ghent. He receives payment for his *Rinaldo and Armida* from Charles I in March, and the same day is able to subscribe 4800 guilders to the loan of 100,000 guilders raised by the city of Antwerp. Van Dyck is now known as 'painter to Her Highness' the Archduchess Isabella and receives an annual salary of 250 guilders as painter to the court at Brussels. Like Rubens before him, he does not have to stay at court but is allowed to live in Antwerp. In December the Antwerp restorer J.-B. Bruno mentions Van Dyck's exquisite collection of pictures. Over the next two years Van Dyck paints three altarpieces for the Minorites of Mechelen: *The Crucifixion* (Cathedral, Mechelen), *Saint Bonaventure* (Caen) and *Saint Anthony of Padua and the Ass of Rimini* (fig.83), for which he is paid 2000 guilders by the chevalier Jan van der Laen, Lord of Schriek and Grootloo. He is paid 500 guilders for *The Adoration of the Shepherds* (in situ) for the altar of the Confraternity of Our Lady, Our Lady's Church, Dendermonde.

Philippe Le Roy sells a house for Jean van Bodecq the elder, a relative in Frankfurt. On the death of Jean van der Stegen, Jacques II Le Roy is created President of the Chambre des Comptes de Brabant. He leases the territory of Herbaix.

1631

In May the United Provinces join in alliance with the Swedish and French, and then prepare to invade Flanders. Perilously short of money and vulnerable to attack, the government in Brussels experiences great unpopularity. Sections of the populace and nobility in the Spanish Netherlands openly support the Prince of Orange.

PORTRAIT OF MARIE DE RAET

Van Dyck also paints a *Portrait of Jacques II Le Roy* (fig.47), probably again commissioned by Philippe Le Roy. In May Van Dyck acts as godfather to Antonia, daughter of the engraver Lucas Vorsterman, and in September/October he paints the portraits of the exiled Marie de Medici (Bordeaux) and her son Gaston, duc d'Orléans (fig.119). Marie de Medici's secretary Puget de la Serre admires Van Dyck's 'Cabinet de Titien'. In the winter Van Dyck again travels to The Hague to work for the court of the Prince and Princess of Orange, and the exiled court of the Elector Palatine.
29 May: marriage of Philippe Le Roy and Marie de Raet at the Church of Saint George, Antwerp. An engraving by Pontius after Van Dyck describes Philippe as 'Lord of Ravels, etc. Connoisseur and Lover of Painting' (fig.51). Pontius is also probably responsible for reworking Van Dyck's etching of 'Philippe Le Roy' at the same time.

1632

The Prince of Orange captures Venloo, Roermond and Maastricht. His advance is assisted by widespread treachery among the Flemish nobility. Archduchess Isabella sues for peace. A truce is established. The Archduchess's hopes for peace, however, become increasingly faint with the news of the death of the King of Sweden at the battle of Lützen, and the naming of Philip IV's brother, the Cardinal-Infante Ferdinand, as her successor.

In January Van Dyck paints the portrait of Constantijn Huygens and meets the artist Frans Hals in The Hague. By March he is back in Brussels where Balthasar Gerbier writes to Charles I: 'Van Dyck is here, and says he is resolved to go over to England'.

RETURN TO LONDON 1632–4

Van Dyck is in England by 1 April, where he lodges with Nicolas Lanier's brother-in-law, the miniaturist Edward Norgate (author of *Miniatura, or The Art of Limning*) who receives 15 shillings a day 'for ye diet and lodging of Signor Antonio van Dike and his servants'. Towards the end of May Van Dyck moves to a house on the river at Blackfriars, beyond the jurisdiction of the City of London Painter-Stainer's Company. The Crown pays his rent, and he is also given a residence in the summer palace at Eltham. In July he is acknowledged as 'principalle Paynter in ordinary to their Majesties' and knighted by Charles I at Saint James's Palace. The king purchases a number of portraits painted by Van Dyck in Flanders including the portrait of Gaston d'Orléans, a portrait of the Archduchess Isabella, portraits of the Prince and Princess of Orange and their son Prince William. Van

Dyck also paints *The Greate Peece* (Royal Collection), the group portrait of Charles I, Henrietta Maria, Prince Charles and Princess Mary (Royal Collection), as well as individual pictures of the King and Queen.

Marie-Madeleine, the first of fourteen children, is born to Marie de Raet and Philippe Le Roy on 3 January. Their first nine children are born in Antwerp, between 1632 and 1644, and baptised at the Church of Saint George. Marie Madeleine's maternal grandfather, François de Raet, and great-aunt, Jeanne Maes, act as godparents. Philippe, later the same year, acts as his father and stepmother's agent in the Maes family's sale of a 'large stone house in the Mattestraet' to Gérard Bouwen. Anne Le Roy also engages her half brother Philippe Le Roy to administer the capital of two annuities belonging to her.

1633

Death of Archduchess Isabella in Brussels. Before the arrival of the new Governor, the Cardinal-Infante Ferdinand, six interim provisional Governors are appointed: the marquis d'Aytona, the Archbishop of Malines, don Carlos Caloma, the duc d'Aerschot, the marquis de Fuentes and the comte de Feyra. The interim Governors ignore the wish for peace of their Flemish subjects, dissolve the States General, and have the ambassador, sent to Philip IV to further the settlement, arrested in Madrid.

Van Dyck is given a golden chain worth £110 by Charles I, receives payment for nine pictures of the King and Queen, and is granted a pension of £200 per annum. He paints a portrait of the Queen for the Earl of Pembroke, is paid £40 by the King for a further 'Picture of Our dearest Consort the Queene', ands portrays *Charles I on Horseback with Monsieur de Saint Antoine* (Royal Collection).

Jacques Le Roy, now styled Lord of Herbaix, welcomes five of the provisional Governors. Philippe Le Roy and Carel Batkin act as almoners to the Maagdenhuis (Girls' Orphanage; fig.52) in Antwerp. His mother-in-law, Marguerite Maes, charges Philippe Le Roy to ensure the regularity of the requiem masses she initiates at the church of Saint George in memory of her husband François de Raet. Philippe's eldest son, the future historian Jacques III Le Roy, is born, and baptised on 29 October at the church of Saint George. His paternal grandfather, Jacques II Le Roy, and maternal grandmother, Marguerite Maes, act as his godparents.

1634

Hapsburg success at the Battle of Nordlingen. The Protestant princes submit to the Emperor, and the Spanish seize the French passes to the Rhineland. On the 4 November the new Regent, Cardinal-Infante Ferdinand, enters Brussels in state.

TRIP TO FLANDERS 1634

By the end of March Van Dyck is again in Antwerp. He acquires an interest in the estate of Het Steen, later bought by Rubens, and moves to Brussels by April, where he paints the new Governor of the Spanish Netherlands, and is recorded as living in ''t'Paradijs' ('The Paradise'), a house near the City Hall in December.

Jacques II Le Roy presents the congratulations of the Chambre des Comptes first to the marquis d'Aytona, and then to the Cardinal-Infante in person. The same year Philippe Le Roy buys the 'right of appropriation of lost animals' in Ravels from the Hospital of Turnhout, thereby acquiring the superior appellation 'Lord in Ravels'. In Antwerp he helps to fund the expansion of the Maagdenhuis (1634–5), which is duly recorded in an inscription in the new courtyard (fig.53).

1635

France makes a new Dutch alliance and openly declares war on Spain. Rubens orchestrates the festivities for the Triumphal Entry of Cardinal-Infante Ferdinand into Antwerp, and the same year sends the Banqueting House ceiling decorations to London. The Cardinal-Infante proves to be popular with his new subjects who also fear the Franco-Dutch alliance. But his power is undermined by interference from Madrid. Nevertheless, by the end of the year he has captured Diest, Goch, Gennep, Limburg and Schenk.

RETURN TO LONDON 1635–40

Van Dyck is back in London by the Spring, when a jetty is built into the Thames at Blackfriars to facilitate the visit of the King to his studio in June and July. Van Dyck paints *The Three Eldest Children of Charles I* (Turin) and *Charles I in Three Positions* (fig.34). A census of foreigners in London includes 'Sir Anthony Vandyke, 2 years, 6 servants'.

A lavish stained glass window designed by Abraham van Diepenbeeck, and depicting the almoners, including Philippe Le Roy, is installed in the Almoners' chapel of the Cathedral of Our Lady in Antwerp (figs.55–6). The same year Philippe Le Roy buys several houses in Antwerp for the 'Camere van den armen' (Council for the Poor). His third child, Marie–Marguerite, is born in November.

1636

The Roman sculptor Bernini is commissioned to carve a bust based on the *Triple Portrait* of the King, and Van Dyck depicts *Charles I in Robes of State* (fig.105). At the same period the artist is recorded dealing in Italian art.

Philippe Le Roy becomes Regent of the Maagdenhuis. Later he donates a monument to the institution to commemorate his association with it (fig.54).

1637

Death of Emperor Ferdinand II, and accession of his son Ferdinand III. The Prince of Orange captures Breda, the first serious check to the Cardinal-Infante.

In a letter to the artist the Duke of Newcastle declares how much he enjoys Van Dyck's company. Van Dyck receives a payment in February of £1,200 from Charles I for 'certaine pictures by him delivered for our use', and later in the year attends a dinner at the Painter-Stainers' Company together with the architect Inigo Jones, Matthew Wren (uncle of the famous architect), and Edward Norgate.

A second son, François Modeste, is born in May to Marie de Raet and Philippe Le Roy. He will later become Canon at the Cathedral Church of Saint Gudule in Brussels.

1638

Birth of a son and heir (the future Louis XIV) to Louis XIII and Anne of Austria, after 23 years of marriage.

A memorandum from Van Dyck to the King lists 25 paintings, plus five years arrears of his annual pension, for which the artist is awaiting payment. The pictures include *The Portrait of the King at the Hunt* (Louvre), *The Five Eldest Children of Charles I* (Royal Collection) and three bust portraits of *The Queen* for Bernini (Royal Collection and Memphis). In his annotations the King reduces the price of the pictures he commissioned and indicates the Queen should do the same. Van Dyck receives a first payment of £1,603 in December.

Philippe Le Roy, now Councillor and Receiver General of Licences (tax collector) in Antwerp, buys the forest of Kerreman-bosh, near Reeth. He and his wife give a crown decorated with the first twelve Emperors of Austria to the chapel of the Miracle of the Holy Sacrament in Saint Gudule, Brussels. At about the same period Le Roy and Marie de Raet contribute toward the cost of a silver tabernacle placed on the altar of the same chapel.

1639

Viscount Wentworth, later Earl of Strafford, becomes chief advisor to Charles I. Admiral Tromp sinks the Spanish fleet in English waters.

Van Dyck receives a further payment of £305 from the King in February, and the same year marries Mary Ruthven, lady-in-waiting to the Queen, and granddaughter of the 1st Earl of Gowrie.

On the recommendation of the Cardinal-Infante Ferdinand, and in recognition of thirty-five years of faithful service, Jacques II Le Roy is knighted by Philip IV of Spain.

1640

Death of Rubens on 30 May. The Spanish withdraw help from the Spanish Netherlands who are threatened on all sides by Dutch and French armies. In England the Long Parliament meets in London without Royal permission: Strafford and Archbishop Laud are impeached for high treason and imprisoned in the Tower of London.

The Countess of Sussex writing to Ralph Verney implies that Van Dyck intends to leave London, and the Earl of Arundel obtains a passport for Van Dyck and his wife to travel to Antwerp.

VISITS TO FLANDERS AND FRANCE

1640–1

In October Van Dyck attends the Saint Luke's Day Feast in Antwerp and, like Rubens alone before him, is named honorary Dean of the Guild of Saint Luke. Martin van Enden publishes the first edition of Van Dyck's *Iconography*, depicting the famous princes, statesmen, artists and amateurs of the day, in Antwerp. Van Dyck rejects the commission to complete Rubens' unfinished designs for the Torre de la Parada for Philip IV, but is willing to undertake new commissions. At the end of the year he travels to Paris in an unsuccessful attempt to win the commission for the Grand Galerie of the Louvre (awarded to Poussin).

Jacques II Le Roy acquires complete rights of ownership to the territory of Herbaix. Philippe Le Roy, called 'Jonkheer' (Knight), acquires the château and estate of ter-Varent at Mortsel from 'Jonkheer d'Ableing' (the Knight of Ableing). His fifth child, Elisabeth Jacqueline, is born in January.

1641

Princess Mary of England marries Prince William of Orange in May. The same month there is rioting in London and Strafford is executed.

The painter Claude Vignon writing to the dealer François Langlois mentions Van Dyck in Paris in January. He is back in London by August when the Prince of Wales visits him at Blackfriars. The Countess Roxburghe the same month writes of the artist's illness, recovery, and intention to travel to Holland. Van Dyck visits Antwerp in October, and travels to Paris the following month, but has to refuse a commission to paint 'the Cardinal' (either Richelieu or Mazarin) due to illness.

RETURN TO LONDON AND DEATH

Van Dyck returns to London where his daughter Justiniana is born on 1 December. On 4 December Van Dyck makes a new will leaving his Antwerp property to his Beguine sister Susanna, instructing that she should care for their younger sister Isabella, and for his illegitimate daughter, Maria Theresia. He leaves the rest of his estate to his wife and newborn daughter, and bequeaths £3 'to the poore of the parish of Blackfriars'. Although a Catholic, Van Dyck also requests that he be buried in Saint Paul's Cathedral. On 9 December Van Dyck dies at Blackfriars, and is buried two days later in Saint Paul's, where the King erects a monument in his honour.

Anne Thérèse, sixth child of Marie de Raet and Philippe Le Roy is born in February. Philippe Le Roy sells the manor house of ter-Varent at Mortsel to his mother-in-law, Marguerite Maes. The same year his father gives him another annuity of 40 florins.

1642

Charles I and Henrietta Maria leave London: the King goes North, the

Queen goes into exile at the Hague. Death of Richelieu; Cardinal Mazarin assumes his position.

Van Dyck's first grandchild, Gabriel Franciscus Essers, son of his daughter Maria Theresia and Gabriel Essers, is baptised in the Church of Saint Gommarus, Lier. Abraham Cowley writes *On the Death of Sir Anthony Vandike, The famous Painter.*

Philippe Le Roy is created Commissioner General of Supplies to the Spanish Royal army in Flanders (commissaire général des vivres des armées du roi aux Pays-Bas) in February, and in September is named Superintendent of Taxes (surintendant des contributions greffiers). His seventh child, Pierre, is born in May.

1643

Death of Louis XIII, and accession of Louis XIV. His mother, Anne of Austria, becomes Regent. Cardinal Mazarin, her trusted advisor, effectively rules France. The French victory at Rocroi in the Spanish Netherlands marks the effective destruction of the Spanish army, the sole protection of Flanders.

Birth in June of Antoine Marie, eighth child of Philippe Le Roy and Marie de Raet. He later becomes a captain in the cavalry and an ambassador in the service of the Emperor, and is known by the title of Baron of the Holy Roman Empire and Lord of Saint-Lambert.

1644

Victory of the French at Lens in the Spanish Netherlands. The growing power of France alarms her ally, the United Provinces, who thus become more open to peaceful overtures from the Spanish. The Congress of Münster is convened to discuss terms for peace. On his way to the Congress the French Ambassador, Claude d'Avaux, outrages the Dutch Estates in The Hague by announcing the French King's wish that they should tolerate Catholics. The Congress opens in December.

Philippe Le Roy is sent on his first recorded mission to The Hague, to investigate the possibility of agreement with the North regarding the shipping of Spanish silver. In April, profiting from the governmental alienation of leasehold land, he is able to acquire complete rights to the estates of Broechem and Oeleghem, in the region of Santhoven. He is described as Clerk to the Council of Finances (greffier du conseil des finances) in the deeds of purchase. In November his fifth son and ninth child, Joseph Elie, is born: the future Baron of Oeleghem, and seneschal to Emperor Leopold I, who later becomes Superintendent of Buildings and Works at the Court of Brussels and Tervueren. Jacques II Le Roy acquires full and clear rights to the estate of Herbaix for 2500 livres.

1645

Despite the famine and hardship engendered by the wars in central Europe, the delegates at the Congress spend the first six months arguing points of precedence. They then spend over a year trying to determine the 'subjecta belligerentia' or reasons why the war was being fought. Continuing hostilities also complicate the peace proceedings further. Among the delegates are the Spanish ambassador, Count Guzman de Peñaranda, and his second, Antoine Brun. Adriaen Pauw of

Holland represents the pro-Spanish party from the United Provinces, and his colleague, Jan van Knuyt of Zeeland, supports the Orange party with their French leanings. In addition to the war in Germany, the peace between Spain and the United Provinces and the peace between France and Spain are under discussion. The aim of the Spanish envoys is not merely to negotiate peace for their own government, but also to split the Franco-Dutch alliance. In financial difficulties, the government in Brussels raises a loan of 600,000 florins. On the insistence of the Marquis de Castel-Rodrigo, the functionaries of the administrative and judicial services are obliged to guarantee part of the loan from their own pockets. In London William Laud, Archbishop of Canterbury, is executed. Defeat of Charles I at the Battle of Naseby.

Death of Mary Ruthven, now married to Sir Richard Price. Legal wrangles over Justiniana van Dyck's inheritance.

President Jacques II Le Roy guarantees 6000 florins of the governmental loan.

1646

Death of the Cardinal-Infante Ferdinand. After some hesitation, Archduke Leopold William, brother to Emperor Ferdinand III, is made Regent of the Netherlands. The French approach the Spanish with the suggestion that they exchange Catalonia, occupied by French troops, for the Netherlands. The United Provinces, incensed by such treachery, prepare peace terms acceptable to Spain.

The tenth child of Philippe Le Roy and Marie de Raet, a daughter, Barbe, is the first of their children to be born in Brussels and baptised at the Cathedral church of Saint Gudule in March. Philippe Le Roy's half-brother, Ignace, acts as godfather. Philippe is granted a passport on 15 October, and given letters of recommendation, written in Brussels on 28 December by the Marquis de Castel-Rodrigo, to the Estates-General and to the Prince and Princess of Orange.

1647

The abandonment of their project for the cession of the Spanish Netherlands inspires the French to prosecute the war all the more fiercely. Mazarin orders Turenne to turn his troops against the Low Countries. The Archduke Leopold crosses the frontier of Brabant, and prepares for new campaigns against the French. Simultaneously Spanish diplomacy in The Hague aims to drive a wedge between the Northern Netherlands and their ally France, as this would allow the Spanish Netherlands to repulse the French from their borders without fear of reprisals from the North. To this end they encourage French ambitions for a marriage between the young Louis XIV and the Spanish Infanta, and then reveal this treachery to the United Provinces. This, together with the skilled negotiations of the representative of the Spanish Netherlands in The Hague, Philippe Le Roy, prompts the United Provinces to sign a truce with Spain in June. Also, unfortunately for the French, Turenne's army suffers mutiny, and is unable to march on Flanders. Archduke Leopold reconquers Armentières, Comines, Lens and Landrecies.

At the beginning of the year Philippe Le Roy receives letters patent from the Emperor Ferdinand III, confirming his right to a knighthood. He is officially permitted to bear the Le Roy arms adopted by his father, quartered with those

of his mother's family, Hoff. He then departs for The Hague. His brief, from the Marquis de Castel-Rodrigo, is to negotiate an armistice between Spain, the Southern Netherlands and the Northern Netherlands. When the French ambassador Servien learns of Le Roy's intentions he tries unsuccessfully to get him expelled from The Hague. Le Roy's negotiations are, however, successful, in recognition of which he is awarded a pension by Archduke Leopold, and a gold chain with the Emperor's portrait. In August Le Roy is named Councillor and Advisor on Land and Finance (conseiller et commis des domaines et finances) to the Court in Brussels, at an annual salary of 1983 livres 4 sols; a position he retains until 1661. He is described as living in Brussels in the rue Isabelle when his infant daughter, Barbe Le Roy, dies and is interred at Saint Gudule. Marie de Raet gives birth for the eleventh time in April to another daughter, Marie Angèle, for whom Ignace Le Roy again serves as godfather.

1648

The Peace of Westphalia is concluded between Spain and the United Provinces on January 30th whereby the independence of the United Provinces is officially recognised. Spain effectively sacrifices the loyal provinces that had fought for her, in order to get better terms. Although relative peace returns to the Spanish Netherlands, economic decline sets in, as the River Scheldt remains closed for trade. Antwerp, in particular, is hard hit, and Amsterdam consolidates its position as undisputed trading capital of the Netherlands. In August, the French, under Enghien, destroy Archduke Leopold's forces at Lens. His brother, the Emperor Ferdinand, then agrees to The Treaty of Westphalia, which is signed in Münster on 24 October , marking the end of the Thirty Years War (fig.57). The first 'Fronde' (Revolt of the Nobles) in France similarly aids the speedy acquiescence of the French. In England the Rump Parliament tries and condemns Charles I.
In Brussels Le Roy acquires a house behind the Cathedral church of Saint Gudule from his brother-in-law, Dominique de Raet. His twelfth child, Philippe, who was later to become a monk at the Abbey of Afflighem, is born. The obituary list for Saint Gudule in the same year records the loss of a further three children to Le Roy and his wife. The children are interred on 20 February, 31 March and 10 November. Le Roy's biographers imply that following his diplomatic success, he retires, aged 52, to his estates at Broechem.

1649

Execution of Charles I in London.
Philippe Le Roy acquires the manor of 'Root hoffken' (Red Court) in Broechem from Guillaume van der Rijt, Lord of Wuestwezel. He uses the foundations of this building as the basis for a superb new château, to be known as the château of Broechem, built to reflect his new position of prestige (figs.62–4). The same year, Philip IV of Spain confirms Philippe Le Roy's nobility and his right to bear the coat of arms: Le Roy quartered with Hoff. He also permits him to augment the device by replacing the bourrelet (twisted roll) on the casque (helmet) with a golden crown, surmounted with lambrequins (wings) of argent (silver) and gules (red) and a cross of Jerusalem (a cross of Lorraine as it finally appears) in red; the whole flanked by aisles (attachments) of silver edged in red, and supported by two Swiss guards carrying pikes with pennants. According to new letters-patent from the same king, Jacques II Le Roy is also allowed to augment his arms, although not quite so lavishly (with two supporting wings of silver, and to replace the bourrelet (twisted roll) on his helmet with a crown). Philippe Le Roy's portrait is painted by Anselmus van Hulle and engraved by Pontius (see fig.59). The same year Jacques II Le Roy gives the estate of Herbaix to his son Ignace on the occasion of the latter's marriage.

1650

'Sale of the late King's goods' in London. The Second 'Fronde' in Paris (1650–3).
Philip IV authorises Jacques II Le Roy to change the colour of the supporting wings of his coat of arms from silver to gold. A dispute concerning the plantation rights in the estates of Broechem and Oeleghem between Philippe Le Roy and the Bishop of Antwerp, Gaspard Nemius, and the Abbot of Tongerloo, Augustin Wichmans, is resolved in Philippe's favour and ratified the following year by Philip IV. Le Roy's thirteenth child, Jeanne-Catherine, is born in September. Her uncle, Ignace Le Roy, and great-aunt, Jeanne Maes, act as godparents.

1651

Philip IV allows Philippe Le Roy to augment his arms further by replacing the pennants, carried by the Swiss Guard supporters, with square banners depicting the arms of his father Le Roy on the left and his mother Hoff on the right (fig.59). This allows Philippe to call himself a 'chevalier-banneret'. The Bishop of Antwerp authorises the celebration of mass in the castle chapel at Broechem.

1653

After the distraction of the Frondes, Mazarin returns to his aggressive foreign policy directed against Spain. Most of the subsequent fighting takes place in the Spanish Netherlands.
Justiniana van Dyck, aged twelve, married to Sir John Stepney.
Philip IV permits Jacques II Le Roy to quarter his arms with those of the princely French family de Dreux. This is rescinded the following year when Le Roy is only authorised to use the arms acknowledged in 1650. Philippe Le Roy acquires the estate of Chapelle-Saint-Lambert near Bruxelles (fig.65). The ownership is subsequently disputed by Nicolas Antoine de Spangen, Lord of Moustier-sur-Thyl etc., and is not resolved until 1657, when the courts rule in favour of Le Roy. Philippe Le Roy and Marie de Raet's fourteenth and youngest child, Françoise Pauline Le Roy de Saint Lambert, is born in Brussels and baptised at Saint Gudule in April. The same year the couple donate a painting by Gaspar de Crayer to the Abbey of Nazareth near Lier (Zwartzusters, Antwerp).

1654

Jacques II Le Roy dies in his house in the rue Isabelle in Brussels. His funeral is held in the church of Saint Gudule. His son Ignace inherits the house in Brussels. Lommelin engraves Van Dyck's 1631 'Portrait of Jacques Le Roy', which is dedicated by the publisher Hendricx to the sitter's son Philippe Le Roy, Chevalier Banneret, Lord of Broechem and Oeleghem etc. (fig.66).

1655

Ignace Le Roy is made Master and Councillor of the Chambre des Comptes in Brussels, and eventually President, after Jacques van Parijs, who had himself succeeded Jacques II Le Roy.

1656

Abdication of Archduke Leopold (dies 1662). Philip IV's illegitimate son, Don Juan of Austria, is made Regent of the Spanish Netherlands. Oliver Cromwell appointed Lord Protector in England.

Adriaan Waterloos produces two commemorative medals depicting Philippe Le Roy (fig.67).

1657

Death of Emperor Ferdinand III. His son Leopold I (d.1705) succeeds him.

1658

Death of Oliver Cromwell.

At the age of 25, Jacques III Le Roy, eldest son of Philippe Le Roy and Marie de Raet, is named Clerk of the Land and Finances of the King (greffier des domaines et finances du roi). He marries Dimphne Marie de Deckere, daughter of Pierre Pascal de Deckere, Knight and Lord of Monteleone, Zevenbergen, Ranst & Millegem etc., and Cornélie Marie Houtappel, Lady of Ranst.

1659

Death of Don Juan of Austria. Archduchess Maria Elisabeth, daughter of Leopold I, becomes Regent of the Spanish Netherlands (d.1741). The Treaty of the Pyrenees ends the war between France and Spain. Louis XIV marries the Spanish Infanta, Marie-Thérèse of Austria, and the Spanish cede Artois and other important frontier towns in the Spanish Netherlands to France.

Date of the first known publication by Jacques III Le Roy: a book on Marian Devotions, 'Dévotes conceptions...à la glorieuse Vierge Marie', collected from the works of V.P. Nicolas de le Ville, and published in Leuven.

1660

Charles II is restored as King of England.
Many pictures are returned to him, including a number of works by Van Dyck.

1661

Death of Mazarin. Louis XIV assumes complete control of France.

Le Roy retires from his position as Councillor and Advisor on Land and Finance to the Court in Brussels. His eldest son Jacques succeeds him. He and his wife draw up their will in Brussels on 16 March. To their eldest son, Jacques III Le Roy, already described as Councillor and Financial Advisor to His Majesty, and to his male heirs, they leave the château and estates of Broechem. On the event of his death without male issue the estate is to pass to the eldest of his brothers. They also charge him to pay a capital of 20,000 florins, or the interest on such a sum at 5%, to those of his brothers and sisters not in religious orders.

1662

Death of Marie de Raet, aged 47, 20 August. Following the death of his wife Philippe writes to her relatives to clarify her genealogy. It is probably her death that inspires him to commission a portrait of himself from Victor Boucquet (fig.68) and to plan an elaborate monument in the church at Broechem (fig.69). In the event this commemorates Philippe's achievements rather more than the memory of his wife.

1663

Philippe Le Roy assigns an annuity of 10 florins to pay for an annual mass in the parish church of Broechem on the anniversary of his wife's death. Philippe has his seal, describing him as 'knight of Broechem and Oelegem', engraved by E.V. Ordonie.

1664

The will of Philippe Le Roy and Marie de Raet is opened before the notary Nicolas Claessens in Brussels. Jacques III Le Roy is sent to Madrid, on the orders of the Governor-General, the Marquis de Caracena, to report to the King on the precarious financial and commercial situation of the Spanish Netherlands.

1665

Death of Philip IV of Spain; he is succeeded by his imbecilic son, Charles V.

The Marquis de Castel-Rodrigo is made Captain General of the Spanish Netherlands. Owing to disagreements with the latter, Jacques III Le Roy resigns. According to a document in the archives de la Chambre des Comptes Le Roy is paid the sum of 20,300 florins: 18,000 florins reimbursing the sum he lent to his Majesty when attaining the position of Clerk of Finances, 800 florins that he paid for the right to exercise his functions as Clerk, and 1,500 florins for the position of Advisor of Finances.

1666

Death of Frans Hals in Haarlem.
Van Dyck's tomb is destroyed together with the old Cathedral of Saint Paul's in the Great Fire of London.

1667

France again attacks Spain by invading the Spanish Netherlands: The War of Devolution (1667–9). The United Provinces, loath to end their traditional alliance with France, nevertheless mistrust expansionist French policies directed against the Spanish Netherlands.

Death of Ignace Le Roy, who is interred in Saint Gudule in Brussels. Jacques III Le Roy and his wife buy out their co-heirs and thus become owners of the château of Zevenbergen at Ranst. Their eldest son, Peter, dies the same year, aged 7.

1668

The Prince de Condé occupies Franche-Comté. The United Provinces conclude the Anglo-Dutch Treaty, which becomes the Triple Alliance on the admission of Sweden, and offer to mediate between France and Spain. At the Treaty of Aix-la-Chapelle, Louis XIV relinquishes

Franche-Comté, but retains all French conquests in the Spanish Netherlands.

Death of Dimphne de Deckere, first wife of Jacques III Le Roy. A monument in her memory and that of her son is eventually raised opposite that of Philippe Le Roy and Marie de Raet in Broechem parish church.

1669

Death of Rembrandt in Amsterdam.

Second marriage of Jacques III Le Roy with the 19 year-old Anne Isabelle Macquereel, at the church of Saint George, Antwerp. A group of prominent Spanish noblemen act as witnesses including: Don Juan Domingo de Zuñiga y Fonesca Haro y Guzman, comte de Monterey, Lieutenant-General and Governor of Burgundy and the Netherlands (1670–5); Don Juan de Velasco, comte de Salazar, marquis de Belevedere, Knight of the Golden Fleece, and future Governor of the Town and Citadel of Antwerp (1675–8); and Philippe d'Anneux, first marquis de Warigny, vicomte de Cambrai, baron de Crèvecoeur, Lord of d'Abancourt, Rumilly etc., Member of the Council of War, Colonel of Infantry, and Governor of Avesnes. In the marriage contract, signed before the notary Gisberti at Antwerp, Philippe Le Roy promises to leave the estate of Broechem to the future children, male or female, of Jacques and his new wife. He also engages not to alienate or reduce the property by anything other than the mortgage originally mentioned in his will of 1661. The couple bring all their property and goods, which are to be held in common, to the marriage. In the event of her husband's death, Anne Isabelle Macquereel is to be given a dowry of 15,000 florins; should the opposite happen, Jacques Le Roy is to be given 10,000 florins. Later the same year, to the dismay of his first wife's family, Jacques III Le Roy sells the château of Zevenbergen, with all related property and rights in the region of Ranst, to his father-in-law François Macquereel. The latter resides in the hôtel d'Arenberg, in Antwerp, which will in turn become the residence of Jacques Le Roy.

1670

Richard Collin engraves the monument of Peter Pascal Le Roy and Dimphne de Deckere. The engraving of the monument of Philippe Le Roy and Marie de Raet, also by Collin, may have been started soon after, but not completed until after Philippe had received his barony, and before his death (fig.69).

1671

In recognition of his services in the Netherlands to the Spanish King Philip IV and to the Holy Roman Empire, the Emperor Leopold I makes Philippe Le Roy a Baron of the Holy Roman Empire, a title which is to be inherited by all his children, male and female. To mark the occasion, Van Dyck's 1630 etching, possibly reworked by Pontius, is re-issued with the addition of an inscription describing Philippe's new title and coat of arms (fig.71). The coat of arms, with a baronial coronet replacing the knight's helm, is also engraved separately by F. Erlinger.

1672

France goes to war against the United Provinces. They and their allies take Nijmegen, Overijssel and part of Gromingen. The Dutch save Amsterdam by opening the dykes.

1673

The Emperor and the Spanish enter the war in alliance with the United Provinces. The French take Maastricht.

1674

The English make peace with the Dutch.

Philippe Le Roy writes a Memoir to his children, disingenously claiming that his mother, Elisabeth Hoff, granddaughter of Marc[Max] Hoff, 'Knight and Governor of Fribourg', was descended from the poor but noble family of Hoff and the Spanish family of Cordoua. He maintains that the family papers were lost during the sacking of Malines, and that Elisabeth's father, Jacques, was stripped of his fortune by heretical troops. This allows him, according to the Memoir, to add the arms of the Spanish family to his own coat of arms. Meanwhile, despite the precautions described above, Philippe Le Roy, with the apparent connivance of his son, seems intent on mortgaging his estates: François Macquereel, father of Anne Isabelle, initiates legal proceedings against him. On the 9 May the bailiff for the federal Court of Brabant seizes the estates of Broechem. It becomes clear in the subsequent legal proceedings that Jacques III Le Roy has already alienated or mortgaged part of the fortune of his second wife.

1675

The Emperor rallies the German princes against the French.

Philippe Le Roy's barony confirmed by the Queen-Regent of the Spanish Netherlands. To circumvent the actions of François Macquereel, Philippe Le Roy and his children borrow 18,000 florins from Catherine van Vinckenborch, to be repaid over four years, using the château, estates, and seigneurial rights of Broechem and Oeleghem as surety. Philippe receives a further capital of 5000 florins at 6¼% from Adrien Borrekens, former alderman and almoner of Antwerp, mortgaged on the same property.

1678

The French take Ghent and Ypres in the Spanish Netherlands.

Publication of Jacques III, baron Le Roy, 'Notitia Marchionatus Sacri Romani Imperii', in Amsterdam. It contains an extensive chapter about the Le Roy estates, and includes engravings of his father's estates at Broechem and Chapelle-Saint Lambert, plus his coat of arms, seal, and monument.

1679

The Peace of Nijmegen (1678–9) ends the war.

Death of Philippe Le Roy, aged eighty four, at Broechem on 5 December. He is interred next to his wife in front of the magnificent monument in the parish church (figs.70 & 72). The following year a monument is erected to the memory of Philippe and his wife in the Parish Church at Oeleghem. After his death, his children divide the estate of Broechem and Oeleghem. Jacques III Le Roy renounces all claim on the estate and accepts in its stead the relatively modest château of La Tour at Chapelle-Saint-Lambert with its dependencies.

Bibliography

ADRIANI 1940 Adriani G., *Anton van Dyck: Italienisches Skizzenbuch*, Vienna, 1940

ANTWERP 1899 *Exposition Van Dyck à l'occasion du 300e anniversaire de la naissance du maître*, exh. cat., Koninklijk Museum voor Schone Kunsten, Antwerp, 1899

ANTWERP 1949 *Van Dyck Tentoonstelling*, exh. cat., Koninklijk Museum voor Schone Kunsten, Antwerp, 1949

ANTWERP 1991 *Antoon Van Dyck (1599–1641) & Antwerpen*, exh. cat. by A. Moir *et al.*, Stedlijk Prentenkabinet, Museum Plantin-Moretus, Antwerp, 1991

ANTWERP 1996 *Een Venster op de Hemel: De Glasramen van de Onze-Lieve-Vrouwekathedral van Antwerpen*, exh. cat. by S. Grieten *et al.*, Onze-Lieve-Vrouwekathedral, Antwerp, 1996

ANTWERP 1999a *Van Dyck 1599–1641*, exh. cat. by C. Brown, H. Vlieghe *et al.*, Koninklijk Museum voor Schone Kunsten, Antwerp & Royal Academy, London, 1999

ANTWERP 1999b *In the Light of Nature*, exh. cat. by M. Royalton-Kisch, Rubenshuis, Antwerp & British Museum, London, 1999

ANTWERP 1999c *Anthony van Dyck as Printmaker*, exh. cat. by C. Depauw and G. Luijten, Stedelijk Prentenkabinet, Museum Plantin-Moretus, Antwerp & Prentenkabinet Rijksmuseum, Amsterdam, 1999

ANTWERP 1999d *In Dialogue with Van Dyck*, special supplement, ed. J.Capenberghs, Antwerp, 1999

ATHENAEUM 1888 *The Athenaeum*, 21 January 1888

BALIS 1996 Balis A., 'Paul de Vos', in *The Dictionary of Art*, ed. J. Turner, vol.32, London, 1996, pp.705–7

BARNES 1994 Barnes S. J. *et al.*, *Van Dyck 350 (Studies in the History of Art, 46)*, Washington, 1994

BELLORI 1672 Bellori G. P., *Le vite de' pittori, scultori et architetti moderni*, Rome, 1672, English trans. by T. Henry and C. Brown in BROWN 1991

BLANC 1857 Blanc C., *Les Trésors de l'Art à Manchester*, Paris, 1857

BOSTON AND TOLEDO 1993–4, *The Age of Rubens*, exh. cat., ed. P. Sutton, Museum of Fine Arts, Boston; Toledo Museum of Fine Arts, Toledo, 1994–4

BRIGSTOCKE 1982 Brigstocke H., *William Buchanan and the 19th Century Art Trade*, New Haven, 1982

BROWN 1982 Brown C., *Van Dyck*, Oxford, 1982

BROWN 1991 Brown C., *Van Dyck Drawings*, London, 1991

BROWN 1990 Brown C. and Ramsey N., 'Van Dyck's Collection:

Some new Documents', *The Burlington Magazine*, CXXXII, 1990, pp.704–9

BROWN 1998 Brown C., 'Revising the canon: the collector's point of view', *Simiolus*, Vol.26, No.3, 1998, pp.201–13

BRUSSELS 1991 *Le Palais de Bruxelles, huit siècles d'art et d'histoire*, exh. cat. by A. Smolar-Meynart *et al.*, Palais Royal, Brussels, 1991

BRUSSELS 1995 *Fiamminghi a Roma 1508–1608*, Palais des Beaux-Arts, Brussels and Palazzo delle Esposizione, Rome, 1995

BUCHANAN 1824 Buchanan W., *Memoirs of Painting*, London, 1824

BÜRGER 1865 Bürger W. (Théophile Thoré), *Les Trésors de l'Art à Manchester*, Paris, 1860

CARPENTER 1844 Carpenter W.H., *Pictorial Notices, Consisting of a Memoir of Sir Anthony Van Dyck*, London, 1844

CASTIGLIONE 1528 Castiglione B., *The Book of the Courtier*, Venice, 1528, trans. G. Bull 1967, repr. 1976

CAVALLI-BJÖRKMAN 1987 Cavalli-Björkman (ed.), *Bacchanals by Titian and Rubens*, Stockholm, 1987

CRICK 1998 Crick S., *Philippe le Roy, heer van Broechem-Oelegem en de Vrede van Münster. Herdenking 350 jaar 'Vrede van Münster 1648'*, Antwerp, 1998

CUNNINGHAM 1829 Cunningham A., *Lives*, London, 1829

CUST 1900 Cust L., *Anthony Van Dyck: An Historical Study of his Life and Work*, London, 1900

DAMM 1996 Damm M.M., *Van Dyck's Mythological Paintings*, Ph.D. diss. University of Michigan, 1966

DAVIES 1997 Davies N., *Europe. A History*, Oxford, 1997

DESCAMPS 1753–4 Descamps J.B., *La vie des peintres flamands, allemands et hollandais*, 4 vols, Paris, 1753–4

DESCAMPS 1769 Descamps J.B., *Voyage pittoresque de la Flandre et du Brabant*, Paris, 1769

DUARLOO 1998 Duarloo L. and Thomas W. eds., *Albert & Isabella: Essays*, Brepols 1998

DI FABIO 1996 Di Fabio C., 'Il rittrato di Gerolamo Gallo, musico della Cappella Ducale di Genova e altre aggiunte al catalogo di Luciano Borzone', *Bollettino dei Musei Civici Genovesi*, XVIII, 52–4, June–Dec. 1996

FÉLIBIEN 1666–88 Félibien A., *Entretiens sur les Vies et sur les Ouvrages des Plus Excellens Peintres Anciens et Modernes*, 3 vols, Trévoux, 1666–88

FROMENTIN 1876 Fromentin E., *Les Maîtres d'Autrefois*, Paris 1876, English trans., Oxford 1981

GASKELL 1989 Gaskell I., *The Thyssen-Bornemisza Collection. Seventeenth-century Dutch and Flemish Painting*, London, 1989

GENOA 1992 *Genova nell'età Barocca*, exh. cat. by E. Gavazza and G. Rotondi Terminiello *et al.*, Galleria Nazionale di Palazzo Spinola and Galleria di Palazzo Reale, Genoa, 1992

GENOA 1997 *Van Dyck a Genova: Grande pittura e collezionismo*, exh. cat. ed. S.J. Barnes, P. Boccardo, C. Di Fabio and L. Tagliaferro, Palazzo Ducale, Genoa, 1997

GLÜCK 1931 Glück G., *Van Dyck, des Meisters Gemälde*, Berlin, 1931

GLUCK 1934 Glück G., 'Self-Portraits by Van Dyck and Jordaens', *The Burlington Magazine*, LXV, 1934, pp.194–201

GOFFAERTS 1892 Goffaerts C., 'Jacques Le Roy, baron de Broechem et du Saint-Empire… et sa famille', *Messager des Sciences Historiques de Belgique*, 1892, pp.431–50, pls.I–III

GÖPEL 1940 Göpel E., 'Ein Bildnisauftrag für Van Dyck. Anthonis van Dyck, Philipp le Roy und die Kupferstecher', *Veröffentlichungen zur Kunstgeschichte 5*, Frankfurt am Main, 1940

GROENEWEG 1995 Groeneweg I., 'Regenten in het zwert: vroom en deftig', *Nederlands Kunsthistorisch Jaarboek*, 46, 1995, pp.199–251

GROSSO 1927–8 Grosso O., 'Giovanni Bernardo Carbone', *Dedalo*, viii/I, 1927–8, pp.109–34

GUIFFREY 1882 Guiffrey J., *Antoine Van Dyck: sa vie et son oeuvre*, Paris, 1882

THE HAGUE 1997–8 *Princely Patrons. The Collection of Frederick Henry of Orange and Amalia of Solms*, exh. cat. by P. van der Ploeg and C. Vermeeren, Mauritshuis, The Hague, 1997–8

THE HAGUE 1998 *Gerard ter Borch and the Treaty of Münster*, exh. cat. by A. McNeil Kettering, Mauritshuis, The Hague, 1998

HASKELL 1976 Haskell F., *Rediscoveries in Art*, London, 1976

HEALEY 1997 Healey F., *Rubens and The Judgement of Paris: A Question of Choice*, Brepols, 1997

HELD 1957 Held J.S., 'Artis Pictoriae Amator. An Antwerp Art Patron and his Collection', *Gazette des Beaux-Arts*, 6e Période, L, 1957, pp.53–84

HOUBRAKEN 1753 Houbraken A., *De groote schouburgh der nederlandse konstschilders en schilderessen*, 3 vols, The Hague, 1718–21, 1753 ed., The Hague, reprinted Amsterdam, 1976

HUGHES 1992 Hughes P., *The Founders of the Wallace Collection*, London, 1992

INGAMELLS 1981 Ingamells J. ed., *The Hertford Mawson Letters*, London, 1981

INGAMELLS 1985 Ingamells J., *The Wallace Collection Catalogue of Pictures: I, British, German, Italian & Spanish*, London, 1985

INGAMELLS 1992 Ingamells J., *The Wallace Collection Catalogue of Pictures: IV, Dutch and Flemish*, London, 1992

ISRAEL 1982 Israel J., *The Dutch Republic and the Hispanic World 1606–61*, Oxford, 1982

JAFFÉ 1966 Jaffé M., *Van Dyck's Antwerp Sketchbook*, 2 vols, London, 1966

JAFFÉ 1989 Jaffé M., *Catalogo Completo: Rubens*, Milan, 1989

JAFFÉ 1996 Jaffé M, 'Van Dyck', in *The Dictionary of Art*, ed. J.

Turner, vol.6, London, 1996, pp.475–89

JONES 1997 Jones A., *The Art of War in the Western World*, Illinois 1987, repr. New York, 1987

KEBLUSEK 1998 Keblusek M. & Zijlmans J. eds., *Princely Display. The Court of Frederick Hendrik of Orange and Amalia van Solms*, Zwolle, 1998

KOYEN 1956 Koyen M., 'Tongerlo en de Heerlijkheid van Ravels. Eel', *Taxandria XXXIII*, 1956, pp.3–20

LARSEN 1975 Larsen E. ed., 'La vie, les ouvrages et les élèves de Van Dyck', *Académie Royale de Belgique: Mémoires de la Classe des Beaux-Arts*, 2nd series, xiv-2, Brussels, 1975

LARSEN 1980 Larsen E., *L'Opera completa dei Van Dyck*, 2 vols, Milan, 1980

LARSEN 1988 Larsen E., *The Paintings of Anthony Van Dyck*, 2 vols, Freren, 1988

LEE 1967 Lee R.W., *Ut Pictura Poesis: The Humanistic Theory of Painting*, New York & London, 1967

LEUVEN 1998 *Albert & Isabella*, exh. cat. L. Duerloo and W. Thomas, Koninklijke Musea voor Kunst an Geseidenis en de Katholieke Universiteit, Leuven, 1998

LIER 1986 *750 jaar Abdij van Nazareth*, exh. cat., Stedelijk Museum, Lier. 1986

LONDON 1982–3 *Van Dyck in England*, exh. cat. by O. Millar, National Portrait Gallery, London, 1982–3

LONDON 1984 *Art, Commerce, Scholarship: A Window onto the Art World. Colnaghi 1760–1984*, exh. cat., P.D. Colnaghi, 1984

LONDON 1986 *Reynolds*, exh. cat. by N. Penny *et al.*, The Royal Academy, London and Grand Palais, Paris, 1985–6

LONDON 1999 *The King's Head. Charles I: King and Martyr*, exh. cat. by J. Roberts, The Queen's Gallery, London, 1999

VAN LOON 1732 Van Loon G., *Histoire métallique des XVII provinces des Pays-Bas*, II, The Hague, 1732

MADRID 1993 *Los Austrias Grabados de la Biblioteca Nacional*, exh. cat., Biblioteca Nacional, Madrid, 1993

MAGURN 1955 Magurn R.S., ed. and trans., *The Letters of Peter Paul Rubens*, Cambridge, Mass., 1955

MANCHESTER 1857, *Art Treasures of the United Kingdom*, exh. cat., Manchester 1857

MACQUOY-HENDRICKX 1991 Maquoy-Hendrickx M., *L'iconographie d'Antoine Van Dyck*, 2 vols, 2nd ed. Brussels 1991

MILLAR 1963 Millar O., *The Tudor, Stuart and Early Georgian Pictures in the Collection of H.M. The Queen*, London, 1963

MILLAR 1997 Millar O., exh. review of: GENOA 1997, *Burlington Magazine*, July, 1997

MORETUS PLANTIN DE BOUCHOT 1955 Moretus Plantin de Bouchot R., *Demeures Familiales. Notices historiques sur la Maison Plantin à Anvers*, Anvers, 1955

MOUNT 1996 Mount H. ed., *Sir Joshua Reynolds. A Journey to Flanders and Holland*, Cambridge, 1996

MÜNSTER 1998 *30jähriger Krieg, Münster und der Westfälische Frieden*, exh. cat., Stadtmuseum Münster, 1998

DE NAVE 1995 De Nave F. and Voet L., *Musée Plantin Moretus Anvers*, Ghent, 1995

NIEUWDORP 1969 Nieuwdorp H.M.J., *Adriaan Waterloos 1598–1681. Bijdrage tot de Studie van zijn leven en Werk als medailleur*, unpublished thesis, Leuven University, 1969

PARIS 1988–9 *Seicento: le siècle de Caravage dans les collections françaises*, exh. cat., Grand Palais, Paris, 1988–9

DE PILES 1708 De Piles R., *Cours de Peinture par Principes*, Paris 1708; reprinted Nîmes, 1990

POCH-KALOUS 1966 Poch-Kalous M., 'Josef Danhausers Reiseskizzenbuch', *Albertina Studien IV*, 1966, pp.18–39

POELHEKKE 1948 Poelhekke J.J., *De Vrede van Münster*, The Hague, 1948

PRAGUE 1997 *Rudolf II and Prague*, exh. cat. E. Fučíkova, Prague Castle etc., 1997

DE RAADT 1889 De Raadt J.-Th., 'Notice historique sur Broechem et ses Seigneurs', *Bulletin du Cercle Archaeologique, Littéraire et Artistique de Malines*, I, 1889, pp.62–109

DE RAADT 1891 De Raadt J.-Th.., *Jacques Le Roy. Baron de Broechem et du Saint-Empire. Historien brabançon et sa famille*, Nijmegen, 1891

DE RAADT 1897 De Raadt J.-Th., *Sceaux Armoriés des Pays-Bas et des Pays Avoisinants…Receuil Historique et Héraldique*, Brussels, 1897

REDGRAVE 1866 Redgrave R. and S., *A Century of British Painters*, 1866, ed. Oxford, 1981

REULENS 1887–1909 Reulens C. and Rooses M., *Correspondance de Rubens et documents epistolaires concernant sa vie et ses ouevres*, 6 Vols., Antwerp, 1887–1909

REYNOLDS 1980 Reynolds G., *The Wallace Collection Catalogue of Miniatures*, London, 1980

ROOSES 1879 Rooses M., *Geschiedenis der Antwerpse Schilderschool*, Ghent, 1879

ROOSES 1886–92 Rooses M., *L'oeuvre de P.P. Rubens*, 5 vols., Antwerp, 1886–92

ROY 1999 Roy A. ed., *National Gallery Technical Bulletin 20: Painting in Antwerp and London: Rubens and Van Dyck*, 1999

LE ROY 1678 Le Roy, Jacques, baron, *Notitia Marchionatus Sacri Romani Imperii…*, Amsterdam, 1678

LE ROY 1692 Le Roy, Jacques, baron, *Topographia Historia Gallo-Brabantiae…*, Amsterdam, 1692

LE ROY 1699 Le Roy, Jacques, baron, *Castella et Praetoria Nobilium Brabantiae…*, n.p., 1699

LE ROY 1699 Le Roy, Jacques, baron, *L'érection de toutes les terres, seigneureries et familles Titrées de Brabant*, Leiden, 1699

LE ROY 1730 Le Roy, Jacques, baron, *Le Grand Théatre Profane du duché de Brabant*, The Hague, 1730

LE ROY 1734 Le Roy, Jacques, baron, *Le Grand Théatre Sacré du duché de Brabant*, 2 vols, The Hague, 1734

SCHAEFFER 1909 Schaeffer E., *Van Dyck. Des Meisters Gemälde*, Stuttgart & Leipzig, 1909

SMITH 1829–42 Smith J., *Catalogue Raisonné of the most eminent Dutch, Flemish and French Painters*, 9 vols, London, 1829–42

VAN DER STIGHELEN 1990 Van der Stighelen K., *De Portretten van Cornelis de Vos (1584/5–1651): een kritische Catalogus*, Brussels, 1990

TEL AVIV 1995–6, *Van Dyck and his Age*, exh. cat. by D.J. Lurie and N. Lev, Tel Aviv Museum, 1995–6

VAN THIENNEN 1951 Van Thienen F., *Costume of the Western World: The Great Age of Holland 1600–60*, London, 1951

URZIDIL 1942 Urzidil J., *Hollar, a Czech emigré in England*, London, 1942

VERHELST 1996 Verhelst D., *Tot eerlick onderhoudt van meyskens cleene: Geschiednis van het Maagdenhuis van Antwerpen*, Antwerp, 1996

VEY 1962 Vey H., *Die Zeichnungen Anton van Dycks*, 2 vols, Brussels, 1962

VLIEGHE 1998 Vlieghe H., *Flemish Art and Architecture 1585–1700*, Cambridge, 1998

WAAGEN 1854 Waagen G.F., *Treasures of Art in Great Britain*, 3 vols, London, 1854

WALPOLE 1888 Walpole H., *Anecdotes of Painting in England with some account of the principal artists*, ed. J. Dalloway, revised by J. Wornum, 3 vols, London, 1888

WALKER 1992 Walker R., *The Eighteenth and Early Nineteenth Century Miniatures in the Collection of Her Majesty The Queen*, Cambridge, 1992

WALTER STONE 1968 Walter Stone J., *English Travellers Abroad 1604–1667*, New York, 1968

WASHINGTON 1990–1 *Anthony Van Dyck: Paintings*, exh. cat by S. Barnes, J. Held, A. Wheelock *et al.*, National Gallery of Art, Washington, 1990–1

WATSON 1950 Watson F. J. B., 'Van Dyck's Portrait of a Young Italian Nobleman', *The Burlington Magazine*, XCII, 1950, pp.174–7

WEDGWOOD 1938 Wedgwood C.V., *The Thirty Years War*, London, 1938, ed. 1997

WETHEY 1969–75 Wethey H.E., *The Paintings of Titian*, 3 vols, London, 1969–75

WHITE 1987 White C., *Peter Paul Rubens, Man and Artist*, New Haven & London, 1987

DE WINKEL 1995 De Winkel H., '"Eene der deftigsten dragten": The Iconography of the Tabaard and the Sense of Tradition in Dutch 17th Century Portraiture', *Nederlands Kunsthistorisch Jaarboek*, 46, 1995, pp.145–67

WOOD 1990 Wood J., 'Van Dyck's "Cabinet de Titien"', *Burlington Magazine*, CXXXVI, 1990, pp.37–47

Index

Numbers in normal type refer to page numbers
Numbers in bold refer to illustrations

Photographic credits

Front cover:
Anthony Van Dyck (1599–1641)
Portrait of Marie de Raet, detail, 1631, The Wallace Collection

Inside cover and p.146:
Jan Baptist Vrients, *View of Antwerp*, engraving, 1630, Stedelijk Prentenkabinet, Plantin-Moretus Museum, Antwerp

Frontispiece:
Anthony Van Dyck (1599–1641)
Portrait of Philippe Le Roy, detail, 1630, The Wallace Collection

A large fold out *Map of Antwerp* (taken from Jacques, baron Le Roy, *Notitia Marchionatus Sacri Romani Imperii*, Amsterdam, 1678; British Museum, London) can be found on pages 8–11

Back cover:
Anthony Van Dyck (1599–1641)
Portrait of Marie de Raet, detail, 1631, The Wallace Collection